GREAT MOMENTS IN IRISH FOOTBALL

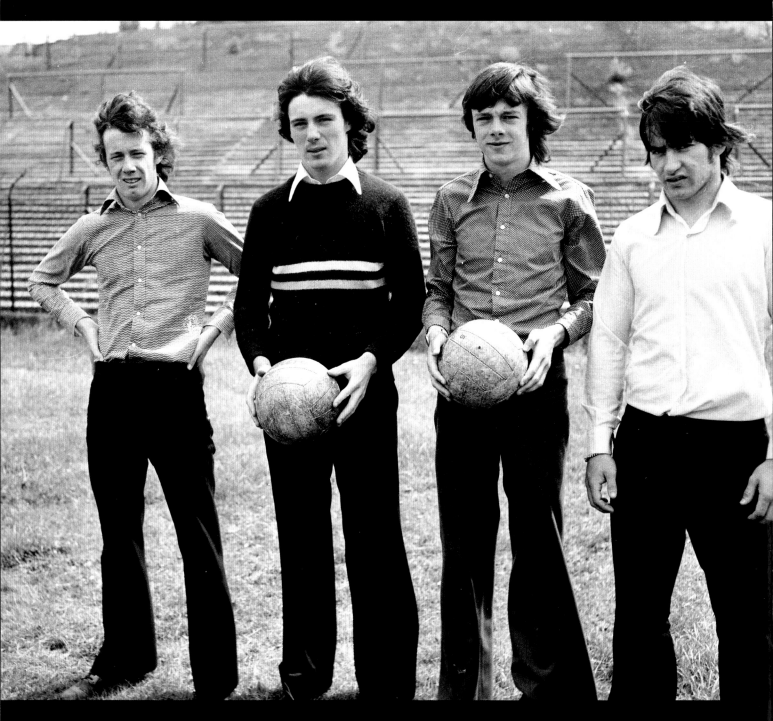

1973

Arsenal players from left, Liam Brady, Frank Stapleton, David O'Leary and John Murphy. Between these four young players, they would later earn 221 international caps for the national side. Irish Arsenal players photocall, Dalymount Park, Dublin.

GREAT MOMENTS IN
IRISH FOOTBALL
from SPORTSFILE

THE O'BRIEN PRESS
DUBLIN

First published in 2019 by The O'Brien Press Ltd,
12 Terenure Road East, Rathgar,
Dublin 6, D06 HD27, Ireland.
Tel: +353 1 4923333; Fax: +353 1 4922777
E-mail: books@obrien.ie
Website: www.obrien.ie
The O'Brien Press is a member of Publishing Ireland.

ISBN: 978-1-78849-134-1

Thanks to Oscar Rogan, Eoin Fegan, David Fegan & Nicola Reddy for their assistance with captions.

10 9 8 7 6 5 4 3 2 1
23 22 21 20 19

Layout and design: The O'Brien Press Ltd.
Printed by L&C Printing Group, Poland.
This book is produced using pulp from managed forests.

Published in:

DUBLIN
UNESCO
City of Literature

CONTENTS

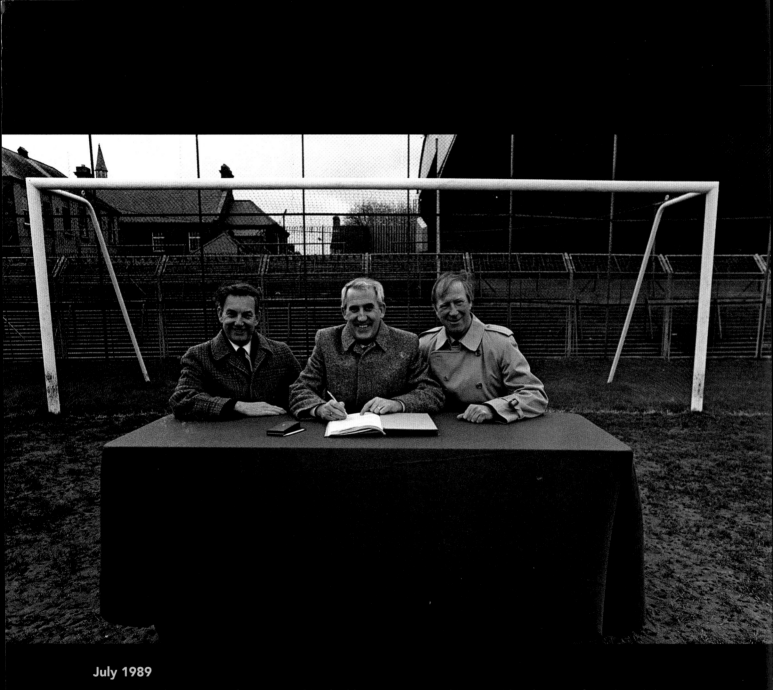

July 1989

Pictured at the signing of a sponsorship deal between General Motors (distributors of Opel) and the Football Association of Ireland are, from left, Michael Hyland, President of the FAI; Arnold O'Byrne, Managing Director of General Motors Distribution Ireland Ltd, and Jack Charlton, manager of the Republic of Ireland soccer team.

INTRODUCTION

It was 12 June 1988, a warm day in Stuttgart, and Ray Houghton had just written himself into history by putting the ball in the English net; I remember that moment like it was yesterday – the euphoria, the rejoicing of the team, the fans, Jack Charlton and the back-room team – and I was there to record it. Capturing that picture-perfect moment is what makes my job so rewarding.

Since I set up Sportsfile in the early 1980s, based purely on my passion for sport and sports photography, I've been determined to provide top-class, up-to-the-minute images. Over the decades, as the company grew and developed, I've assembled and continue to lead a crack team of award-winning photojournalists whose enthusiasm and professionalism are second to none. In our time photographing Irish football, we've been all over the world, capturing the highs and lows, from Italia '90 to the humiliating draw against Liechtenstein, from moments of drama like Thierry Henry's handball to quirkier moments like this 1989 photo call (left) for an Opel/FAI sponsorship deal – later described by the MD of Opel as 'The best sponsorship in the history of Irish sport', such was the publicity the Irish team gave to the car company – where the table set up in front of the goals provided great juxtaposition and caught my eye as a memorable image.

We've been photographing Irish football for decades and whether we're pitch-side for League of Ireland games, major qualifiers, World Cups or friendlies, what always shines through is the speed, skill and commitment of the players, and the passion and loyalty of the fans. I'm lucky to have a team of photographers who eat, sleep and breathe sport and capture the heart of it, match after match.

Ray McManus 2019

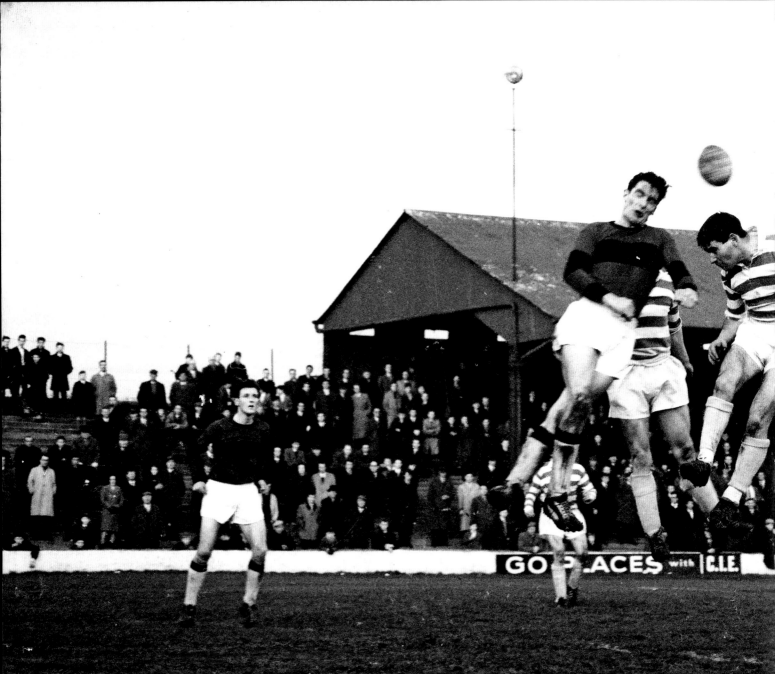

1964

Action from the Dublin derby between Shamrock Rovers and Bohemians. Since the demise of Drumcondra FC, this northside v southside derby has been the league's biggest rivalry. League of Ireland Premier Division, Glenmalure Park, Milltown, Dublin.

Connolly Collection / SPORTSFILE

1960s

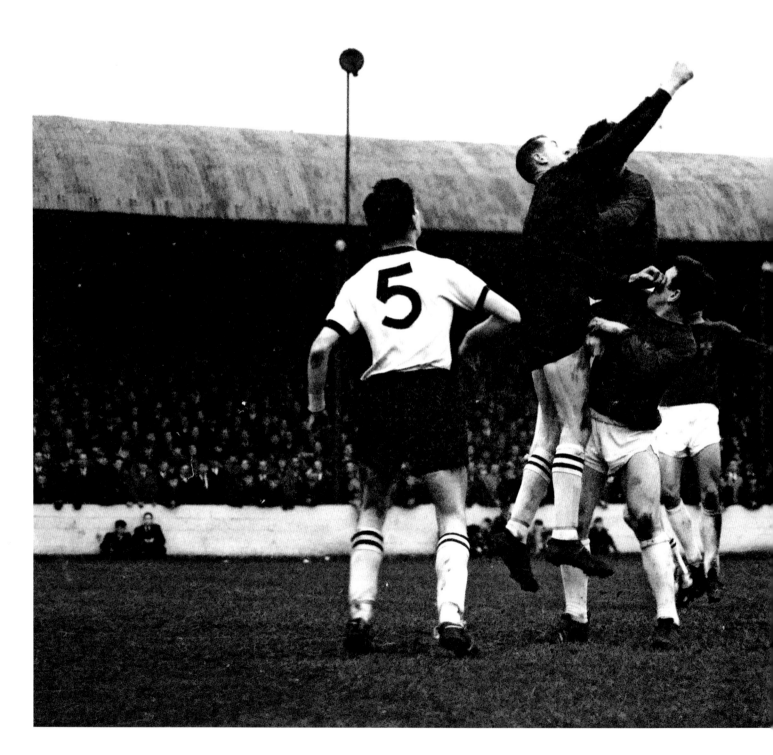

1964

A general view of the action between Shelbourne and Dundalk. League of Ireland Premier Division, Tolka Park, Drumcondra, Dublin.

Connolly Collection / SPORTSFILE

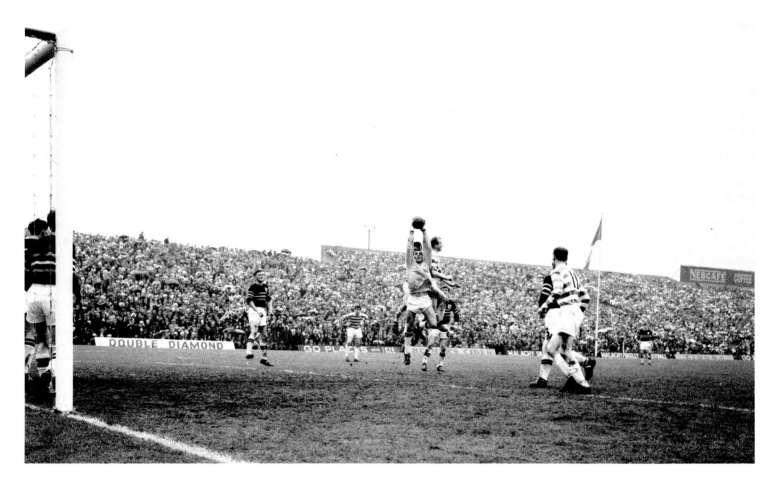

26 April 1964

Paddy Ambrose, Shamrock Rovers, in action against goalkeeper Kevin Blount, Cork Celtic. The game finished in a 1-1 draw, and Rovers went on to win the replay 2-1, to claim their fifteenth cup victory. Rovers legend Ambrose was associated with the club from 1948 until 1973, as a player and then coach. FAI Cup Final, Dalymount Park, Dublin.

Connolly Collection / SPORTSFILE

24 May 1964

England captain Bobby Moore, West Ham United, left, and Republic of Ireland captain Noel Cantwell, Manchester United, lead their respective sides out ahead of the match. Moore and Cantwell had been teammates at West Ham before Cantwell joined Manchester United in 1960. Moore would go on to captain his country to World Cup success in 1966. International Friendly, Dalymount Park, Dublin.

Connolly Collection / SPORTSFILE

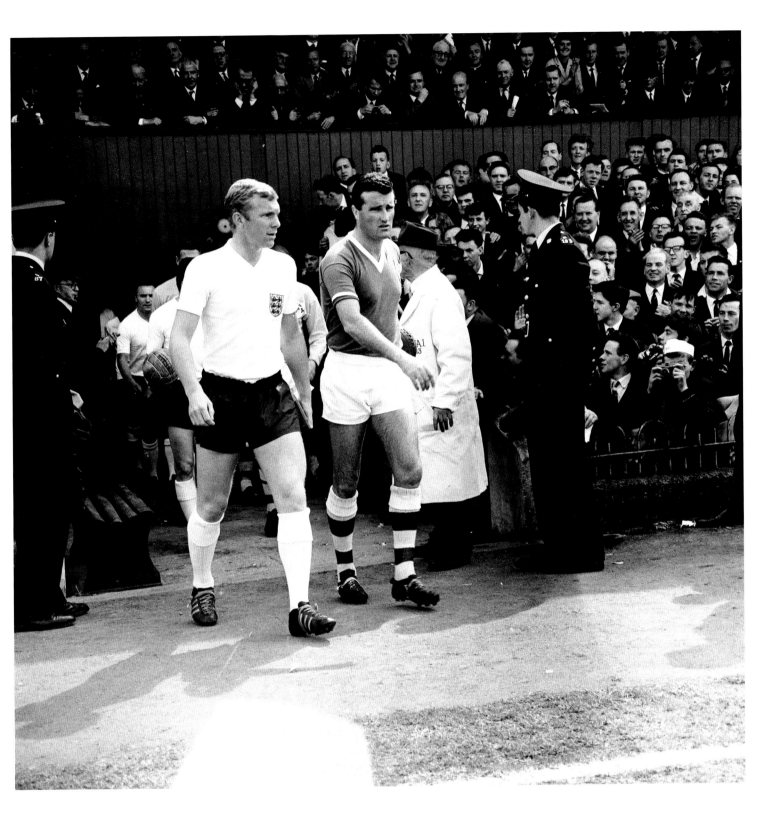

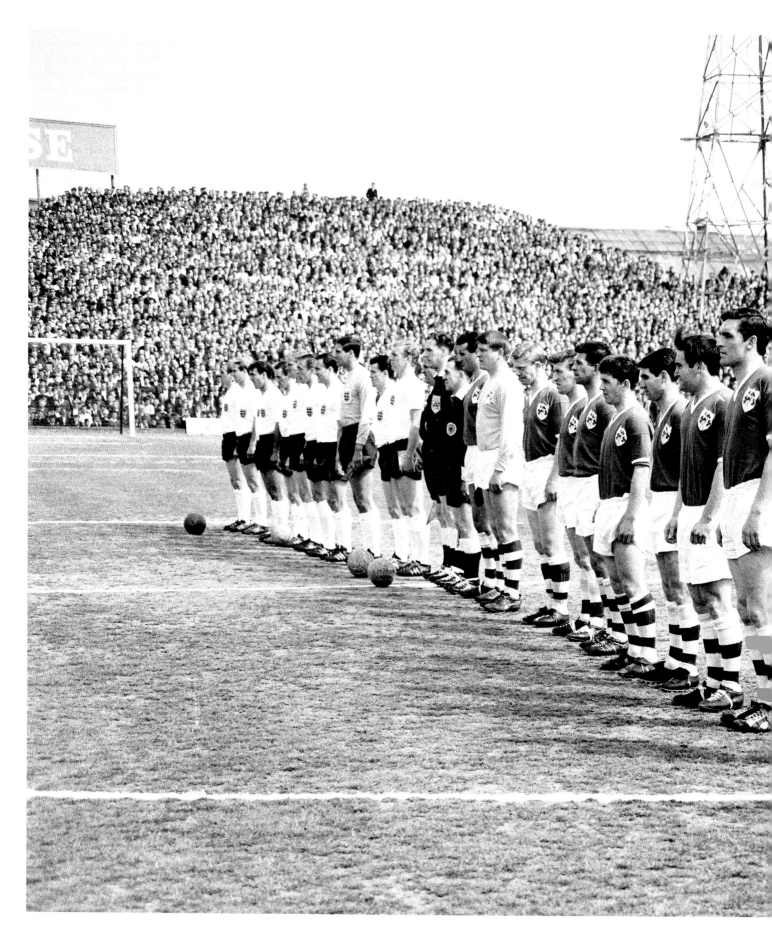

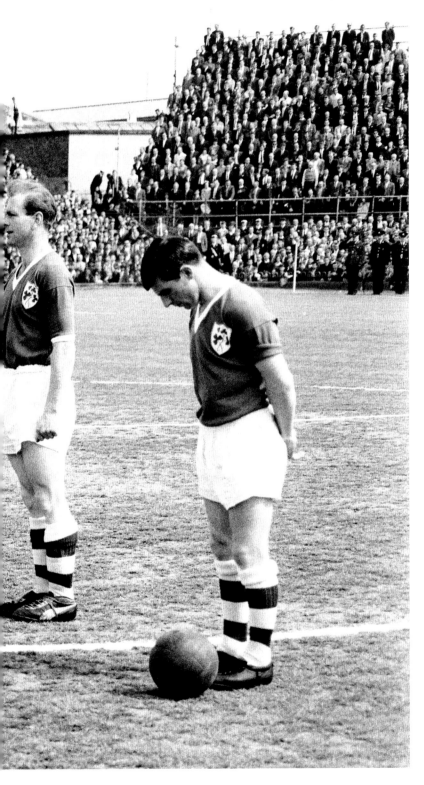

24 May 1964

Republic of Ireland players, from right to left, Joe Haverty, Millwall, Paddy Ambrose, Shamrock Rovers, Willie Browne, Bohemians, Eddie Bailham, Shamrock Rovers, Tony Dunne, Manchester United, Johnny Giles, Leeds United, Andy McEvoy, Blackburn Rovers, Mick McGrath, Blackburn Rovers, Fred Strahan, Shelbourne, Noel Dwyer, Swansea Town, and Noel Cantwell, Manchester United, captain, stand for the National Anthem before the game. International Friendly, Republic of Ireland v England, Dalymount Park, Dublin.

Connolly Collection / SPORTSFILE

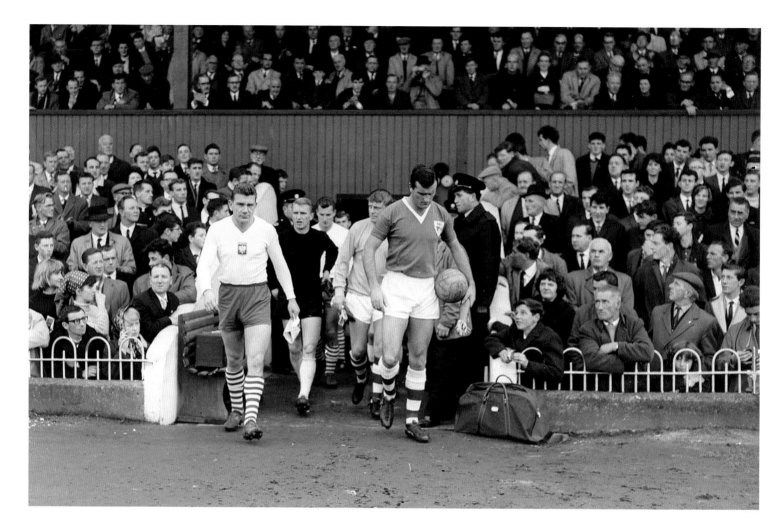

25 October 1964

Ireland captain Noel Cantwell and the Poland captain Henryk Szczepanski lead out their respective teams. Cork native Cantwell was an accomplished sportsman, who also represented his country in international cricket. Ireland won 3-2 in front of 25,100 spectators. Dalymount Park, Dublin.

Connolly Collection / SPORTSFILE

25 April 1965

Dick O'Connor, Limerick, in action against Paddy Mulligan, left, and John Keogh, Shamrock Rovers. Just like the year before, Rovers needed a replay to win the cup. This victory was part of a golden era for the club, as they won six cups in a row. FAI Cup Final, Dalymount Park, Dublin.

Connolly Collection / SPORTSFILE

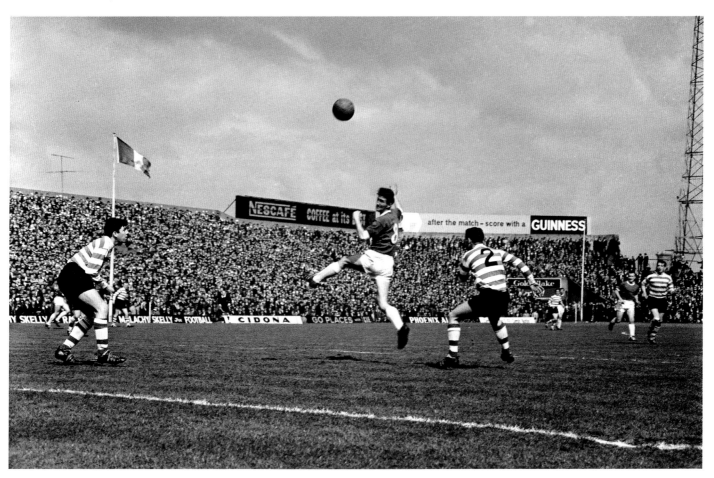

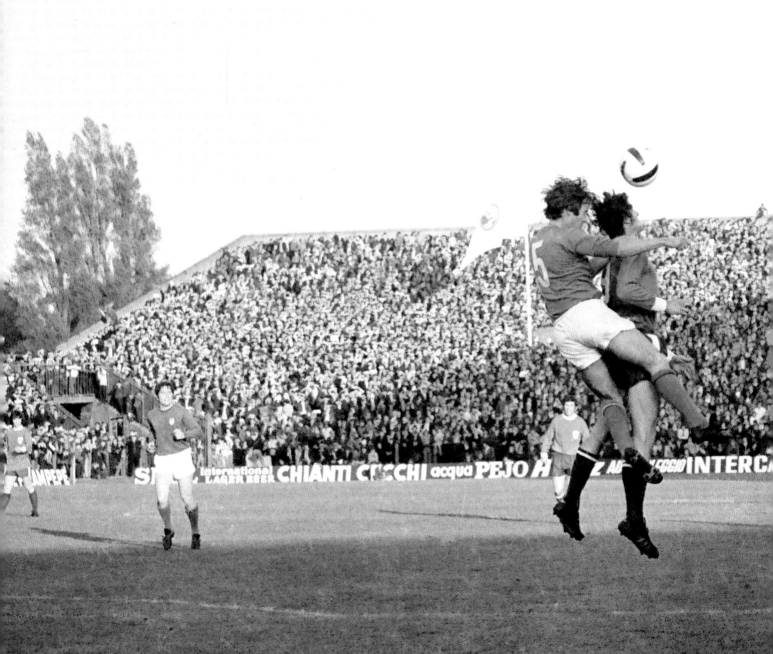

10 May 1971

The Republic of Ireland play Italy in a European Cup Qualifier; Italy 2-1. Ireland's only goal was scored by Jimmy Conway who later went on to coach college soccer teams in the USA and became the first men's college soccer coach in Oregon State history. Lansdowne Road, Dublin.

Connolly Collection / SPORTSFILE

1970s

1973

Teenage Arsenal players from left, John Murphy, David O'Leary, Frank Stapleton and Liam Brady, at a photocall in Dalymount Park. Arsenal had an strong Irish core in the 1970s; Liam Brady – one of the greatest Irish footballers of all time – and Frank Stapleton had been with the club on schoolboy papers for several years when fifteen-year-old David O'Leary joined them in 1973. O'Leary went on to be Arsenal's most-capped player, lining out for the Gunners 722 times.

Connolly Collection / SPORTSFILE

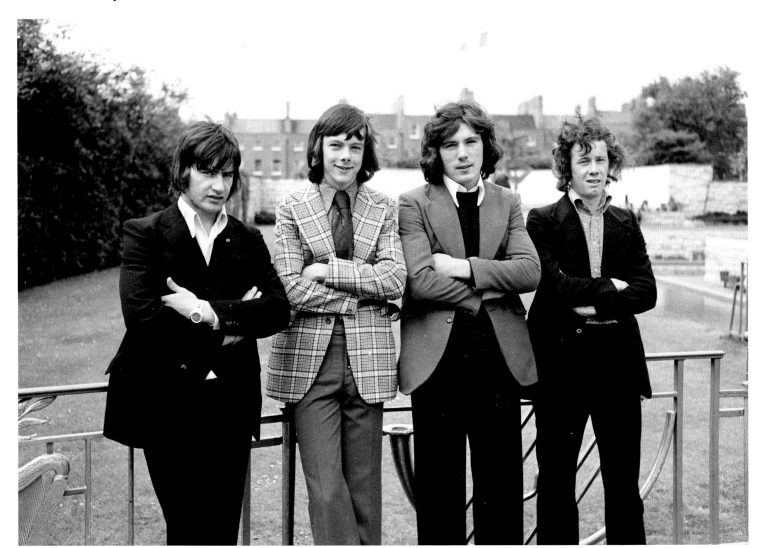

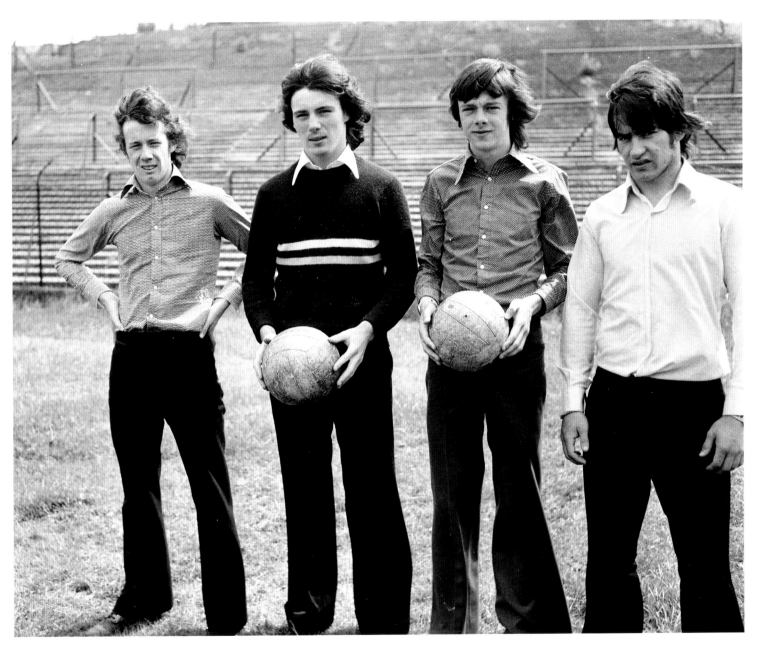

1973

Liam Brady, Frank Stapleton, David O'Leary and John Murphy.

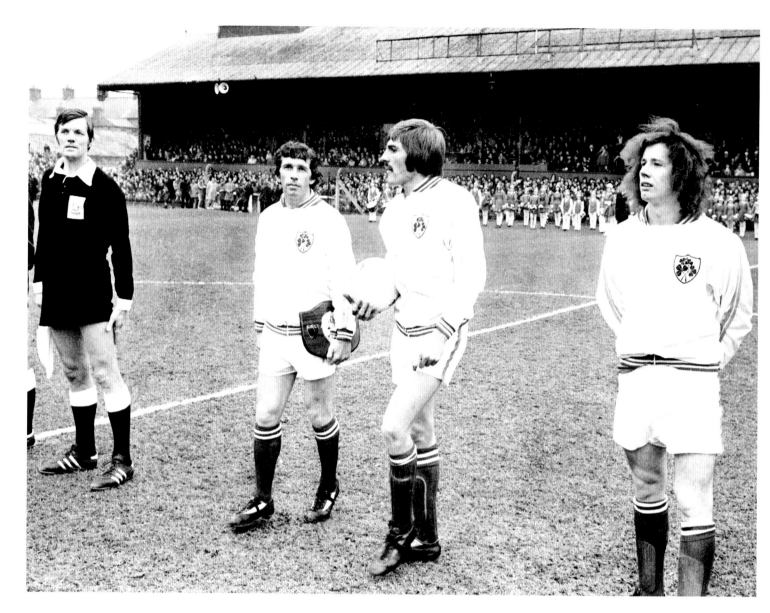

30 October 1974

Liam Brady (right), with Ireland captain Steve Heighway (centre) and John Giles (left), makes his international debut at Ireland's European Championship 1976 Qualifier against the Soviet Union. Brady had been playing professional football with Arsenal since he turned seventeen in 1973. Irish football legend Johnny Giles played for Leeds United in the sixties and seventies, and then went into management before becoming the authoritative voice of Irish football, serving as senior football analyst on RTE from 1986 until 2016. Steve Heighway was also part of the very successful Irish diaspora playing for UK clubs in the 70s; he played for Liverpool and is regarded as one of the greatest ever Reds players. European Championship 1976 Qualifier – Group 6 Dalymount Park, Dublin.

Connolly Collection / SPORTSFILE

1 May 1977

Dundalk legend Tommy McConville, who played a record 580 games for the Lilywhites, lifts the cup after his side's 2-0 victory over Limerick. FAI Cup Final, Dalymount Park, Dublin.

Connolly Collection / SPORTSFILE

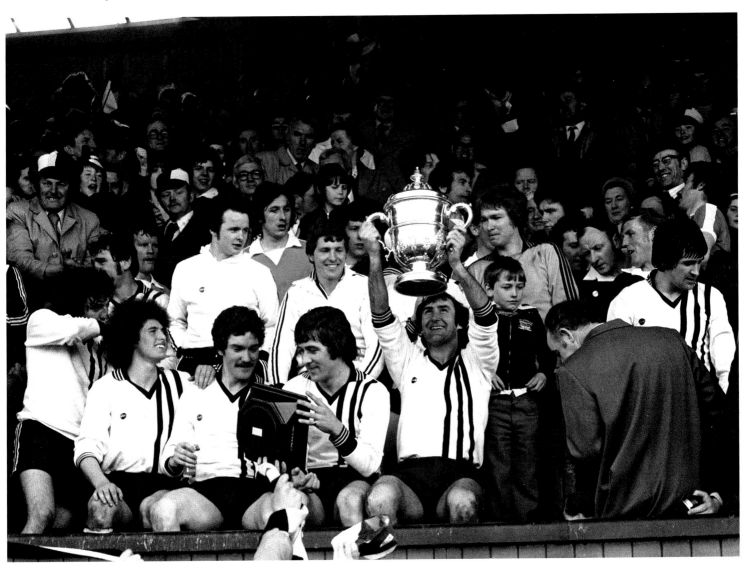

10 August 1977

Three stalwarts of Irish football at a photo-call, Glenmalure Park, Milltown, Dublin: Shamrock Rovers player-manager John Giles, with Ray Treacy, and Eamon Dunphy. Giles asserted, in a December 1977 interview with *Magill* magazine that he aimed 'Ultimately to win the European Cup with Shamrock Rovers'. He cited the wealth of Irish football talent in England and explained that if he could sign up youngsters and keep them in Ireland he could turn League of Ireland football around. It wasn't to be; years later, in a 2015 interview with the42.ie, he recalled, 'it was like trying to climb Everest ... We had nobody [from the football authority] coming with us.' Giles had returned from England to take up the helm at Shamrock Rovers in 1977, bringing Treacy and Dunphy with him to form the backbone of the team and help with youth development. In later years, Ray Treacy returned to Shamrock Rovers as manager and won the league with them in 1994.

Connolly Collection / SPORTSFILE

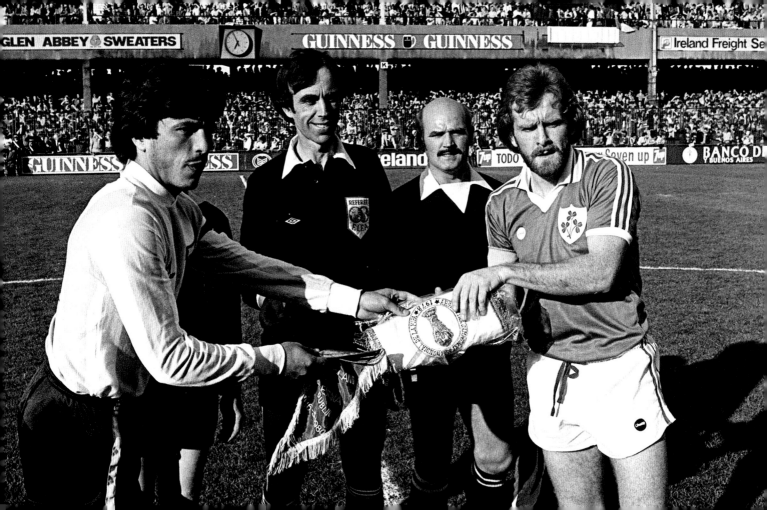

16 May 1980

The Republic of Ireland's Tony Grealish and
Argentina's Daniel Passarella before an international
friendly in Lansdowne Road on 16 May 1980.
The world champions won by a single goal in the
28th minute, but the match will be remembered
– in hindsight at least – as a chance for the
30,000-strong crowd to see nineteen-year-old Diego
Maradona play on Irish soil.

Ray McManus / SPORTSFILE

1980s

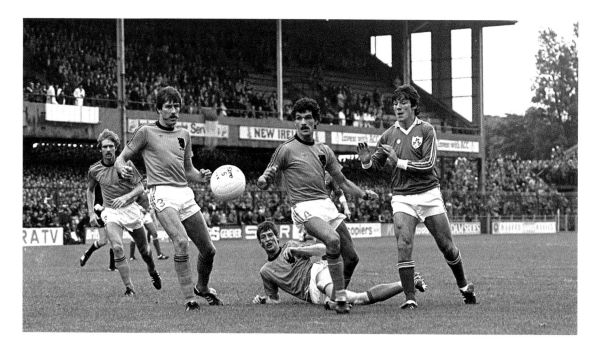

10 September 1980

The Republic of Ireland, with Eoin Hand newly installed as manager, found themselves battling through a difficult group – with Belgium, France, the Netherlands and Cyprus – for a place in the 1982 FIFA World Cup in Spain. Hopes were raised by a stunning victory on home soil against Holland, when the Irish responded to a Dutch goal with two by Gerry Daly and Mark Lawrenson (below, right).

Ray McManus / SPORTSFILE

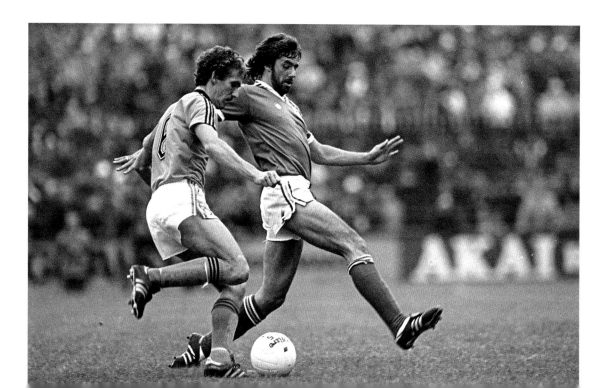

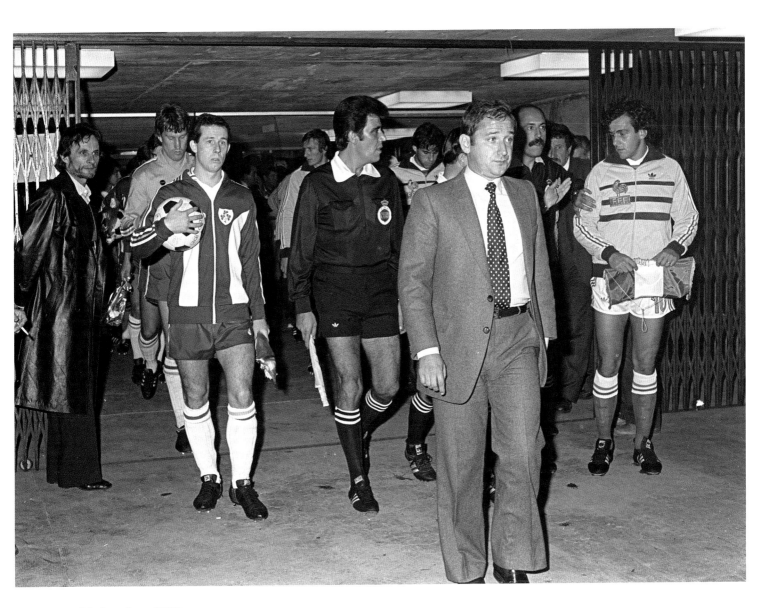

28 October 1980

Captains Liam Brady and Michel Platini lead their teams out for their World
Cup qualifier in Parc des Princes, Paris. 1982 FIFA World Cup Qualifier, France v
Republic of Ireland.

Ray McManus / SPORTSFILE

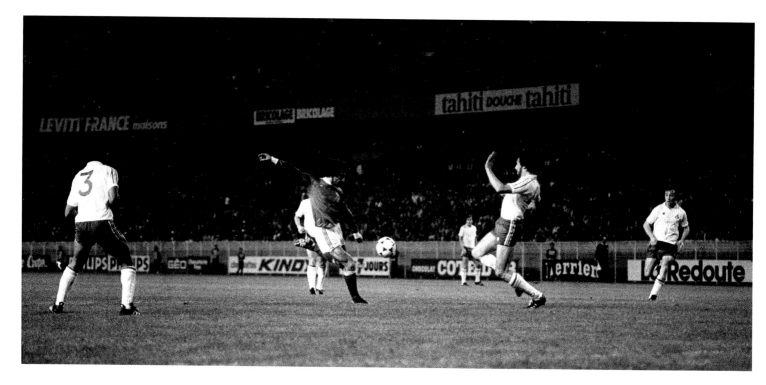

28 October 1980

Didier Six in action against Chris Hughton (left), Mark Lawrenson and Dave Langan in the first of their two World Cup qualifying clashes. The French would score a comfortable win on home turf with goals from Jacques Zimako and captain Michel Platini.

Ray McManus / SPORTSFILE

19 November 1980

An emphatic 6–0 victory over Cyprus in Lansdowne Road reignited Irish hopes for a World Cup qualification. Here, Dave Langan zips past the Cyprus defence. Lansdowne Road, Dublin.

Ray McManus / SPORTSFILE

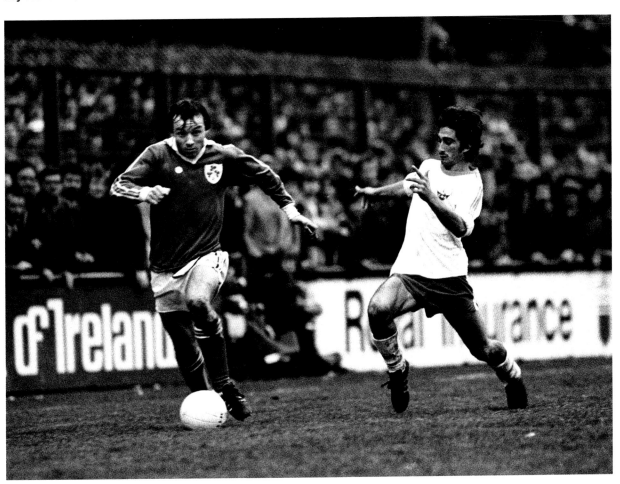

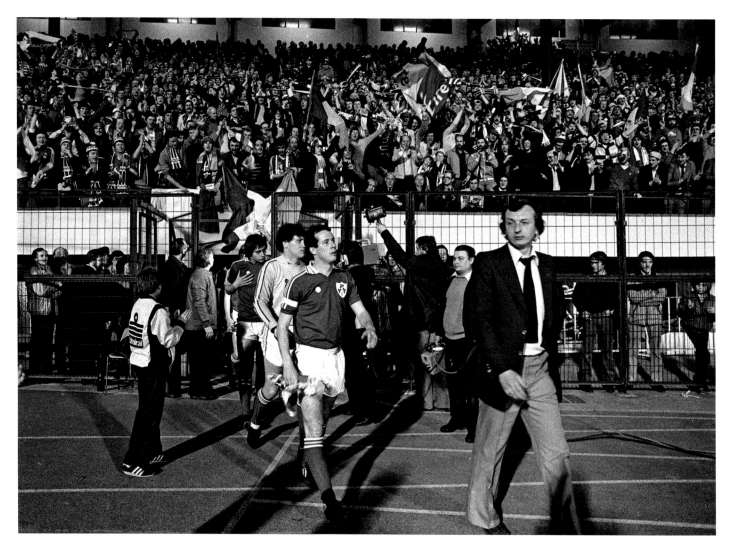

25 March 1981

Captain Liam Brady leads the Republic of Ireland team out against Belgium for their World Cup qualifier in Heysel Stadium, Brussels. Their first clash, the previous year, ended in a draw; this one would end in outrage.

Ray McManus / SPORTSFILE

25 March 1981

Kevin Moran, Tony Grealish, Dave Langan, Chris Hughton, Mick Martin, Steve Heighway, Gerry Daly, Frank Stapleton, Michael Robinson, Gerry Peyton and captain Liam Brady stand for the national anthem ahead of their World Cup qualifier against Belgium in Heysel Stadium, Brussels.

Ray McManus / SPORTSFILE

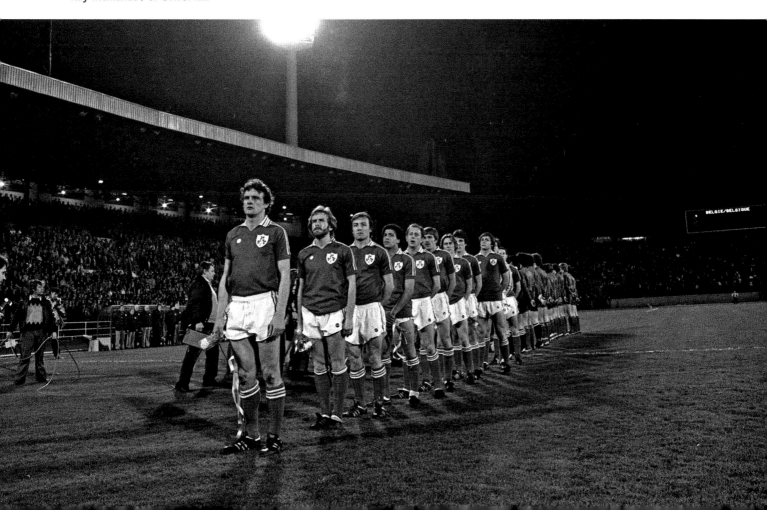

25 March 1981

The two moments that ended our World Cup dream: Frank Stapleton shoots past the Belgian goalkeeper, but the goal was disallowed by Portuguese referee Raul Nazaré – for reasons that continue to baffle Irish fans. And later, in the closing minutes of the game, the Belgians were awarded a free kick for a very questionable foul on Eric Gerets, which led to the match-winning goal by Jan Ceulemans.

Ray McManus / SPORTSFILE

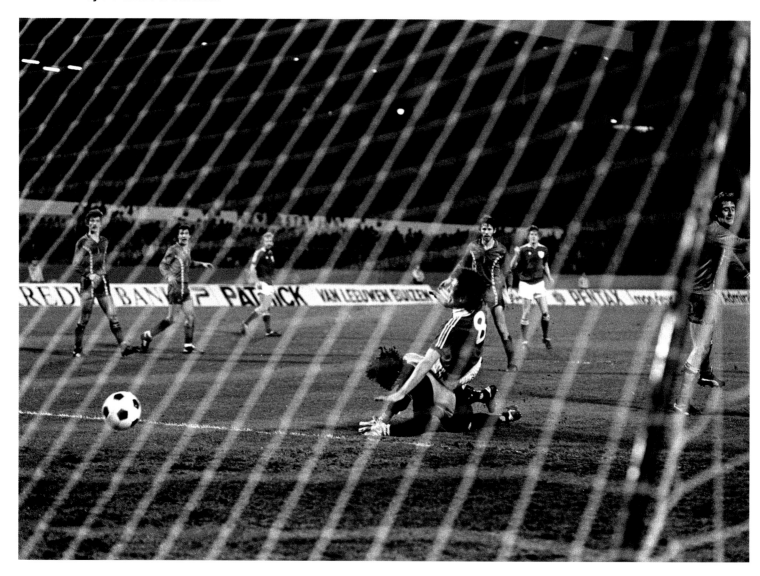

25 March 1981

Irish manager Eoin Hand goes head to head with referee Raul Nazaré after the Belgian game. He later commented, 'I called the referee disgraceful and a cheat to his face, and I will not withdraw the remarks. I am sure that people in authority do not want us to qualify for Spain. They would prefer the more glamorous countries to get there to make sure the tournament is a success. I cannot keep quiet about this, and nothing will change my opinions.'

Ray McManus / SPORTSFILE

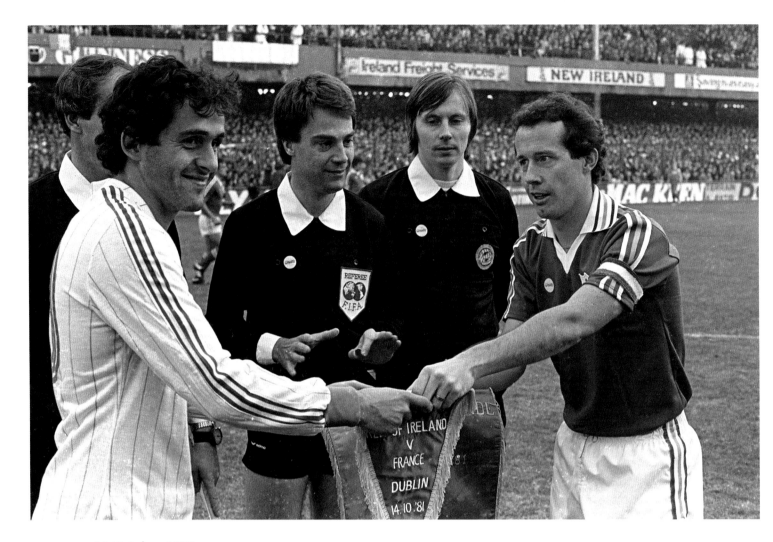

14 October 1981

The start of a great day: Liam Brady shakes hands with French captain Michel Platini as the teams meet in Lansdowne Road for a second World Cup qualifying clash. The first, the previous year in Paris, had ended in a 2–0 victory for the French. 1982 FIFA World Cup Qualifier, Lansdowne Road, Dublin.

Ray McManus / SPORTSFILE

14 October 1981

Frank Stapleton celebrates with Michael Robinson (no. 11) and Ronnie Whelan (no. 10) after scoring in the 25th minute against France. Coupled with an own goal by Philippe Mahut, this brought Ireland to 2–1 in an action-filled encounter. 1982 FIFA World Cup Qualifier, Lansdowne Road, Dublin.

Ray McManus / SPORTSFILE

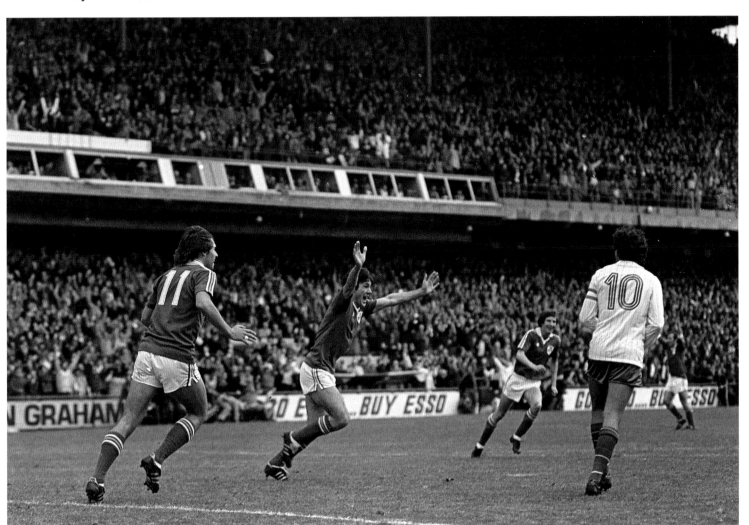

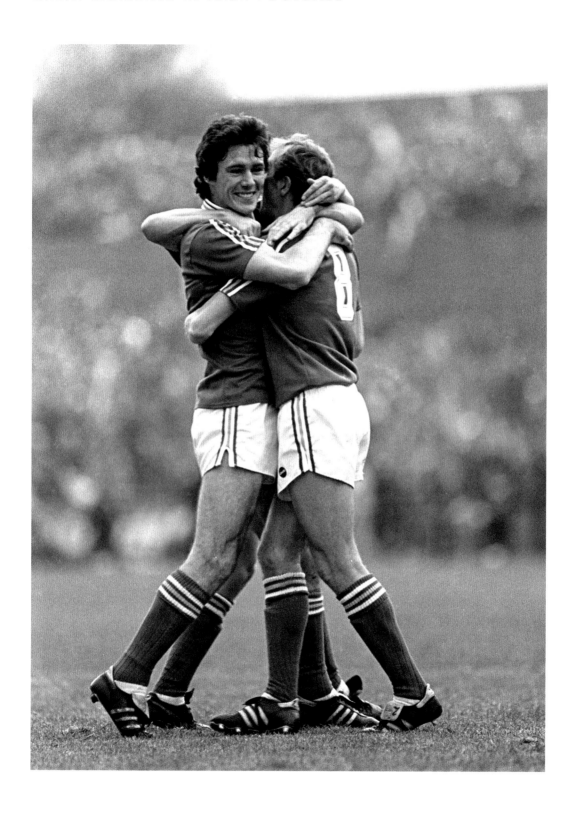

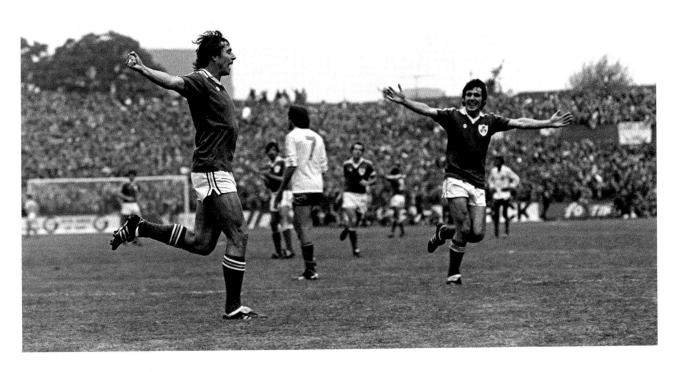

Opposite: 14 October 1981

Frank Stapleton is congratulated by Ronnie Whelan (hidden) and Mick Martin (no. 8) after scoring against France in this 1982 FIFA World Cup qualifier, Lansdowne Road.

Ray McManus / SPORTSFILE

Above: 14 October 1981

Michael Robinson celebrates his goal against France in the 40th minute with fellow scorer Frank Stapleton. Ireland won 3–2 on this historic day, bringing themselves level with the French on points – but they would ultimately lose their World Cup spot on goal difference. 1982 FIFA World Cup Qualifier, Lansdowne Road, Dublin.

Ray McManus / SPORTSFILE

14 January 1982

The legendary Liam 'Rasher' Tuohy (left) and Johnny Fullam watch the Hoops play Athlone Town in Glenmalure Park, Dublin.

Ray McManus / SPORTSFILE

6 April 1982

Irish rugby legend Tony Ward also played for Shamrock Rovers in the 1970s and Limerick FC in the early 1980s. He was part of the Limerick team that defied the odds by beating Bohemians on their home turf in the 1982 FAI Cup final, providing the corner that allowed Brendan Storan to score the match-winning goal.

Ray McManus / SPORTSFILE

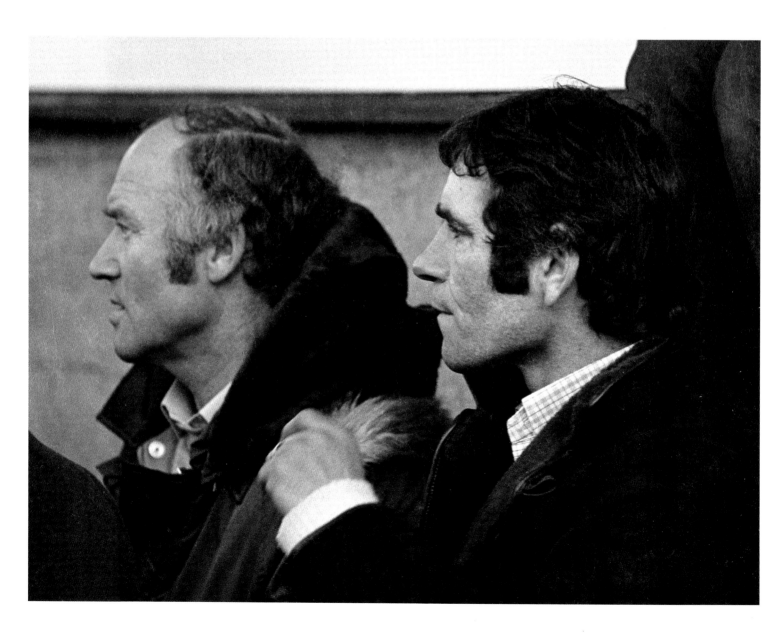

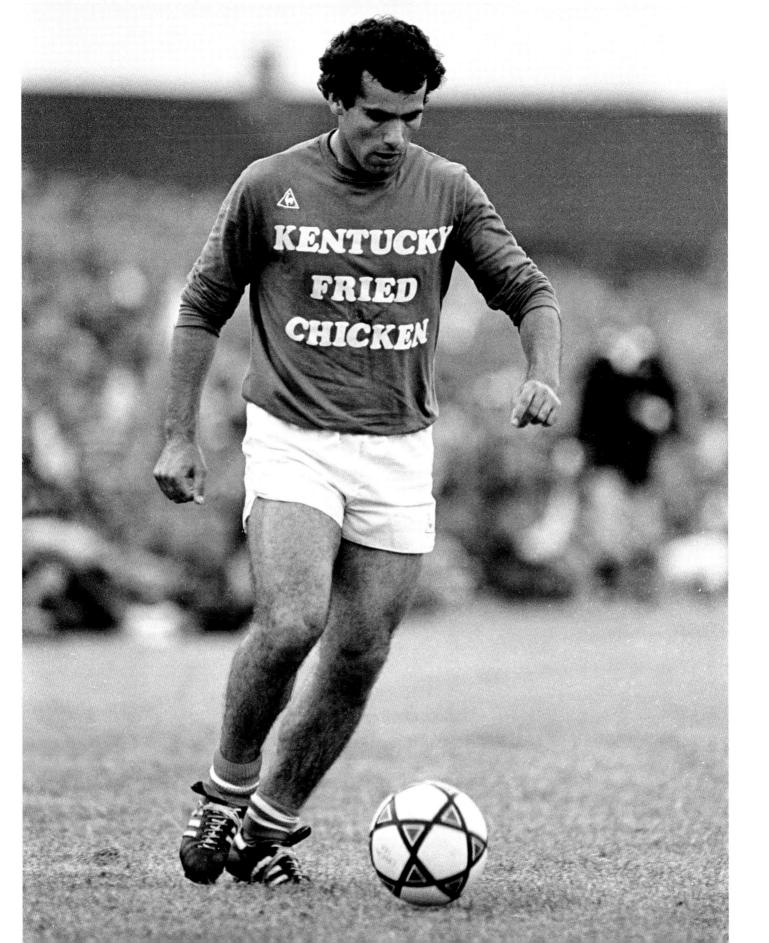

October 1982

Johnny Giles playing for Shamrock Rovers in 1982. The former Leeds United and Republic of Ireland midfielder (and future RTÉ pundit) spent almost six years as a player-manager with the Hoops, leading them to victory in the FAI Cup in 1978.

Ray McManus / SPORTSFILE

Sept 1984

Supporters of Glasgow Rangers clash with members of the Gardaí at Dalymount Park during a UEFA Cup match against Bohemians. Trouble on the terraces overshadowed the drama of the game itself, which Bohs won 3–2.

Ray McManus / SPORTSFILE

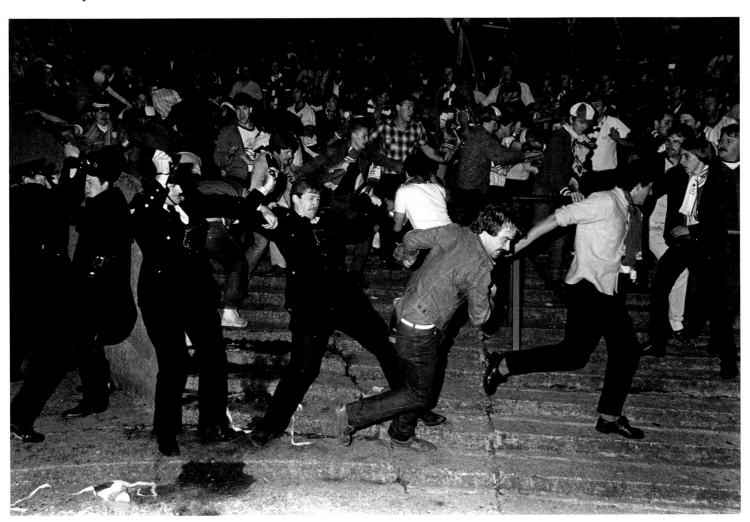

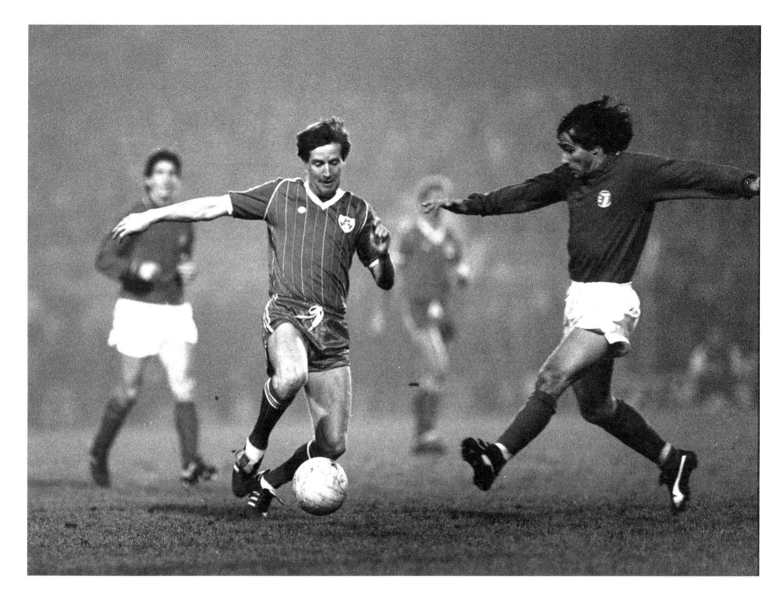

05 February 1985

Ireland v Italy at Dalymount Park drew a huge crowd. Over 40,000 fans turned up, overcrowding delayed the start and the crowds around the pitch meant both teams had to shoulder their way through to the dressing rooms at half time. Also some of the Italian advertising hoardings – put there because the match was being screened on Italian TV – could hardly be seen for the crowds. Fans squeezed in where they could – even onto the roof of one of the terraces **opposite**. The final score was 2-1 to Italy; Ireland's only goal-scorer was Frank Stapleton, though Ronnie Whelan **(above)** in action against Italy's Bruno Conti) was unlucky not to score.

Ray McManus / SPORTSFILE

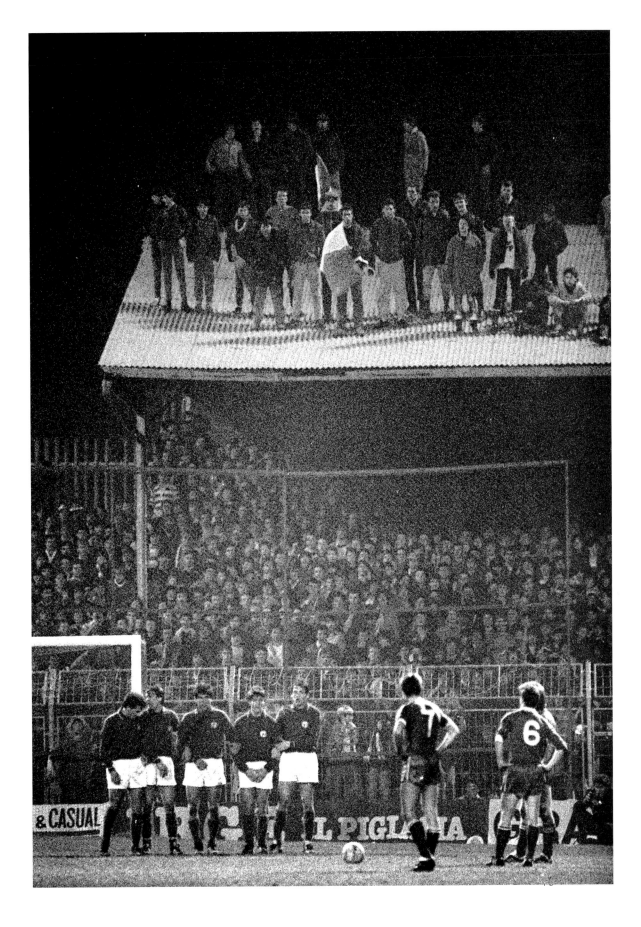

11 February 1986

The new Republic of Ireland manager, Jack Charlton, accompanied by Joe Delaney, assistant honorary treasurer of the FAI (and father of John Delaney, the current executive vice-president of the FAI), arrives at Dublin airport. 'Big Jack' had played on the England team that beat West Germany in the 1966 World Cup final and managed Middlesborough and Sheffield Wednesday before his appointment as Ireland's manager. It was the first time a non-national had been chosen to manage the Irish team, and it was the beginning of a golden age for Irish football, as Charlton led his team to qualification for Euro 88, to their first World Cup in 1990, and to the 1994 World Cup.

Ray McManus / SPORTSFILE

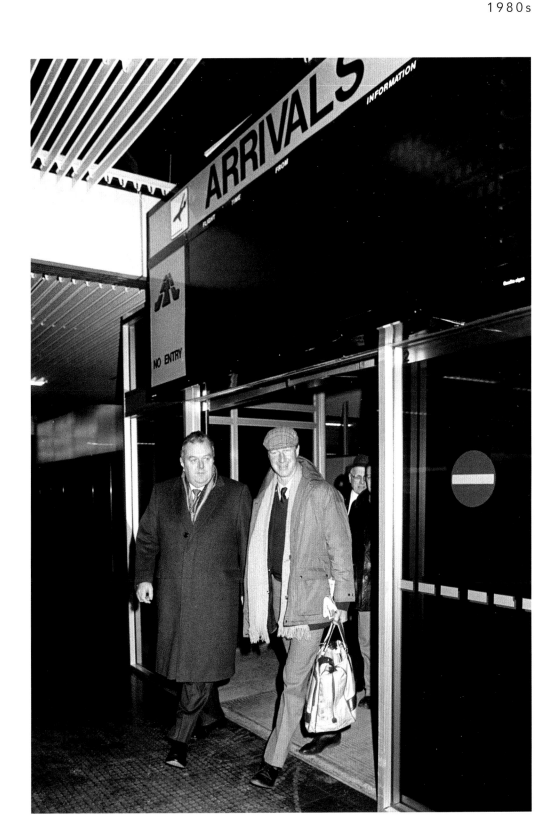

26 March 1986

Jack Charlton, Republic of Ireland manager pictured during his first match in charge, a friendly against Wales. Charlton developed tactics for the Irish team based on the traditional British 4-4-2 system, on the rationale that many of the Irish team played for English clubs and would be ripe for this approach. Lansdowne Road.

Ray McManus / SPORTSFILE

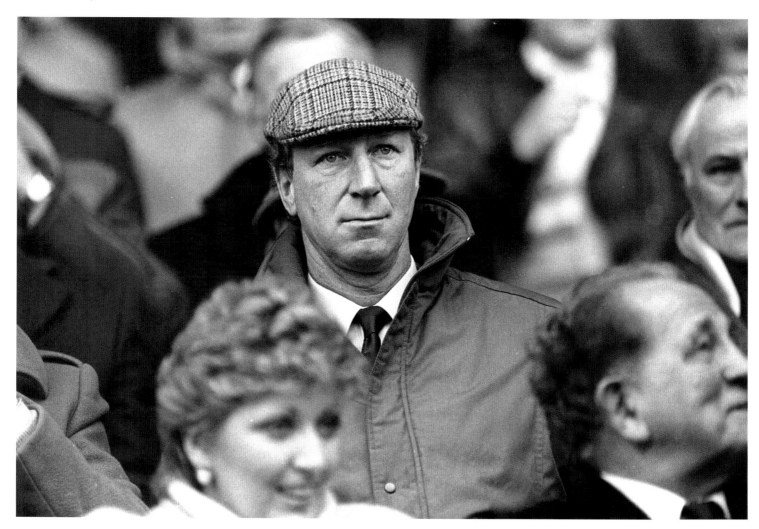

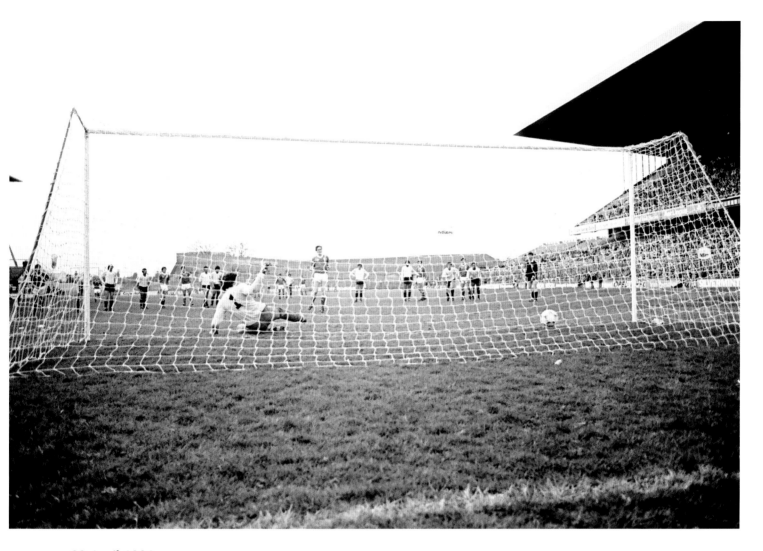

23 April 1986

Gerry Daly, Republic of Ireland, scores from the penalty spot in his last international game. International Friendly Republic of Ireland v Uruguay, Lansdowne Road, Dublin.

Ray McManus / SPORTSFILE

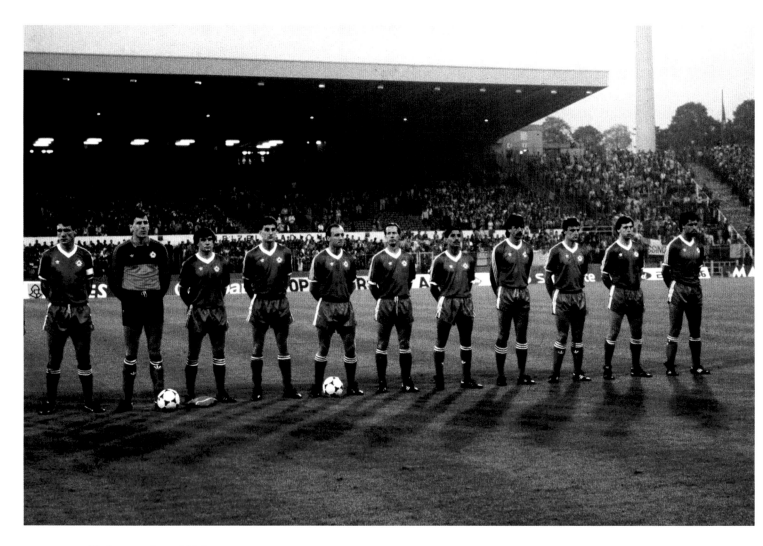

10 September 1986

The Republic of Ireland team who lined out against Belgium in Hysel Stadium, Brussels, Belgium.

Packie Bonner, Chris Hughton, Dave Langan, Mark Lawrenson, Kevin Moran, Paul McGrath, Liam Brady, Tony Galvin, Ray Houghton, John Aldridge. The match finished 2-2, with Ireland's goals scored by Frank Stapleton and Liam Brady.

Ray McManus / SPORTSFILE

18 February 1987

Ray Houghton in action against Paul McStay of Scotland. Despite Ireland's dominant performance, Scotland managed to hold them to a 0-0 draw. Glasgow-born Houghton played so well that it was said that he should have been voted man of the Match – for Scotland. European Championship Qualifier, Hampden Park, Glasgow, Scotland.

Ray McManus / SPORTSFILE

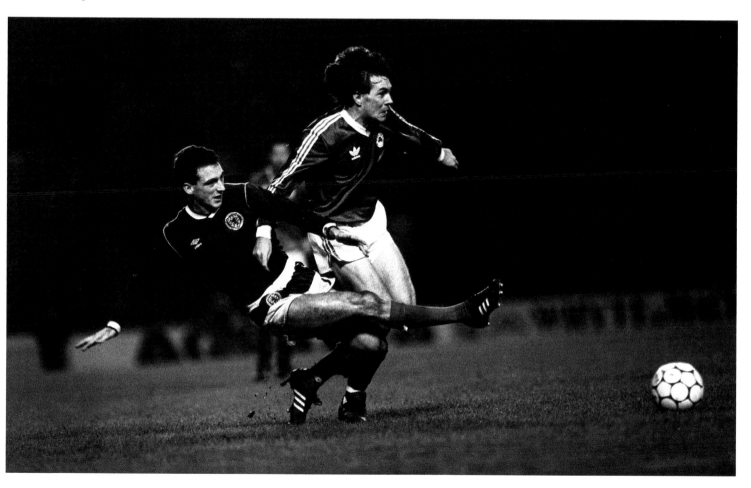

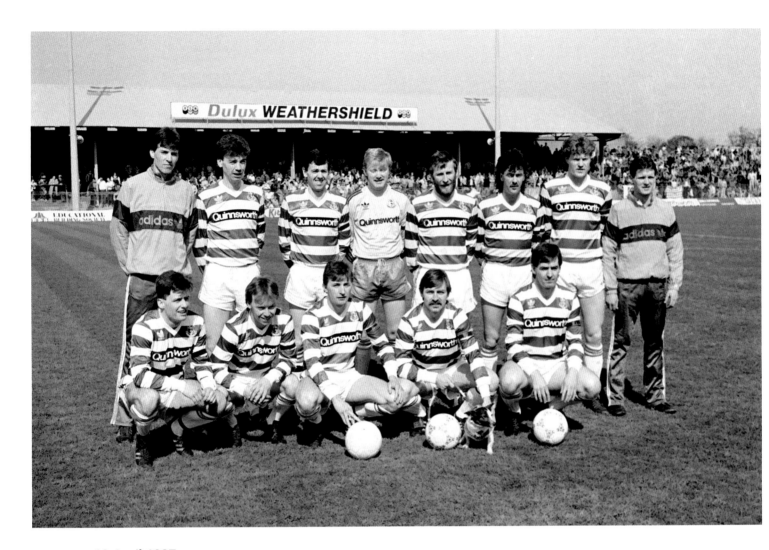

12 April 1987

Despite a a sustained campaign by Keep Rovers At Milltown (KRAM), Shamrock Rovers played their last match at their grounds in Glenmalure Park, Milltown on 12 April. They were being moved across Dublin to share Tolka Park with Home Farm in Drumcondra. **Above** The Shamrock Rovers team who played the last match at Milltow: Back row, from left to right, Johnny Glynn, Peter Eccles, Kevin Brady, Jodi Byrne, Dermot Keely, player-manager, Mick Byrne, Brendan Murphy. Front row, from left to right, Harry Kenny, Keith Duignam, Mick Neville, Pat Byrne, captain, and Noel Larkin. Supporters and member of KRAM let the bosses know how they feel about the move as they stage a pitch invasion at half time **(opposite)**.

Ray McManus / SPORTSFILE

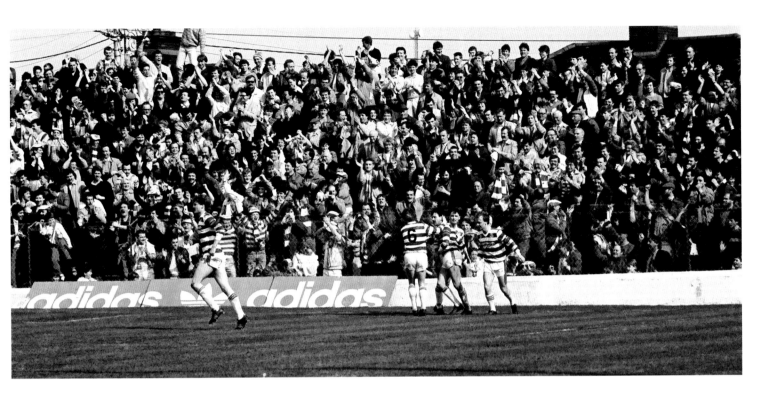

12 April 1987

Mick Byrne is congratulated by Shamrock Rovers players, including Pat Byrne, Harry Kenny and Keith Duignam, after scoring a goal. Shamrock Rovers v Sligo Rovers, League of Ireland, First Division, Glenmalure Park, Milltown, Dublin.

Ray McManus / SPORTSFILE

23 May 1987

Ireland captain Mick McCarthy shakes hands with Brazil captain Geraldao. This was Ireland's first – and still only – victory over Brazil. Liam Brady scored Ireland's goal. Ireland 1, Brazil 0. Friendly International, Republic of Ireland v Brazil. Lansdowne Road, Dublin.

Ray McManus / SPORTSFILE

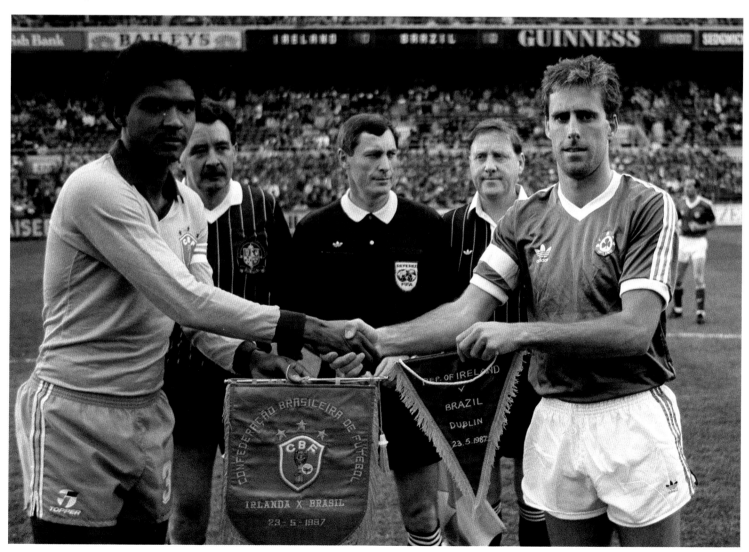

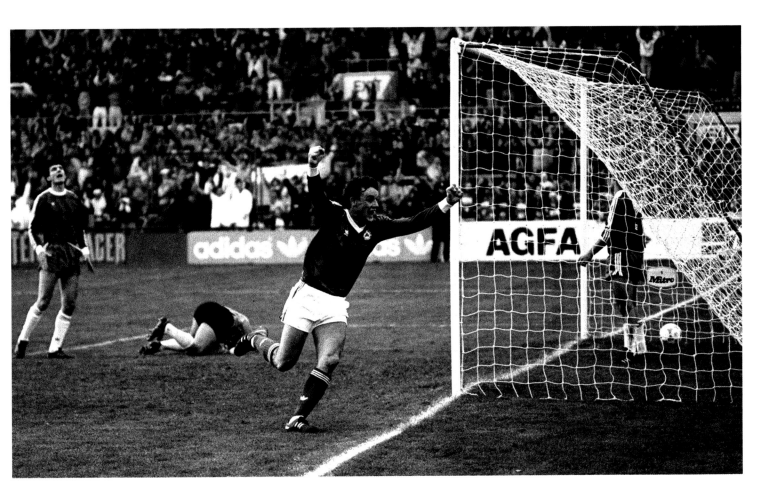

14 October 1987

Kevin Moran celebrates his goal. The final score was 2-0 to Ireland, with Paul McGrath scoring the other goal. Liam Brady was on a two-match suspension after reacting to being kicked by Bulgarian midfielder Sadakov. European Championship Qualifier, Republic of Ireland v Bulgaria, Lansdowne Road, Dublin.

Ray McManus / SPORTSFILE

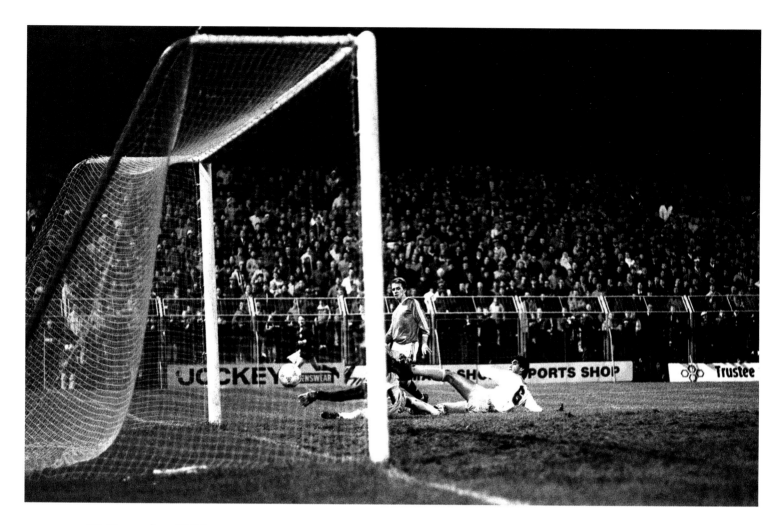

10 November 1987

David Kelly scores one of his three goals. Ireland won an emphatic victory, with goals from John Byrne and Niall Quinn, as well as Kelly's hat-trick. Friendly International, Republic of Ireland v Israel, Dalymount Park, Dublin.

Ray McManus / SPORTSFILE

10 November 1987

Republic of Ireland's Ray Houghton in action against Israel goalkeeper Doni Ginzburg, Friendly International, Republic of Ireland v Israel, Dalymount Park, Dublin.

Ray McManus / SPORTSFILE

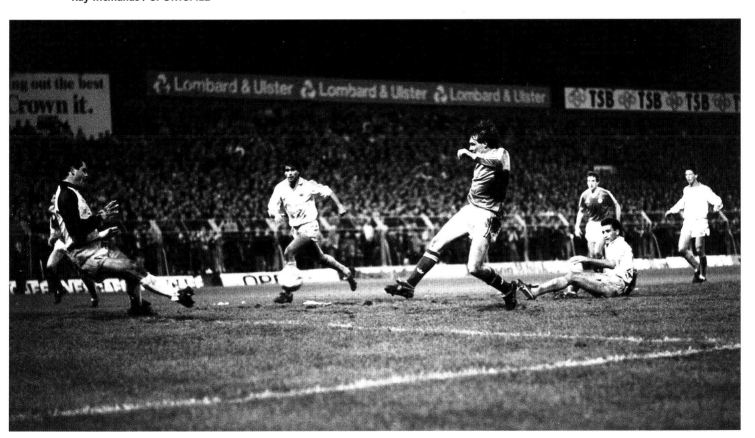

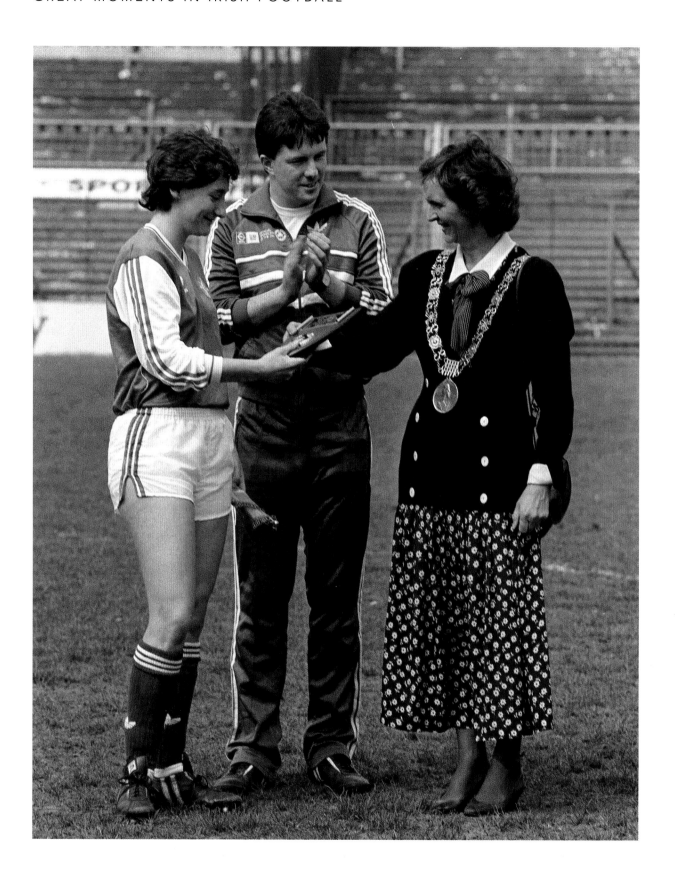

7 May 1988

Left: The Lord Mayor of Dublin Carmencita Hederman is introduced to the Irish captain Marian Leahy and manager Fran Rooney. The Womens' FAI was established in 1973 and made its international debut that April against Scotland. May 1988s 10-0 loss against Sweden was the Irish women's worst ever defeat. UEFA Championship, Republic of Ireland v Sweden, Dalymount Park, Dublin.

Ray McManus / SPORTSFILE

11 May 1988

Dundalk FC's Joey Malone celebrates victory over Derry City in the 1988 FAI Cup Final in Dalymount Park. The win was marred by controversy over a penalty awarded to Dundalk in the 72nd minute, from which John Cleary scored the match-winning goal and secured a League and Cup double for his team.

Ray McManus / SPORTSFILE

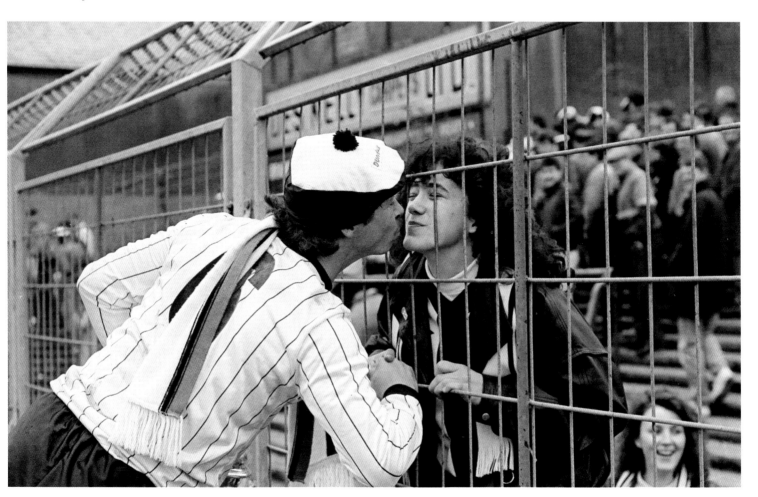

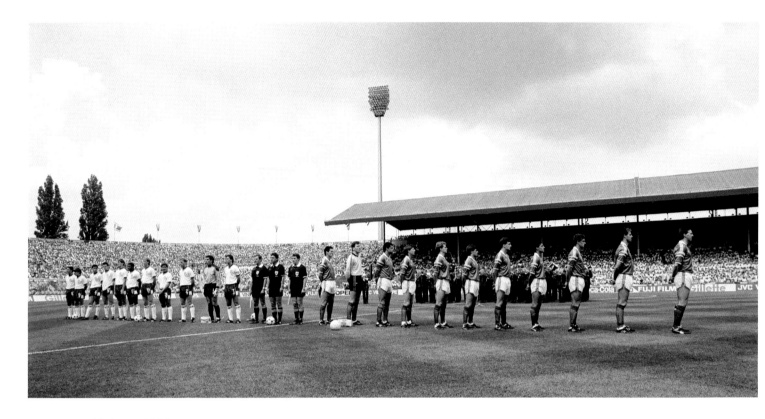

12 June 1988

The day history was made: England, Ireland and the East German match officials line up before an epic Euro '88 clash in Stuttgart. It was Ireland's first match of the Championship – and their first ever in a major international tournament. From right to left: Tony Galvin, Mick McCarthy, Kevin Moran, Chris Hughton, John Aldridge, Ray Houghton, Chris Morris, Ronnie Whelan, Paul McGrath, Packie Bonner and captain Frank Stapleton (Ireland); linesman Klaus Peschel, referee Siegfried Kirschen and linesman Manfred Rossner; captain Bryan Robson, Peter Shilton, Gary Stevens, Kenny Sansom, Mark Wright, John Barnes, Tony Adams, Chris Waddle, Neil Webb, Peter Beardsley and Gary Lineker (England).

Ray McManus / SPORTSFILE

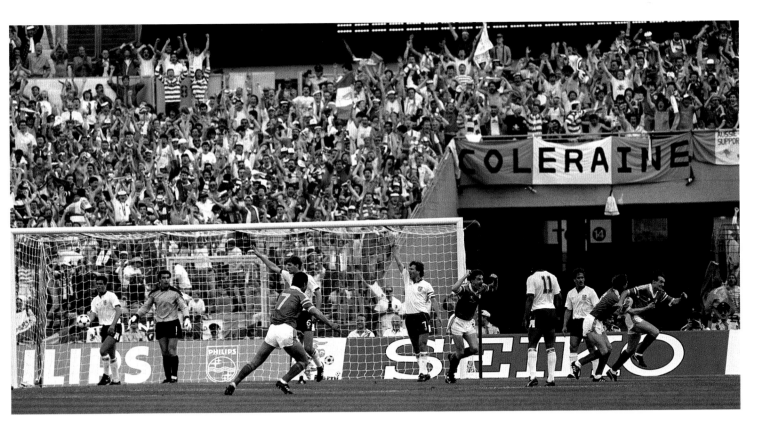

12 June 1988

'Who put the ball in the English net? I did! I did!' All Ireland rejoiced at 2.36pm on 12 June 1988, just six minutes in, when Ray Houghton's header dropped into the net for the only goal of the match. Here, Houghton (right) celebrates with Ronnie Whelan as John Aldridge and Paul McGrath run to join in, and the English team claim for an offside. Houghton's sixth-minute strike put Ireland ahead, a lead they held onto for the rest of the match, thanks to Packie Bonner in goal frustrating all the English attempts to score. A historic victory for Ireland in their first European Championship. European Championship Finals 1988, Group B, Republic of Ireland v England, Neckarstadion, Stuttgart, Germany.

Ray McManus / SPORTSFILE

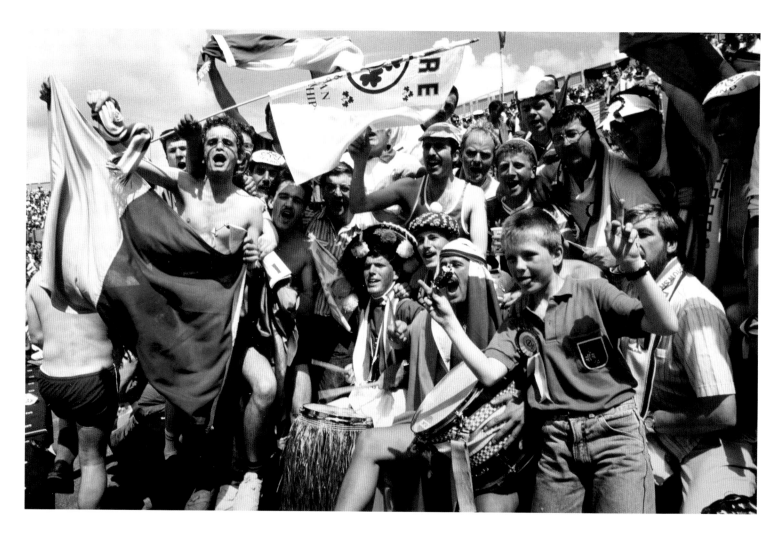

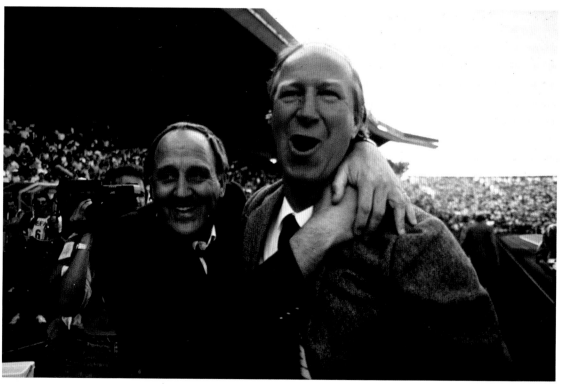

12 June 1988

Ecstatic Irish fans celebrate at the final whistle along with manager Jack Charlton and assistant manager Maurice Setters **(left)**; Chris Hughton and physio Mick Byrne **(below)**. The Charlton era was two years old, but this marked the beginning of a golden age. Goal-scorer Ray Houghton later remembered Ireland's devout goalkeeper Packie Bonner giving the team rosary beads before the game, 'saying they were blessed and holy and would bring us luck. I don't think too many of us believed him before. Maybe afterwards he had a point.'

Ray McManus / SPORTSFILE

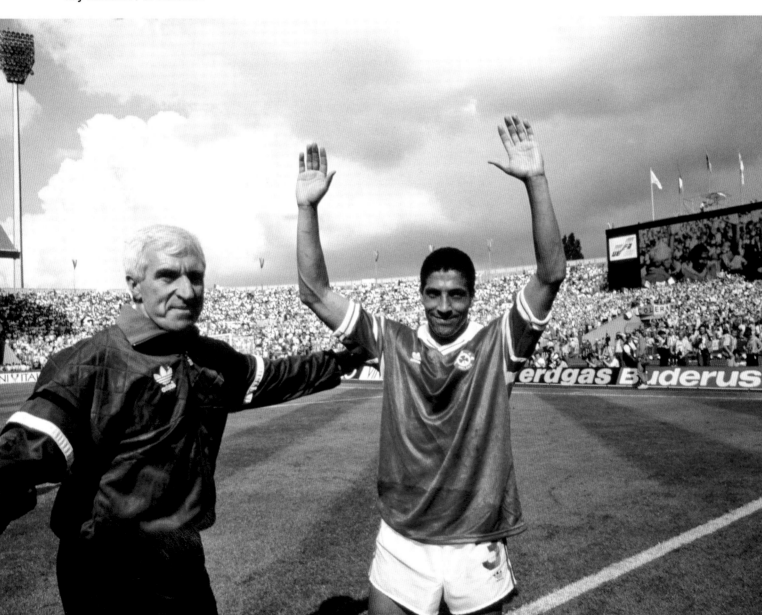

15 June 1988

Ronnie Whelan (hidden) is congratulated by teammates Kevin Sheedy (left), John Aldridge (centre) and Ray Houghton after scoring his side's first goal in Ireland's second group match of the 1988 Euro finals, against the Soviet Union at the Niedersachsenstadion in Hanover, West Germany. If Ireland could hold on to their 1–0 lead until full time, they would advance to the semi-finals of Euro '88.

Ray McManus / SPORTSFILE

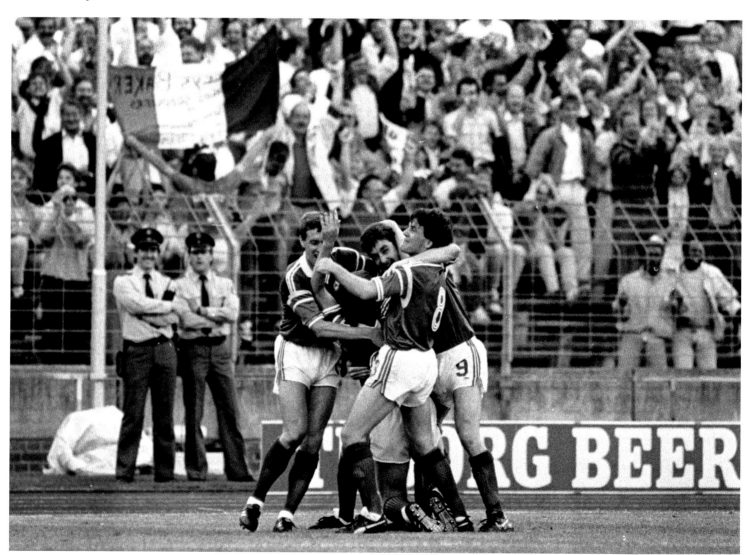

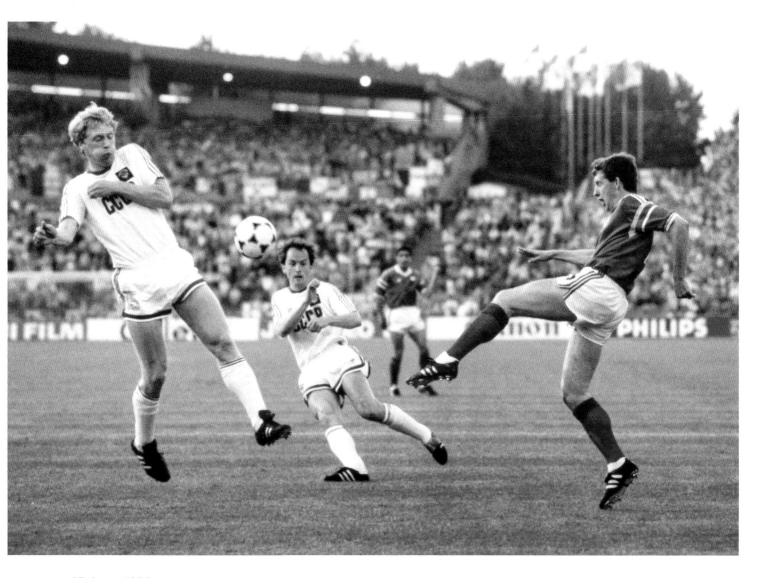

15 June 1988

Kevin Sheedy in action against Oleksiy Mykhailychenko **(left)** and Ihor Belanov. Following Ronnie Whelan's first-half goal, the Soviet Union equalised in the 75th minute, meaning that Ireland would need a draw in their next match against Holland to keep their Euro '88 dreams alive.

Ray McManus / SPORTSFILE

18 June 1988

Ireland went into their third group match of Euro '88 knowing they needed a draw against a talented Dutch team to advance to the semi-finals – Holland needed a win. The Irish played well in the first half, with Paul McGrath coming heart-breakingly close to scoring from a header. Here, Ray Houghton goes up against Holland's Gerald Vanenburg. Houghton would later recall, 'When we look back, you think after making one competition you were going to make another one and another one. It's only later on in life … I remember sitting down with a few of the lads, and it came down to "Wow, what an opportunity that was and how close we were".'

Ray McManus / SPORTSFILE

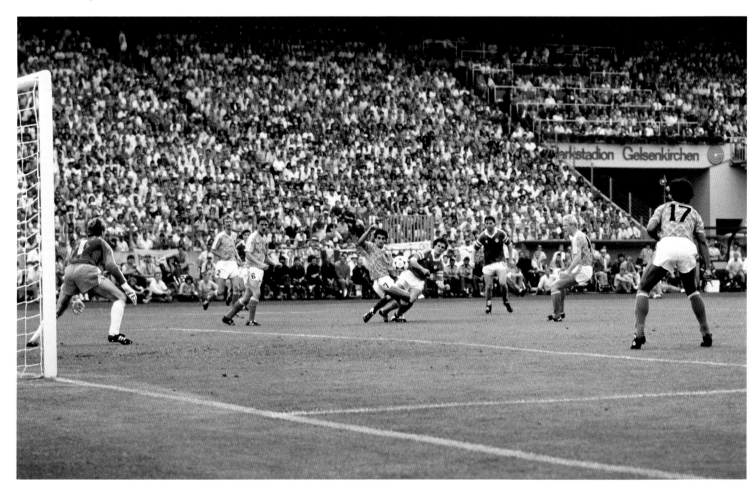

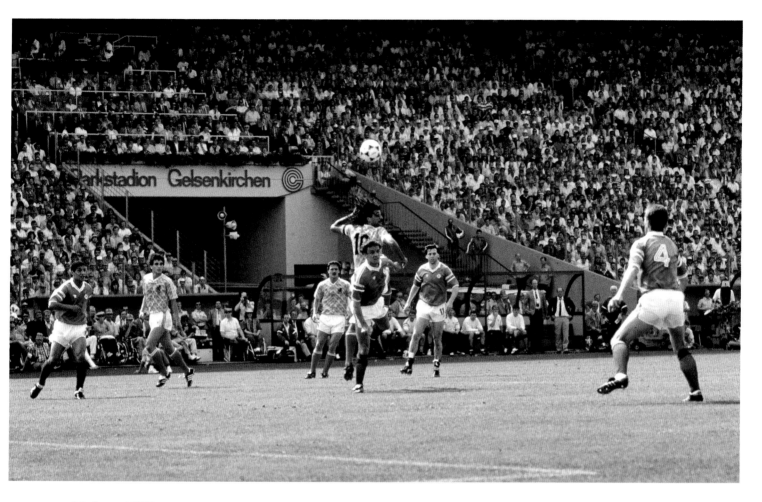

18 June 1988

Kevin Moran in action against Ruud Gullit of Holland. In the closing minutes of the match, it seemed that Ireland would get their draw and a place in the Euro '88 semi-finals – until a fortunate header by Wim Kieft broke the nation's hearts.

Ray McManus / SPORTSFILE

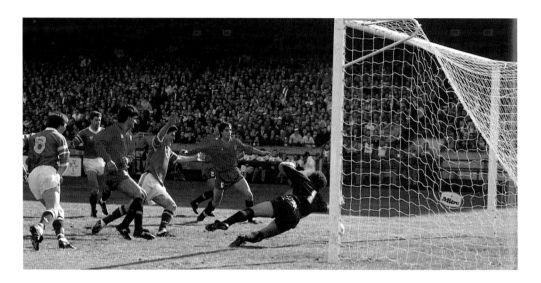

26 April 1989

From left: Ronnie Whelan, Kevin Sheedy and Frank Stapleton react after Spain's José Miguel González Martín del Campo ('Michel') scores an own goal in their Italia '90 World Cup qualifier in Lansdowne Road.

Ray McManus / SPORTSFILE

3 September 1989

Republic of Ireland manager Jack Charlton and his assistant Maurice Setters (right) are shown to their seats for the All-Ireland Hurling Final between Tipperary and Antrim in Croke Park.

Ray McManus / SPORTSFILE

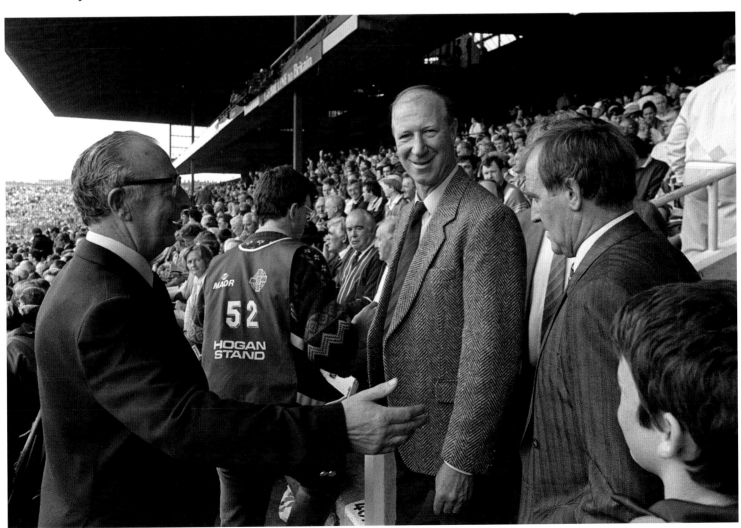

06 September 1989

Liam Brady walks off the field after being substituted by Jack Charlton after thirty-five minutes in the first half of a pre-World Cup friendly against West Germany. At half time, he announced his international retirement.

Ray McManus / SPORTSFILE

15 November 1989

And so it begins: Paul McGrath (left) and Kevin Moran celebrate beating Malta 2–0 in the Ta'Qali National Stadium, a win that would secure them a place in Italia '90 – Ireland's first ever World Cup, on their twelfth attempt at qualifying.

Ray McManus / SPORTSFILE

15 November 1989

Manager Jack Charlton (centre) celebrates with Charlie O'Leary, Ireland's kitman (left) and Mick Byrne, the team physio, after the Malta game.

Ray McManus / SPORTSFILE

15 November 1989

Jack Charlton, Republic of Ireland manager, congratulates David O'Leary, seated, after the team qualified for the 1990 World Cup. Republic of Ireland 2 Malta 0.

Ray McManus / SPORTSFILE

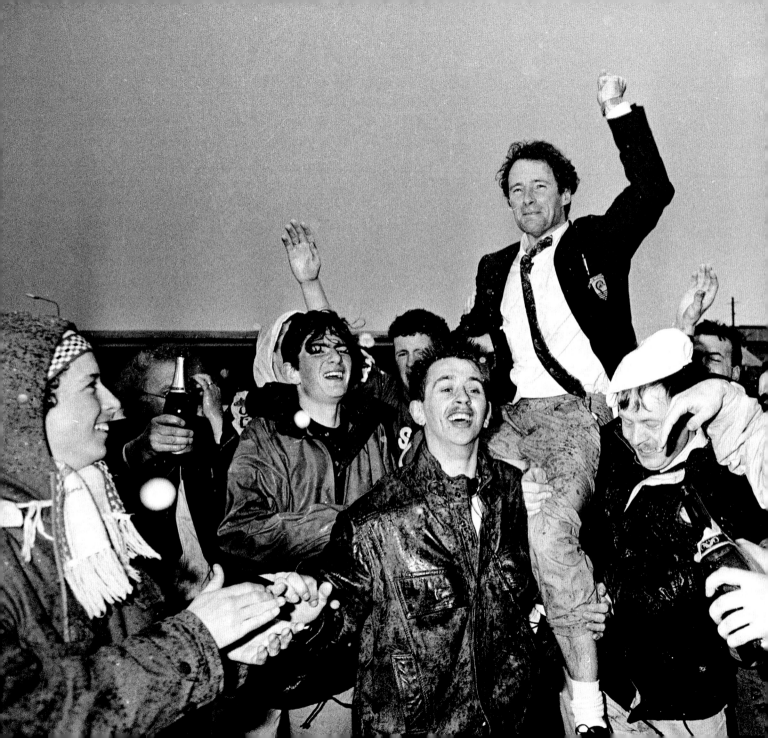

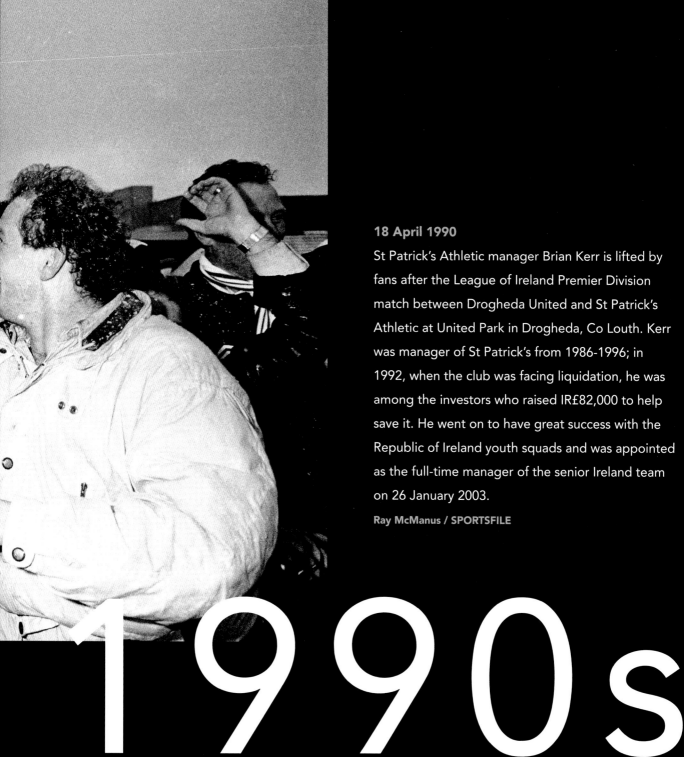

18 April 1990

St Patrick's Athletic manager Brian Kerr is lifted by fans after the League of Ireland Premier Division match between Drogheda United and St Patrick's Athletic at United Park in Drogheda, Co Louth. Kerr was manager of St Patrick's from 1986-1996; in 1992, when the club was facing liquidation, he was among the investors who raised IR£82,000 to help save it. He went on to have great success with the Republic of Ireland youth squads and was appointed as the full-time manager of the senior Ireland team on 26 January 2003.

Ray McManus / SPORTSFILE

1990s

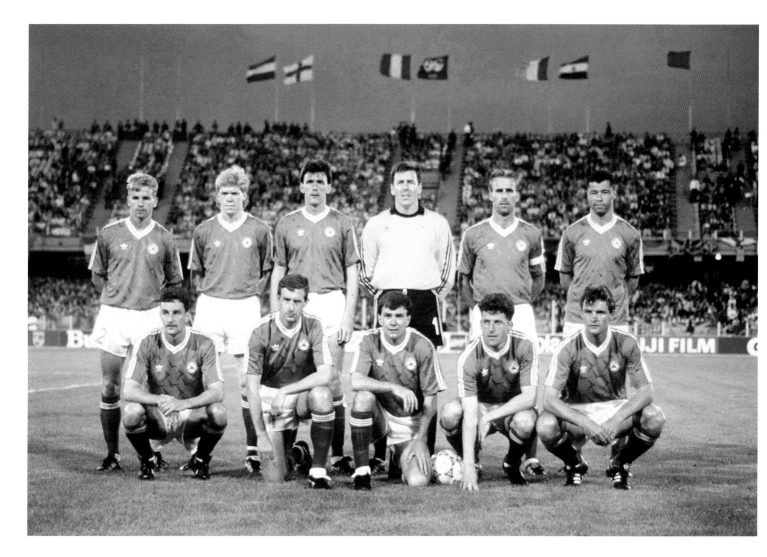

11 June 1990

The Republic of Ireland team who played England. Back row, from left, Chris Morris, Steve Staunton, Tony Cascarino, Packie Bonner, Mick McCarthy and Paul McGrath. Front, from left, John Aldridge, Kevin Sheedy, Ray Houghton, Andy Townsend and Kevin Moran. World Cup Finals, Cagliari, Italy. Soccer.

Ray McManus / SPORTSFILE

11 June 1990

Republic of Ireland's Kevin Sheedy, celebrates scoring a goal against England with team-mates Steve Staunton, left, and Andy Townsend, right. England's leading marksman, Gary Lineker, had scored an early goal, putting his team in the lead. Sheedy's left-foot equaliser past Peter Shilton in goal resulted in a 1-1 draw. This was the first time Ireland had qualified for the World Cup finals, so it was a great boost that they didn't lose their opening match. Republic of Ireland v England, World Cup Finals, Cagliari, Italy.

Ray McManus / SPORTSFILE

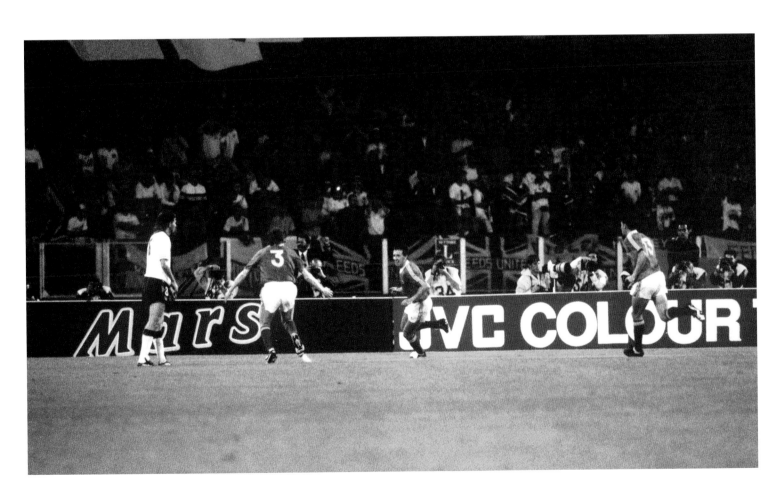

17 June 1990

The Republic of Ireland 'dream team' from left, captain Mick McCarthy, Packie Bonner, Ray Houghton, Steve Staunton, Andy Townsend, Paul McGrath, Chris Morris, John Aldridge, Tony Cascarino, Kevin Sheedy and Kevin Moran. The game finished in a lackluster 0-0 draw, which caused RTÉ pundit Eamonn Dunphy to claim that the team and Charlton were 'a disgrace' and that they 'played ugly football'. World Cup 1st round, Rep of Ireland v Egypt, Genoa, Italy.

Ray McManus / SPORTSFILE

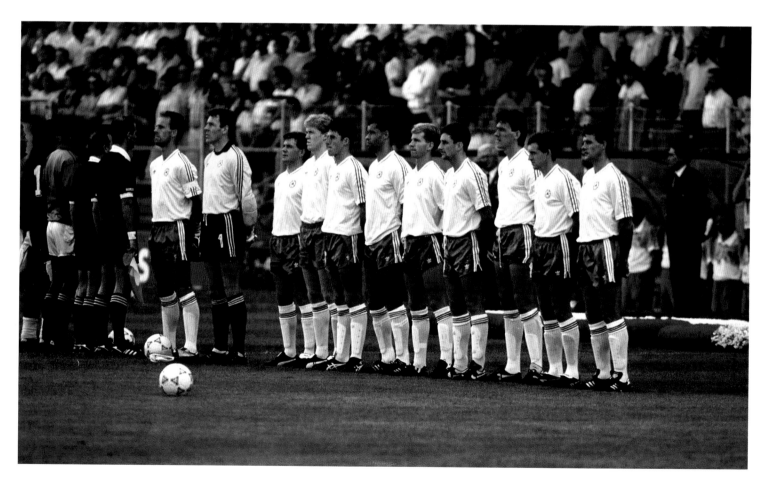

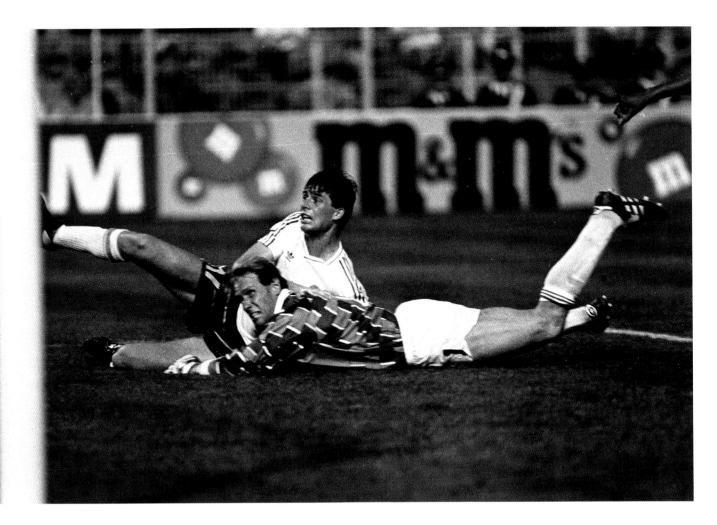

21 June 1990

Niall Quinn scores the equalising goal past Holland's goalkeeper, Van Breukelen.

The Dutch – who were reigning European champions – had beaten the Irish in the last group match of Euro 88. They were a formidable team, with football talents like Ruud Gullit, Marco van Basten, and Frank Rijkaard amongst others. Ruud Gullit scored in the first after ten minutes, but Irish goalkeeper Packie Bonner was in fine form, and the score was held at 1-0 until Niall Quinn slid home this equalizer. World Cup Finals, Group Match, Palermo, Italy.

Ray McManus / SPORTSFILE

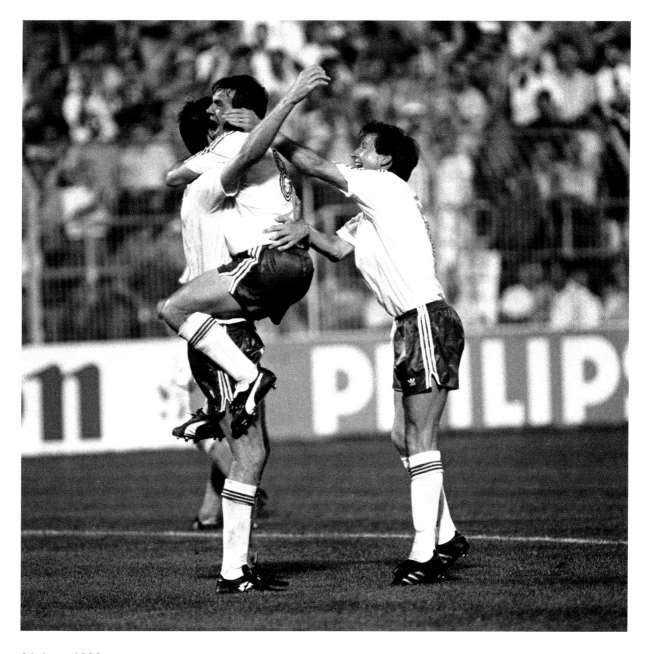

21 June 1990

Niall Quinn celebrates with team-mates Ray Houghton and Ronnie Whelan, after scoring the equalising goal.

Ray McManus / SPORTSFILE

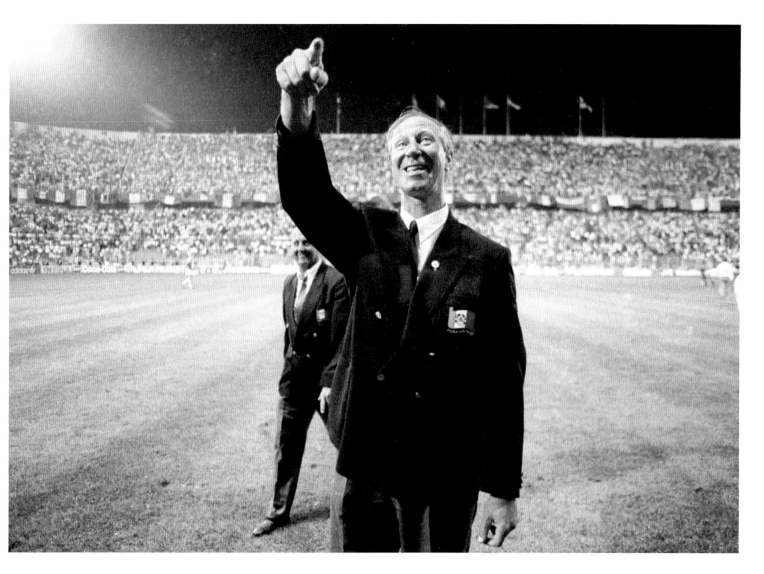

21 June 1990

Republic of Ireland manager Jack Charlton celebrates after his side qualified for the quarter finals.

World Cup Finals 1990, Republic of Ireland v Netherlands, Stadio La Favoritam, Palermo, Italy.

Ray McManus / SPORTSFILE

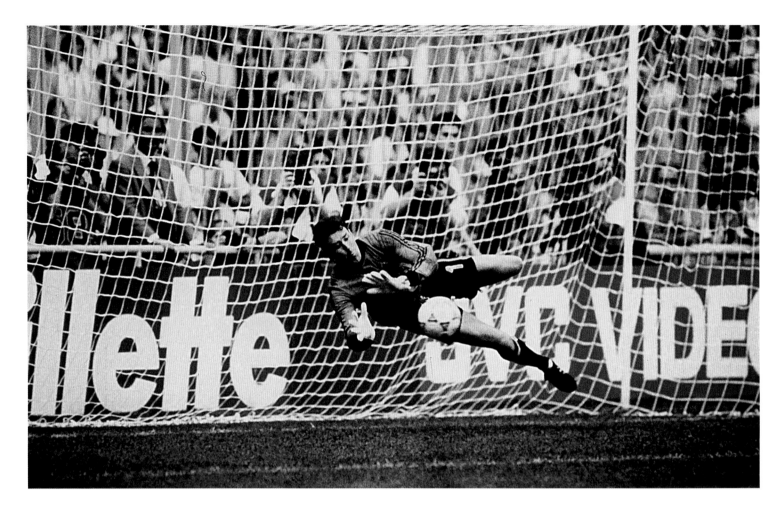

25 June 1990

Possibly the most famous moment in Irish football: after four penalties and four scores from each side, Ireland goalkeeper Packie Bonner saves Romania's Daniel Timofte's shot during the penalty shoot-out. David O'Leary's score from the next penalty put Ireland through to the quarter finals. FIFA World Cup, Second Round, Republic of Ireland v Romania, Stadio Luigi Ferraris, Genoa, Italy.

25 June 1990

Republic of Ireland goalkeeper Packie Bonner celebrates after a saving the penalty against Romania that put Ireland through to the quarter finals.

Ray McManus / SPORTSFILE

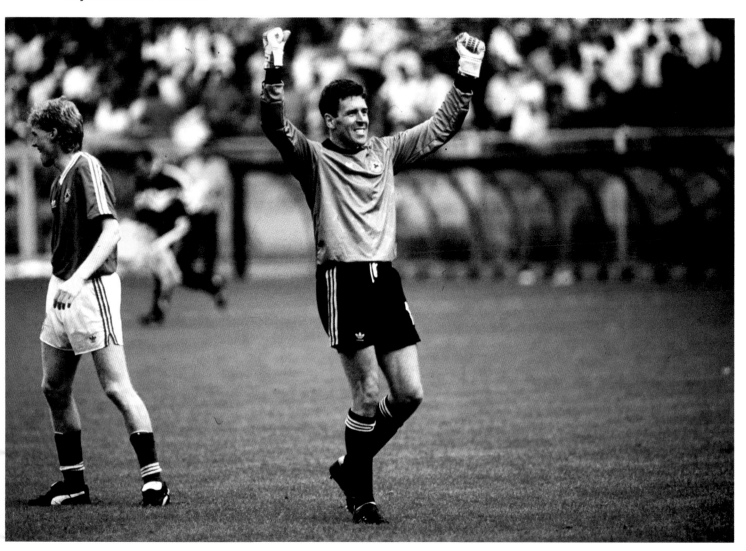

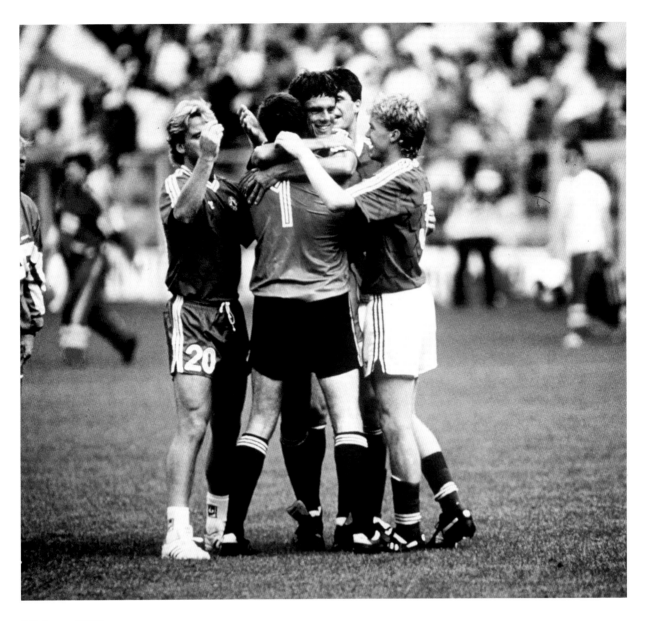

25 June 1990

Above David O'Leary (with teammates Packie Bonner, John Byrne, left, Stephen Staunton, right, and Niall Quinn) is congratulated after scoring the decisive penalty that beat Romania in Genoa during the 1990 World Cup Finals. **Right** Mick McCarthy celebrates the historic victory; this was the first time Ireland had qualified for the quarter finals of the World Cup.

Ray McManus / SPORTSFILE

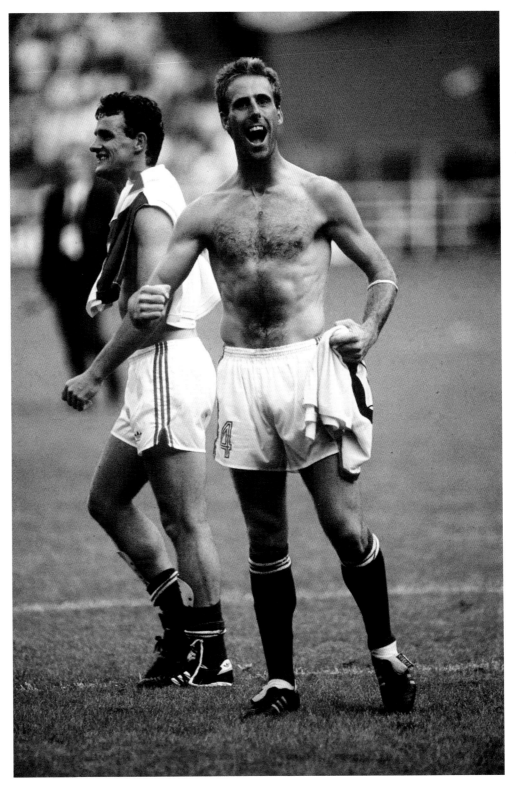

30 June 1990

Rep of Ireland's Steve Staunton in action against Italy. 1990 FIFA World Cup Football Quarter-Final, Stadio Olympico, Rome, Italy.

Ray McManus / SPORTSFILE

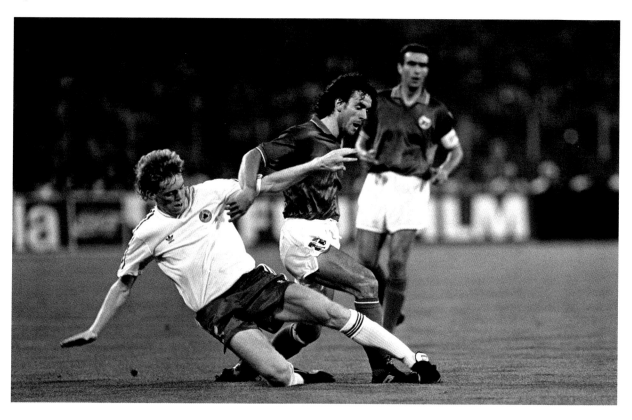

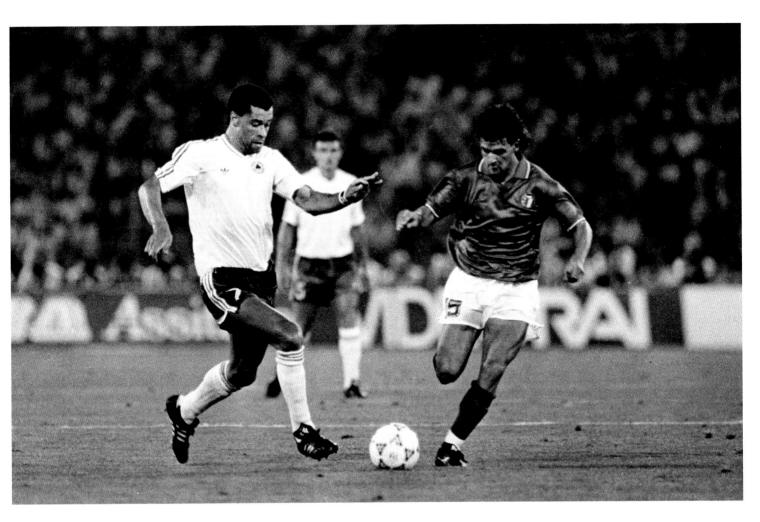

30 June 1990

Italy were one of the favourites to win the World Cup, but the Republic of Ireland, playing in their first World Cup quarter final, held their own against their formidable opponents. Thirty-eight minutes into the first half, 'Toto' Schillachi scored a goal for Italy despite the efforts of the great Paul McGrath (above with Italy's Roberto Baggio) to intercept. Despite Ireland's best efforts, there was to be no equaliser; a final score of 1-0 to the Italians meant Italia 90 was over for the valiant Irish team.

Ray McManus / SPORTSFILE

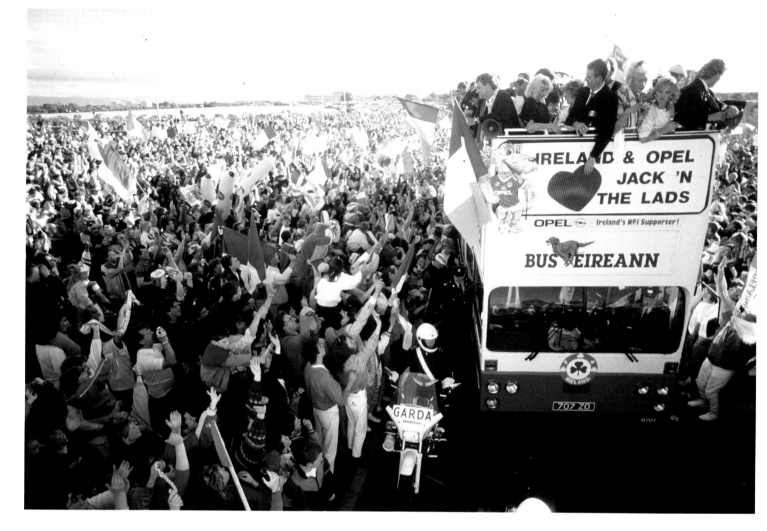

1990

Above The Republic of Ireland team en route from Dublin airport and **right** at College Green, Dublin, after they returned from Italia 90. Soccer. Up to 500,000 people turned out to welcome the 'Jack's Army' home.

Ray McManus / SPORTSFILE

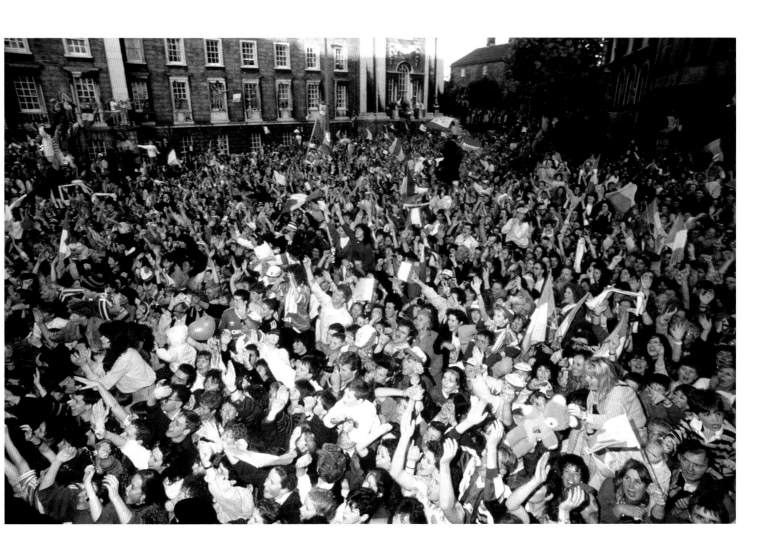

17 October 1990

Below John Aldridge celebrates after scoring one of his three goals in a match that ended up Ireland 5, Turkey nil. Aldridge gave Ireland an early lead when he scored in the fifteenth minute. David O'Leary added another before half time, while the second half saw two more from Aldridge and one from Niall Quinn. Lansdowne Road, Dublin.

Ray McManus / SPORTSFILE

27 March 1991

Right Niall Quinn scores for Ireland! Lee Dixon had put England ahead – with the only international goal he ever scored – in the ninth minute, but Quinn's equalizer ensured the match finished in a 1-1 draw. Such was the excitement amongst the Irish community in London that Quinn took up an offer of £500 to sing on stage at the famous Galtymore Ballroom that night. European Championship Qualifier, Wembley Stadium, London, England.

Ray McManus / SPORTSFILE

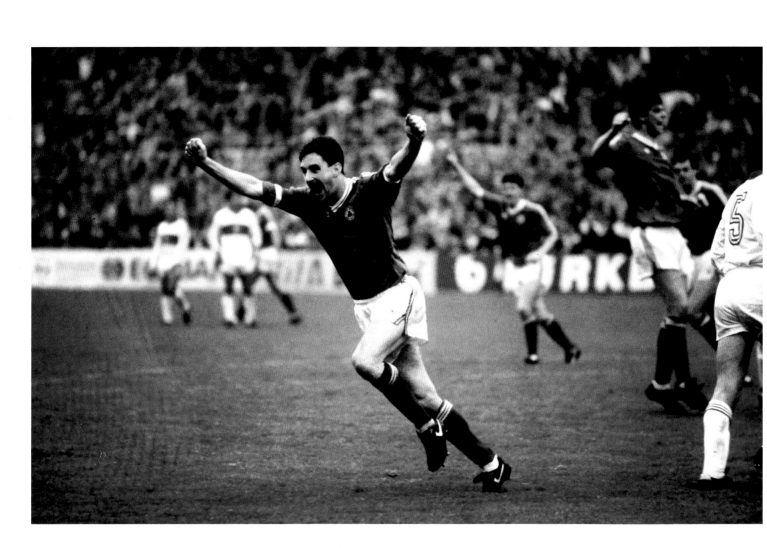

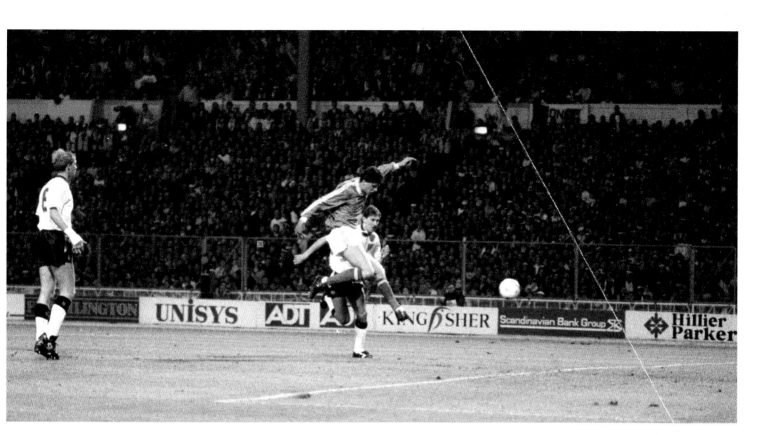
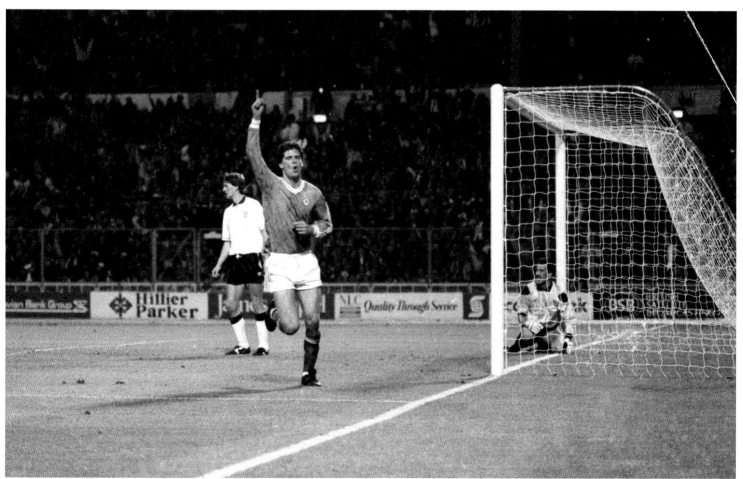

16 October 1991

Republic of Ireland manager Jack Charlton leaves the pitch after the game surrounded by substitutes and backroom staff. UEFA Euro 1992 qualifying Group 7 match, Poland v Republic of Ireland, Stadion Miejski, Poznan, Poland.

Ray McManus / SPORTSFILE

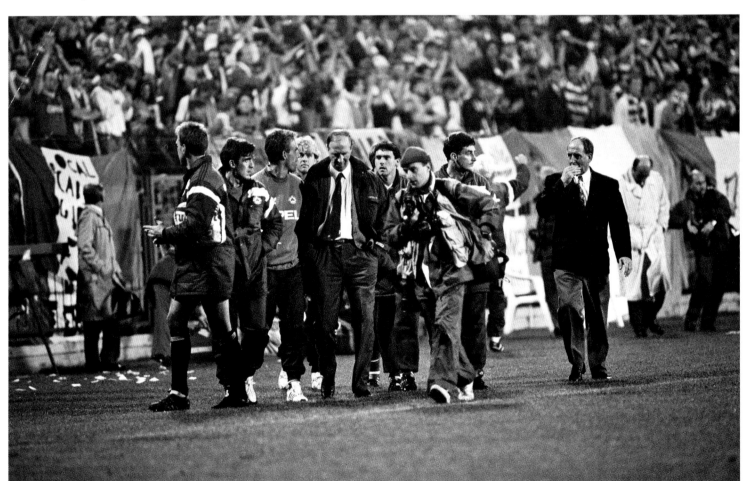

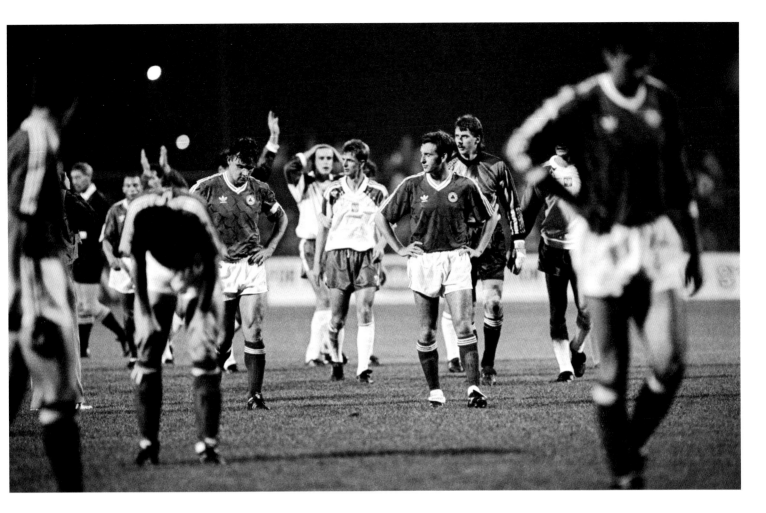

16 October 1991

Republic of Ireland players, including Kevin Moran, centre left, and Kevin Sheedy, centre right, leave the field after the final whistle. The 0-0 result, coming after a draw with England (1-1) left the Republic one point short of qualification for Euro 1992.

Ray McManus / SPORTSFILE

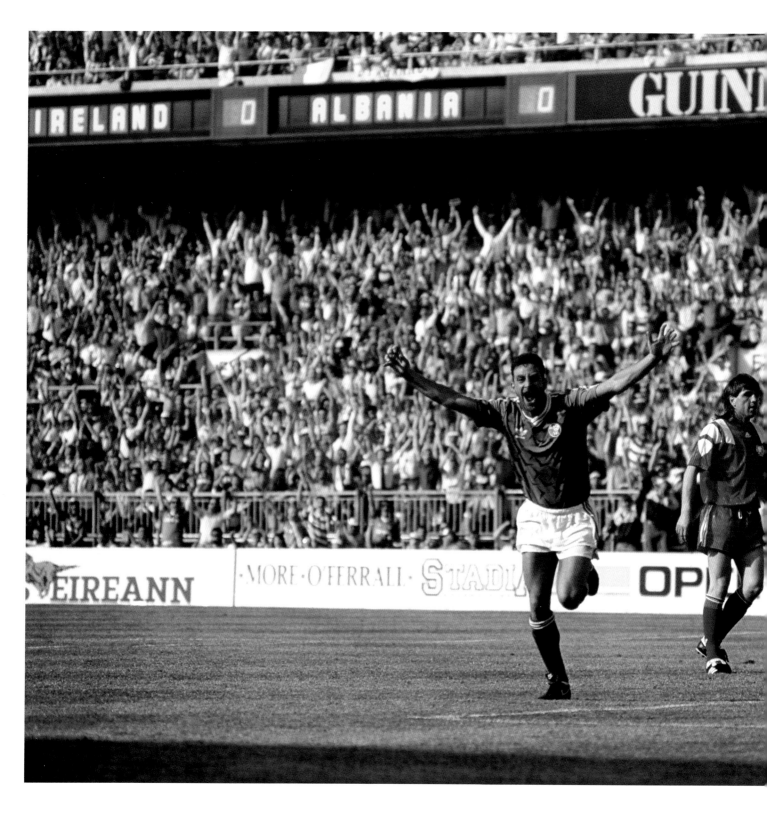

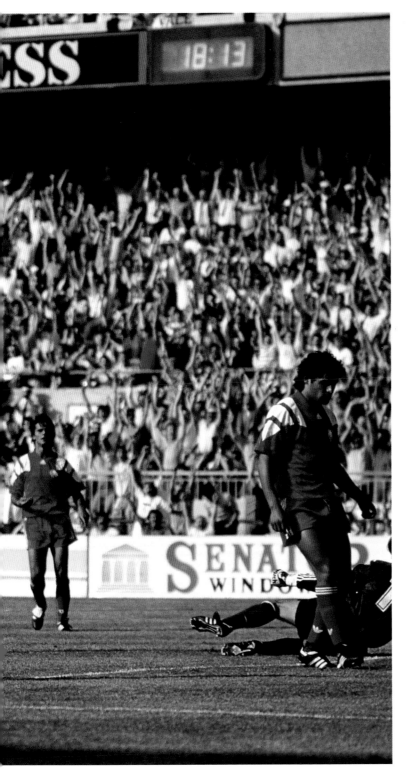

26 May 1992

John Aldridge of Republic of Ireland celebrates his goal against Albania. A hitch with the visiting team's Umbro-sponsored kit meant that the Albanians arrived without a strip to play in. Three Stripe International (who held the Adidas franchise at the time) and the *Cork Examiner* stepped in to supply kit, with the newspaper reporting on 26 May 1992, 'Meanwhile, the looms at the Adidas factory in Cork city were in motion producing the kit. The transfer of the crest will not be put on the jerseys until this morning. The team kit bag will then be rushed to Dublin by fast car in time for the 5pm kick-off.'

Ireland won, 2-1. World Cup Qualifier, Republic of Ireland v Albania, Lansdowne Road.

Ray McManus / SPORTSFILE

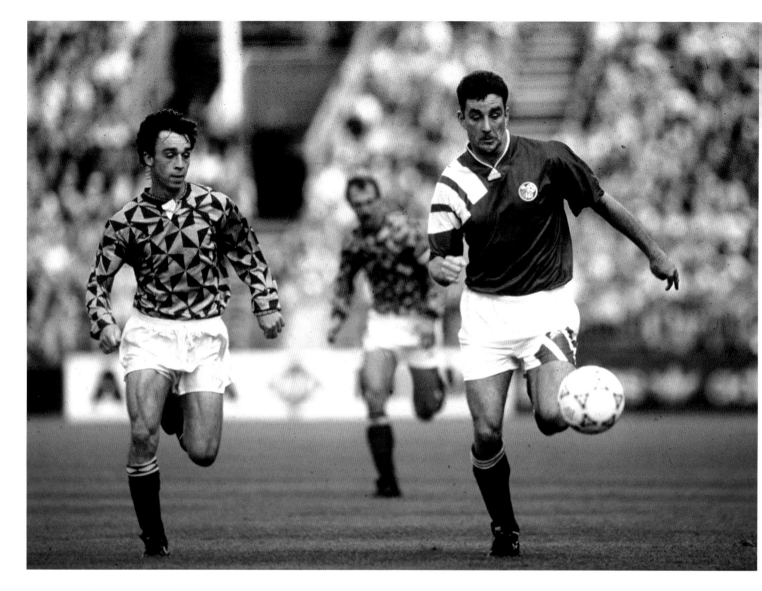

9 September 1992

Ireland's John Aldridge in action against Latvia in Landsdowne Road. Aldridge's three goals, plus one by Kevin Sheedy, resulted in a 4-0 win for the home team.

Ray McManus / SPORTSFILE

14 October 1992

Andy Townsend, Republic of Ireland, in action against Denmark. Without Paul McGrath or Ronnie Whelan, the Irish team were understrength, but with Packie Bonner standing firm between the posts, they they held on for a 0-0 tie. Parken Stadium, Copenhagen, Denmark.

David Maher / SPORTSFILE

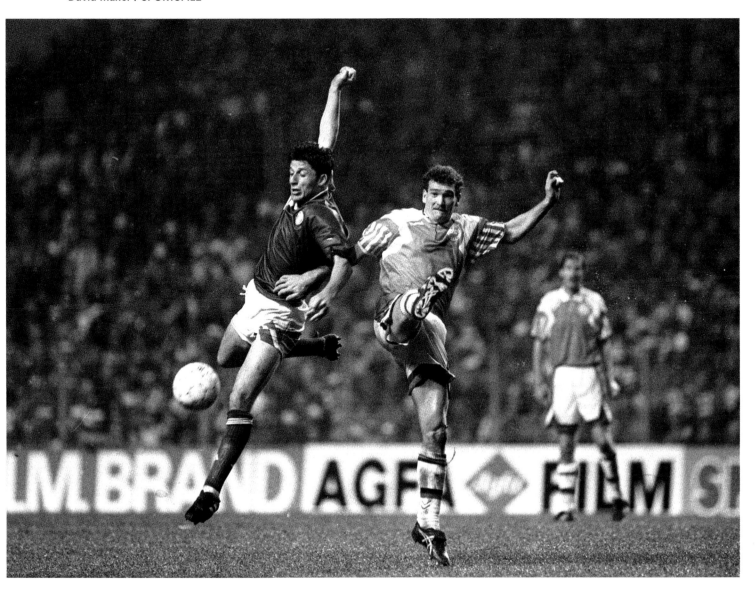

11 April 1993

Players and officials of Bohemians F.C wait by the roadside after their team bus broke down in Whitehall, Dublin, on their way to Oriel Park to play Dundalk. Bohemians needed just one point to secure the league title. They arrived an hour late, were fined £50, and ended up losing 1-0. Cork City would eventually win the title.

Ray McManus / SPORTSFILE

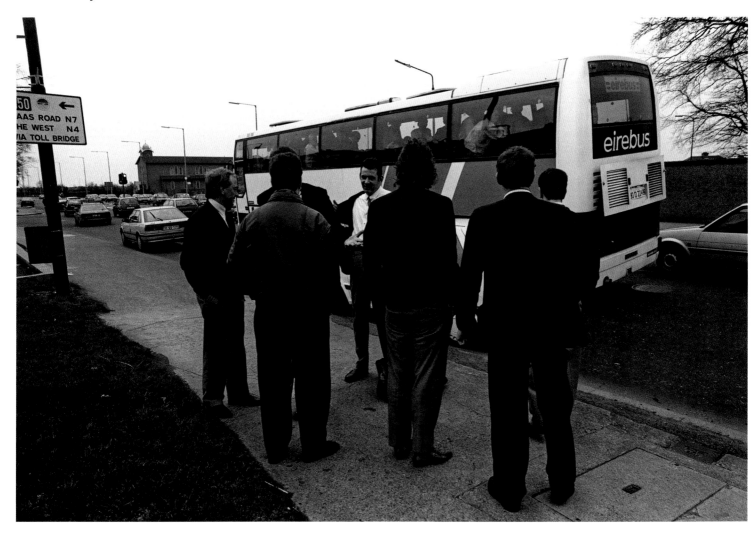

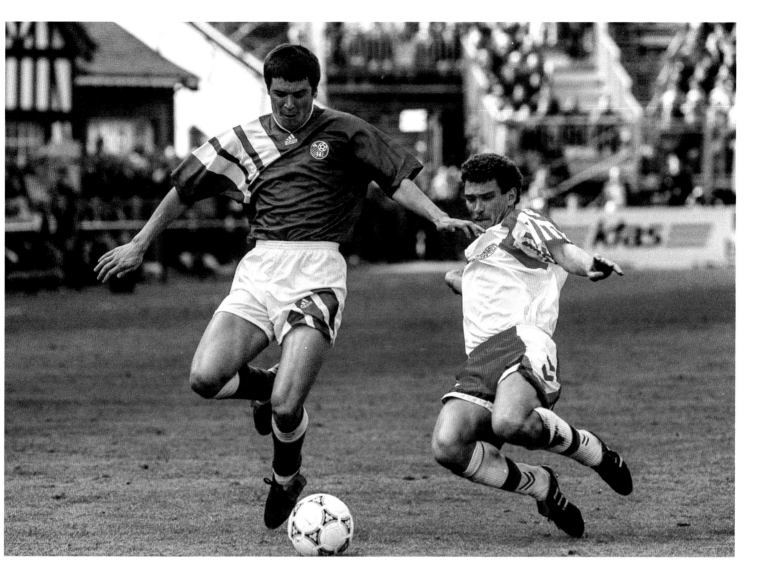

28 April 1993

Roy Keane in action against John Jensen, Denmark. The Danish team were confident, off the back of recent wins over over Lativa and Spain, and took the lead in the 27th minute. Ireland couldn't catch up until a high header from Niall Quinn equalised the score in the 75th minute. The game finished 1-1; Ireland's point was crucial for them as they edged Denmark on goal difference in the race to reach the finals. World Cup Qualifier, Lansdowne Road, Dublin.

David Maher/SPORTSFILE

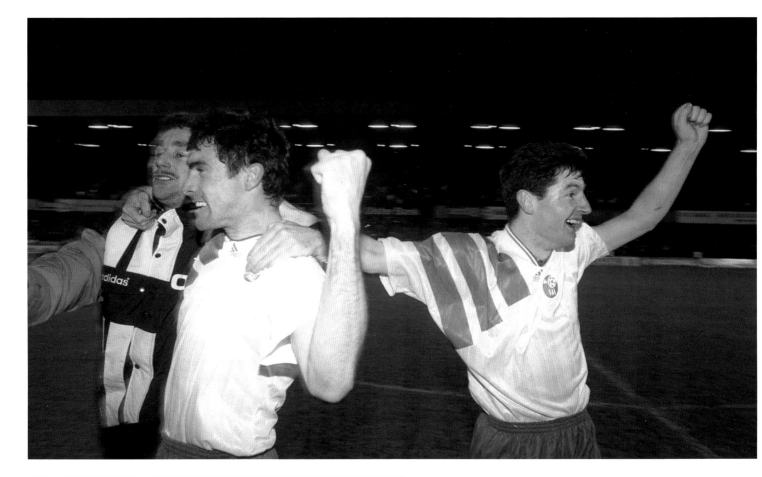

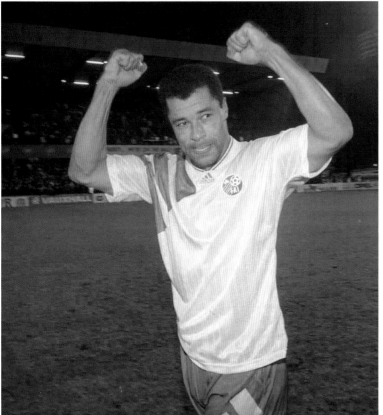

17 November 1993

Above John Aldridge, Alan McLoughlin and Denis Irwin and **(left)** Paul McGrath celebrate after qualifying for the 1994 World Cup Finals, in a 1-1 draw with Northern Ireland. The atmosphere was fueled by political tensions of the time. Fearing violence, the Northern Ireland Football Association did not allocate any tickets to Republic of Ireland supporters and the Republic of Ireland team flew to Belfast from Dublin due to safety concerns. Windsor Park, Belfast.

David Maher / SPORTSFILE

18 June 1994

Republic of Ireland's Ray Houghton shoots to score his side's first goal, in the 11th minute. A Paul McGrath masterclass in defending was central to the Irish team defending their lead for the rest of the game, and gaining revenge over the Italians, who had knocked them out of the 1990 World Cup 1994 World Cup, Pool E, Republic of Ireland v Italy, The Giants Stadium, New Jersey, USA.

David Maher / SPORTSFILE

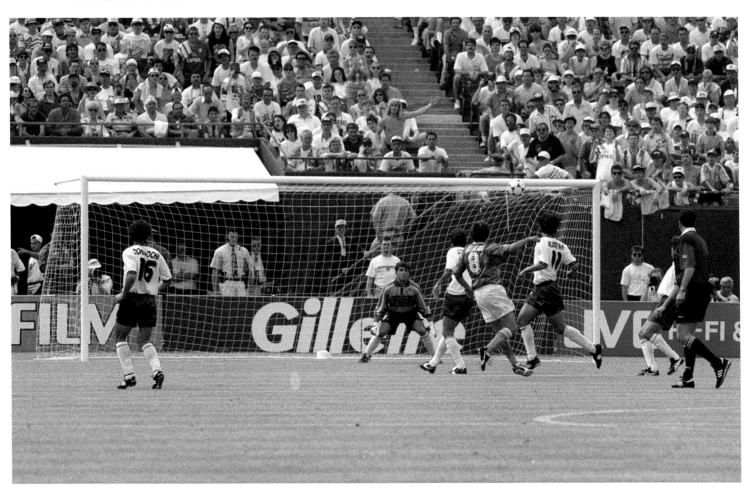

18 June 1994

Though New Jersey is known as a very Italian state, Irish support was huge at the Ireland v Italy game. 'Where are our supporters,' Roberto Baggio is reported to have said, as the players emerged from the tunnel. World Cup 1994, Giants Stadium, New Jersey, USA.

David Maher / SPORTSFILE

18 June 1994

Manager Jack Charlton celebrates Ireland's 1-0 victory over Italy in Giants Stadium, New York, during the 1994 World Cup Finals. Very warm conditions casued anxiety about the players' wellbeing for Charlton; at the press conference he strongly disagreed with the ruling that forbade teams giving water to players outside of designated areas in front of the dugout.

Ray McManus / SPORTSFILE

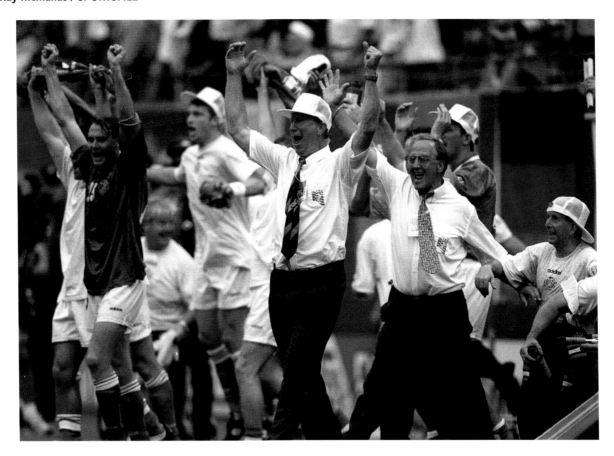

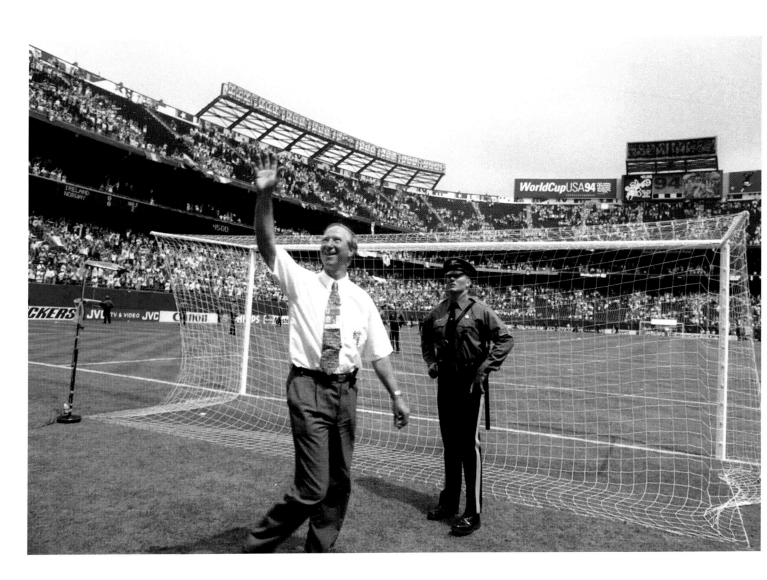

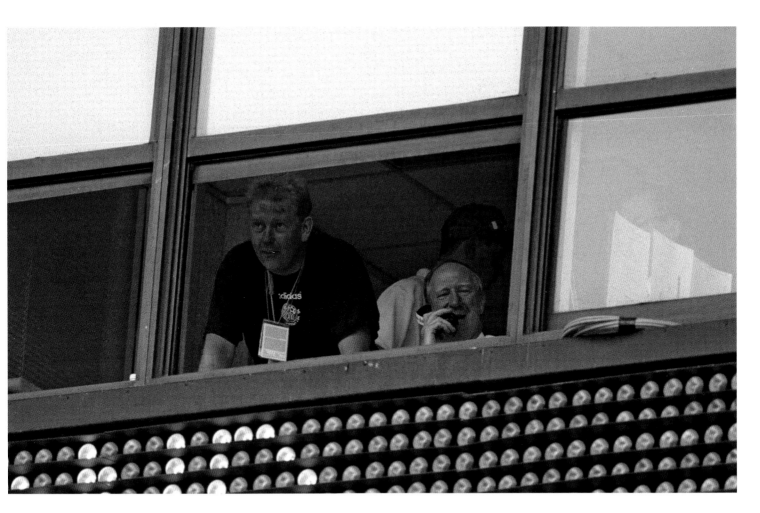

28 June 1994

Left and above Ireland manager Jack Charlton waves to the crowd as his team draw against Norway to qualify for the second phase of the World Cup. Charlton had to watch the Ireland v Norway match from the stand after he was given a touchline ban following an incident during Ireland's match against Mexico in the second group match. Charlton was substituting John Aldridge on for Tommy Coyne; things got heated when a US official, 'the yellow hat' man, impeded Aldridge's entry onto the pitch, leaving Ireland down to ten men. When Aldridge finally made it onto the pitch, Charlton entered into the fray with the official, earning himself a one-match ban.

David Maher / SPORTSFILE

04 July 1994

Holland's Denis Bergkamp is congratulated by team-mate Marc Overmars on scoring their sides goal as Terry Phelan, (3) Republic of Ireland, looks on. Skilled wingers Overmars and Van Vossen caused problems for the Irish defence, and Holland won, 2-1. FIFA World Cup Finals, Orange Bowl, Orlando, Florida, USA.

David Maher / SPORTSFILE

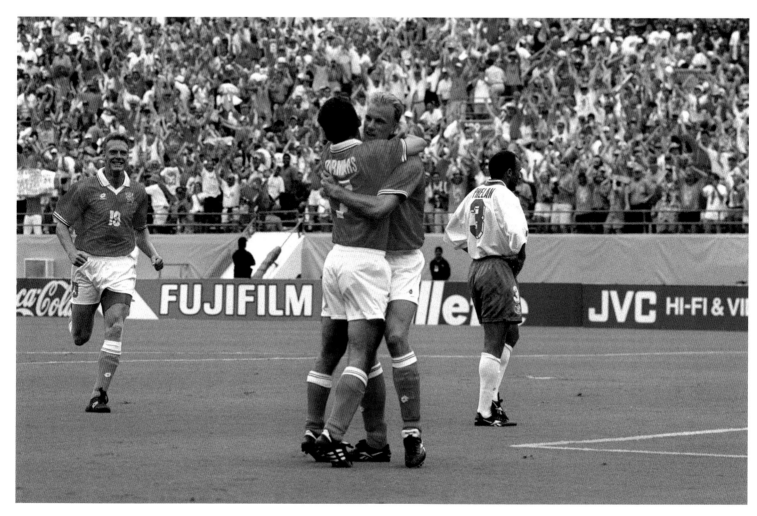

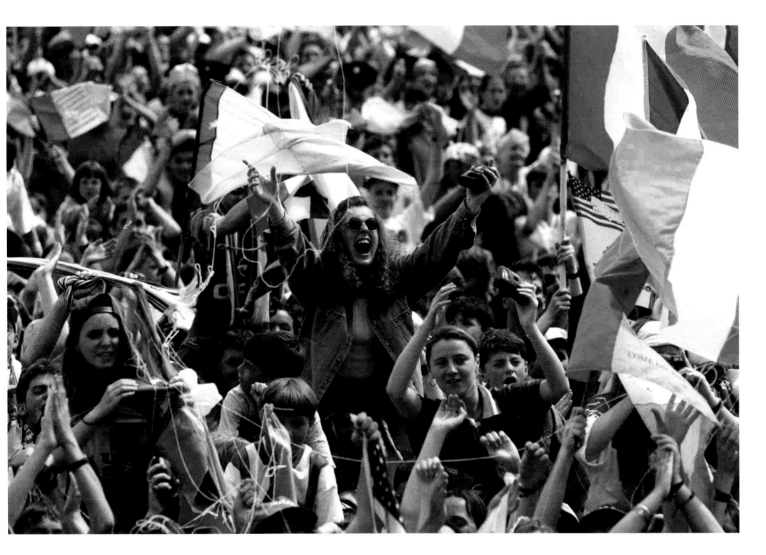

07 July 1994

Ireland fans at the Phoenix Park when the Republic of Ireland team returned from the 1994 World Cup in the USA. There was no open-top bus ride through the city centre on this occasion, as the huge crowds had reached dangerous levels along the bus route after Italia 90.

David Maher / SPORTSFILE

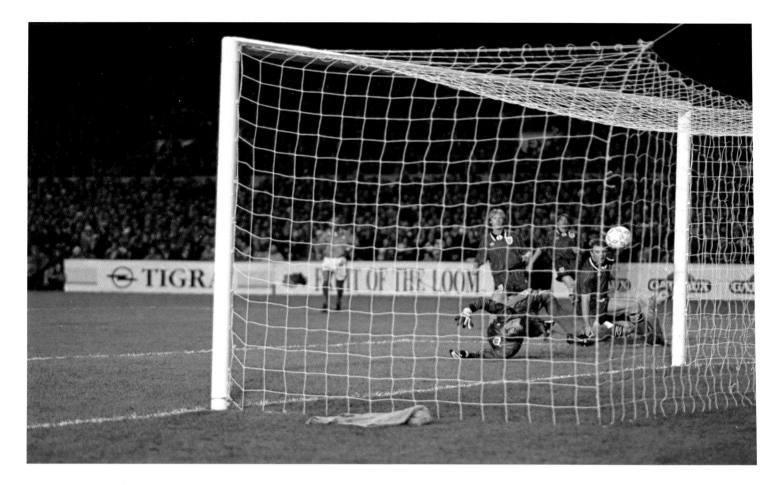

15 February 1995

A dark day for football: David Kelly, Republic of Ireland, scores the only goal of the game against England in Lansdowne Road, after which the game was abandoned after 27 minutes due to rioting by England fans in the Upper West Stand. Ireland manager Jack Charlton said afterwards, 'Every Englishman should be ashamed', while his England counterpart Terry Venables described the night as 'sickening'.

David Maher / SPORTSFILE

04 June 1995

Niall Quinn holds his head in his hands while Jack Charlton watches the final moments of Ireland's 0-0 game against Liechtenstein. The tiny principality, whose team was made up of mechanics, groundskeepers, teachers and other amateur footballers, were playing in their first international tournament, and this was the first match where they had not conceded a goal; they conceded 28 in their previous five games. 'That was the time we became the aged team who couldn't go on any longer,' remarked Tony Cascarino later. European Championship Qualifier, Liechtenstein.

Ray McManus / SPORTSFILE

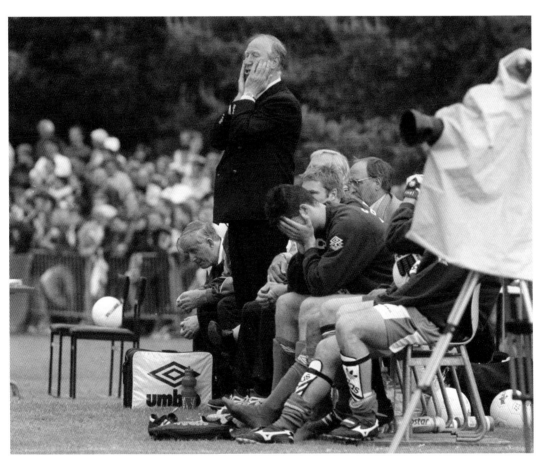

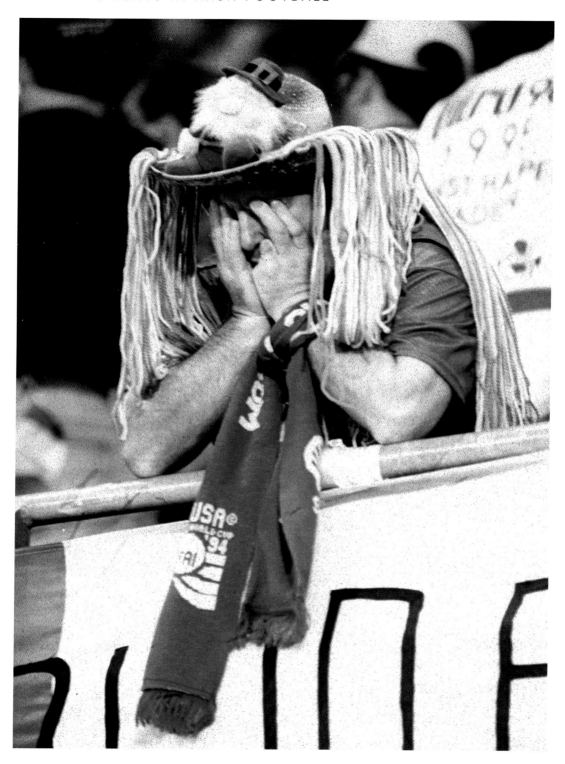

13 December 1995

Republic of Ireland's John Sheridan in action against Denis Bergkamp, Netherlands. The Dutch team featured 8 of the Champions-League winning Ajax. European Soccer Championship Qualifying Play-off, Anfield, Liverpool, England.

David Maher / SPORTSFILE

06 September 1995

A disappointed Irish fan pictured after Ireland's second successive defeat by Austria. It was 'the beginning of the end,' according to Ray Houghton. European Championship Qualifier, Ernst Happel Stadium, Vienna, Austria.

David Maher / SPORTSFILE

13 December 1995

Republic of Ireland's Tony Cascarino in action against Winston Bogarde (5) and Clarence Seedorf (4),
Netherlands. European Soccer Championship Qualifying Play-off, Anfield, Liverpool, England.

David Maher / SPORTSFILE

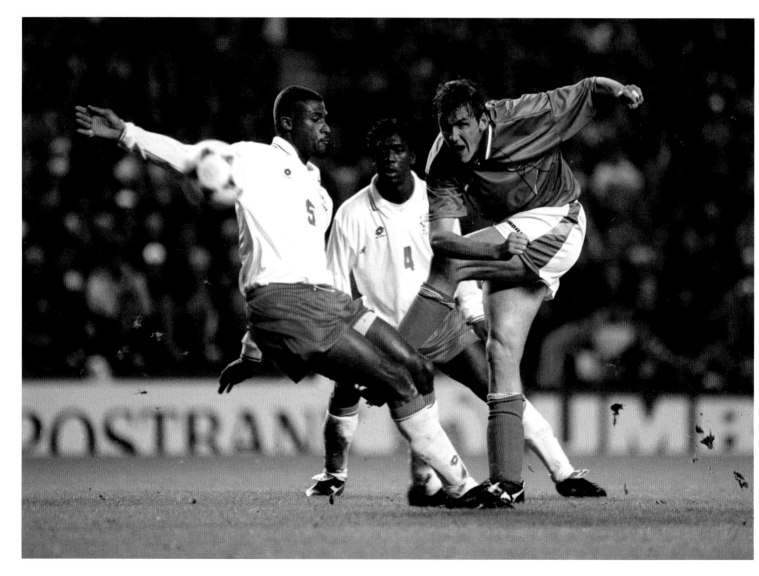

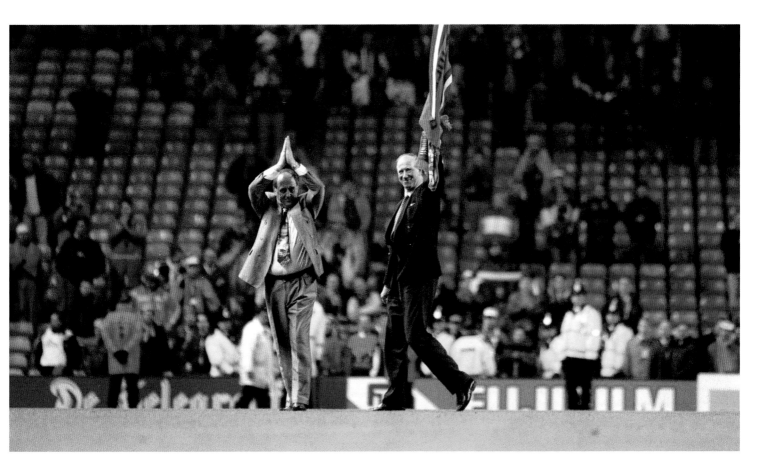

13 December 1995

The end of an era: Republic of Ireland manager Jack Charlton, right, and Assistant Maurice Setters applaud the crowd after their side were defeated by Netherlands. Charlton resigned shortly afterwards. He later said, '... some of my older players had given me all they had to give.' Charlton's tenure as Irish manager brought unprecedented success to the Irish football team and shortly after his resignation he was awarded honourary Irish citizenship in recognition of his achievements with the national side.

David Maher / SPORTSFILE

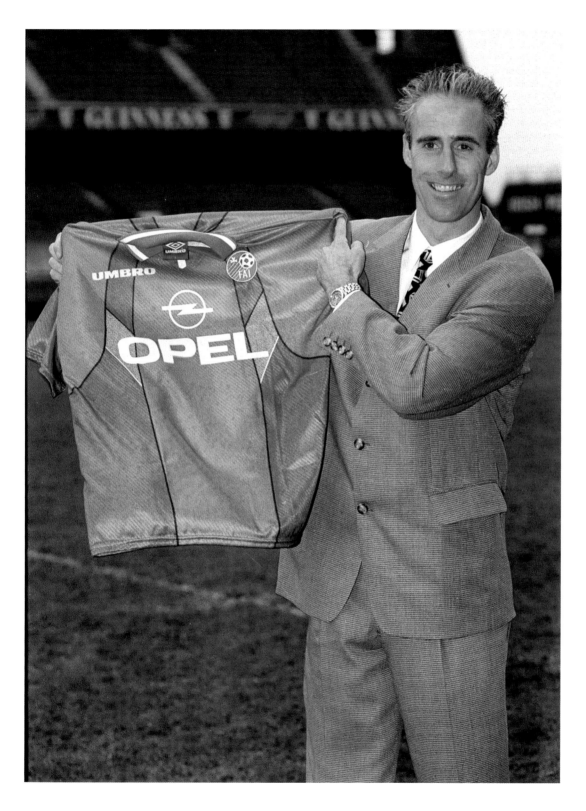

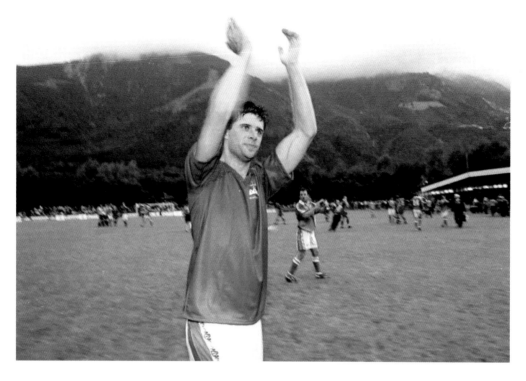

31 August 1996

A year on from their humiliating draw with tiny Liechtenstein, Ireland redeemed themselves with a 4-0 victory. Niall Quinn applauds the fans after the match. World Cup Qualifier, Liechtenstein.

Ray McManus / SPORTSFILE

05 February 1996

Mick McCarthy, the Republic of Ireland's new Soccer manager pictured at Lansdowne Road, Dublin. McCarthy known as Captain Fantastic, during his playing days, played for Ireland 57 times. 1996-2003 was his first stint as Ireland manager; he returned in 2018 to lead a new Irish team.

David Maher / SPORTSFILE

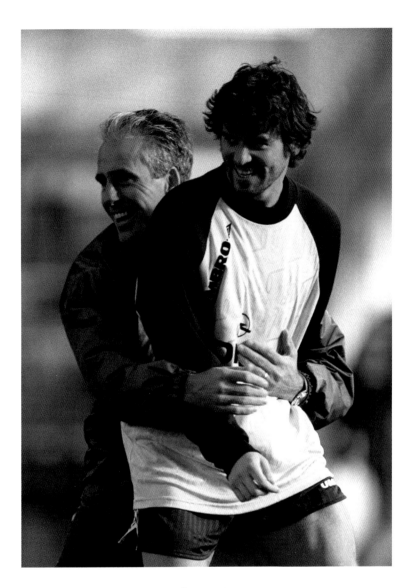

09 November 1996

Happier times: Republic of Ireland manager Mick McCarthy tackles Roy Keane during a squad training session at Lansdowne Road.

Ray McManus / SPORTSFILE

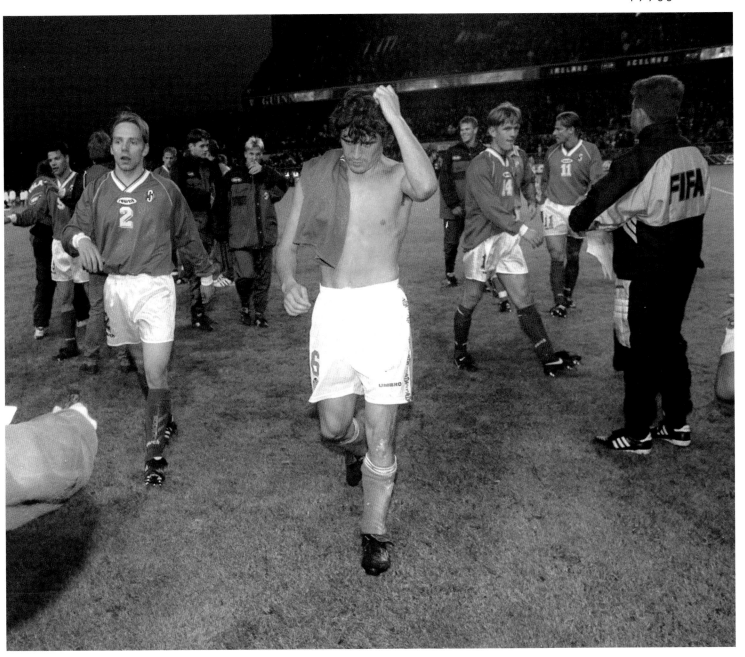

11 November 1996

Republic of Ireland's Roy Keane walks off the pitch at the end of the Ireland v Iceland match. Iceland were the underdogs, but pulled off a surprise 1-0 victory. 'We're disappointed, but that's they way it goes. They defended very well,' said Keane after the match. World Cup Qualifier, Lansdowne Road, Dublin.

David Maher / SPORTSFILE

30 April 1997

Republic of Ireland
manager Mick McCarthy
watches the final moments
of the game as Romania
beat Ireland, 1-0.
Bucharest, Romania.

David Maher / SPORTSFILE

30 April 1997

Republic of Ireland's Roy
Keane leaves the field
alone at the final whistle.
Keane had missed a
penalty in the 47th minute.

Ray McManus / SPORTSFILE

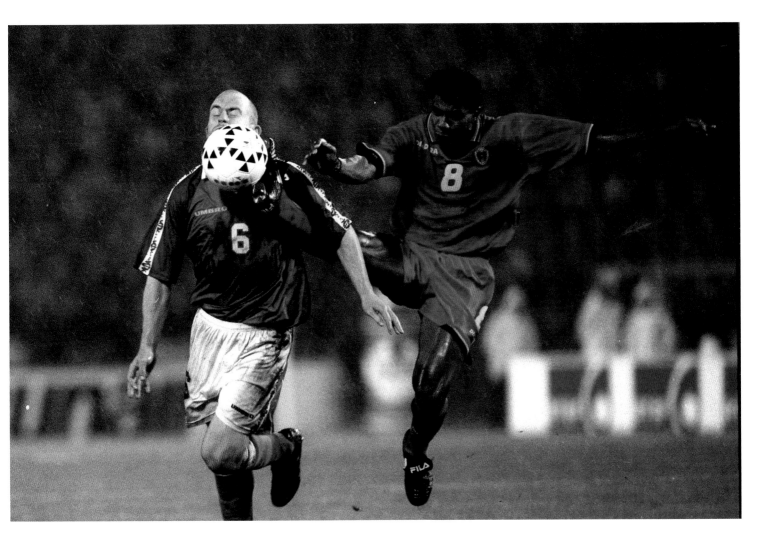

15 November 1997

Lee Carsley, Republic of Ireland in action against Luis Oliviera, Belgium. As Belgium had scored against Ireland in Dublin in October, Ireland had to score an away goal in leg 2 in Brussells. Olivera scored for Belgium, then Ray Houghton came off the bench to score for Ireland. Then with the two sides level, Benko, the referee, incorrectly awarded a throw-in to Belgium; Luc Nilis subsequently scored for Belgium – and Belgium were off to the World Cup! World Cup qualifying match, Hysel Stadium, Brussells.

David Maher / SPORTSFILE

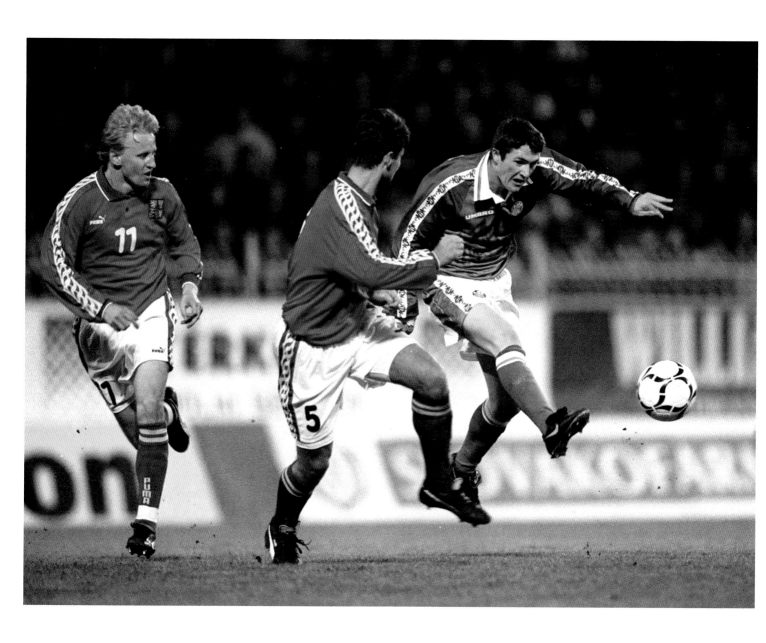

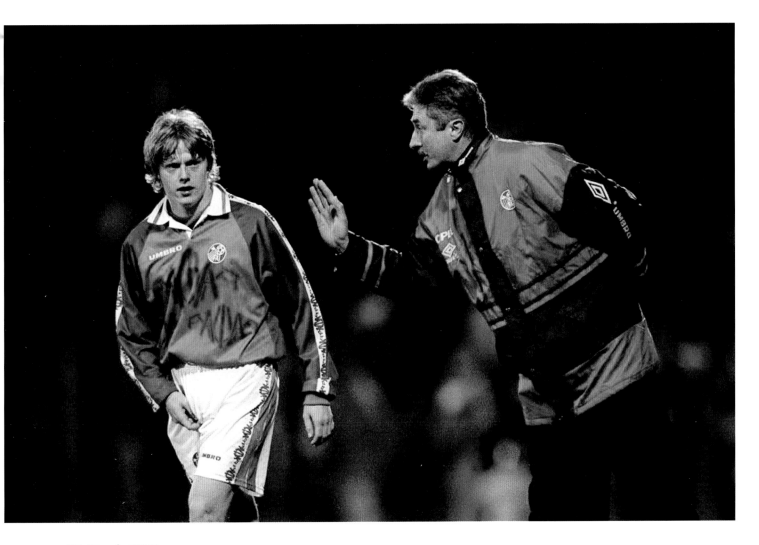

25 March 1998

Left: Republic of Ireland's Robbie Keane in action during his International debut at the age of seventeen. Czech Republic v Republic of Ireland, Sigma Stadium, Olomouc, Czech Republic. Keane went on to become the most-capped Irish player (146 caps) and all-time Irish record goal-scorer, with 68 goals. Also making his debut was Damien Duff **(above)** receiving instruction from assistant manager Ian Evans) who went on to become a titan of Irish football, lining out for the national team for the next fourteen years. Czech Republic v Republic of Ireland, Sigma Stadium, Olomouc, Czech Republic.

David Maher / SPORTSFILE

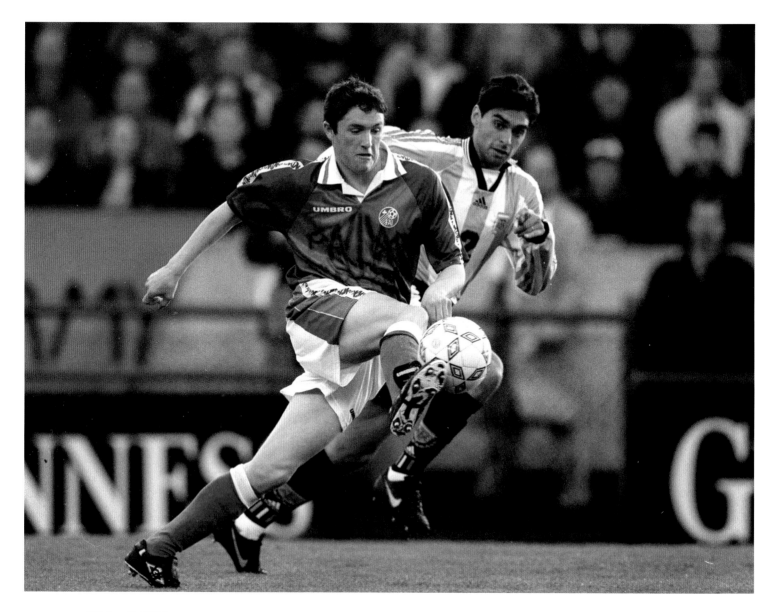

22 April 1998

Robbie Keane in his home debut harries Roberto Ayala of Argentina. Friendly International, Lansdowne Road, Dublin.

Brendan Moran / SPORTSFILE

17 January 1999

Shamrock Rovers' Jason Sherlock attempts a shot at goal in a crowded goalmouth. Sherlock is better known as a Gaelic footballer who played on the Dublin team for fifteen years between 1995 and 2010. FAI National League Soccer, UCD v Shamrock Rovers, Belfield.

Ray McManus / SPORTSFILE

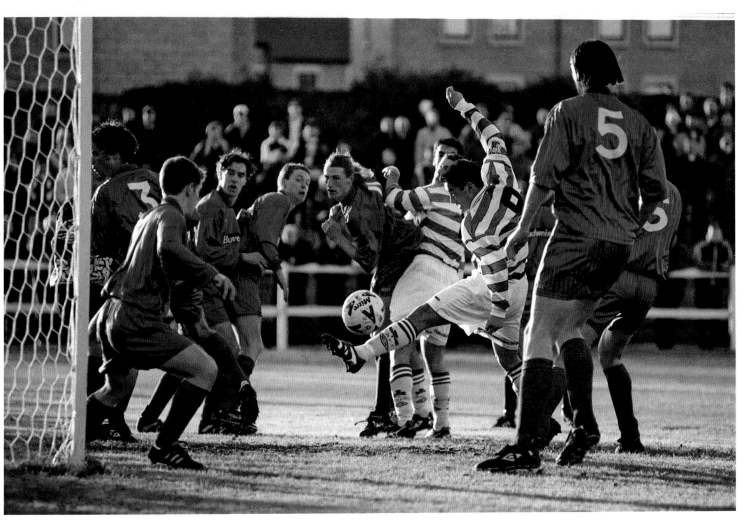

10 February 1999

David Connolly in action against Paraguay. Ireland won 2-0. Connolly and Denis Irwin (**opposite**, being congratulated by Jason McAteer after scoring a penalty) scored the two goals. International Soccer Friendly, Lansdowne Road, Dublin.

Ray McManus / SPORTSFILE

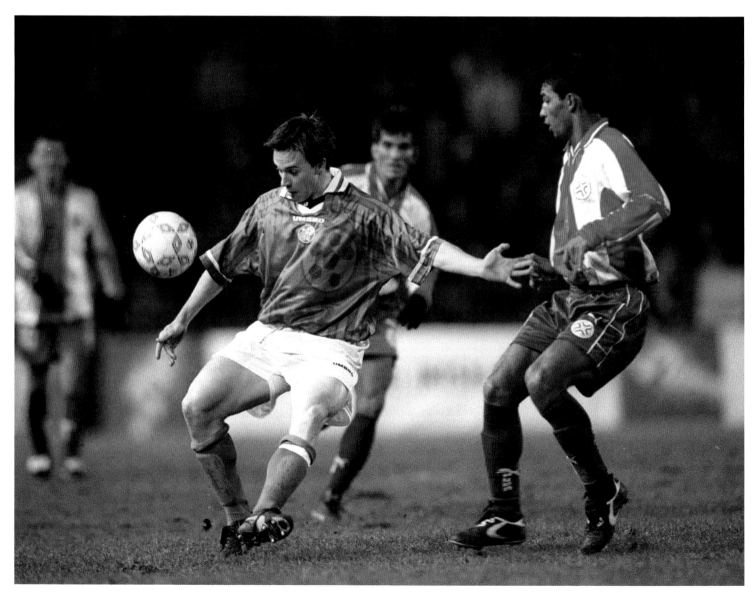

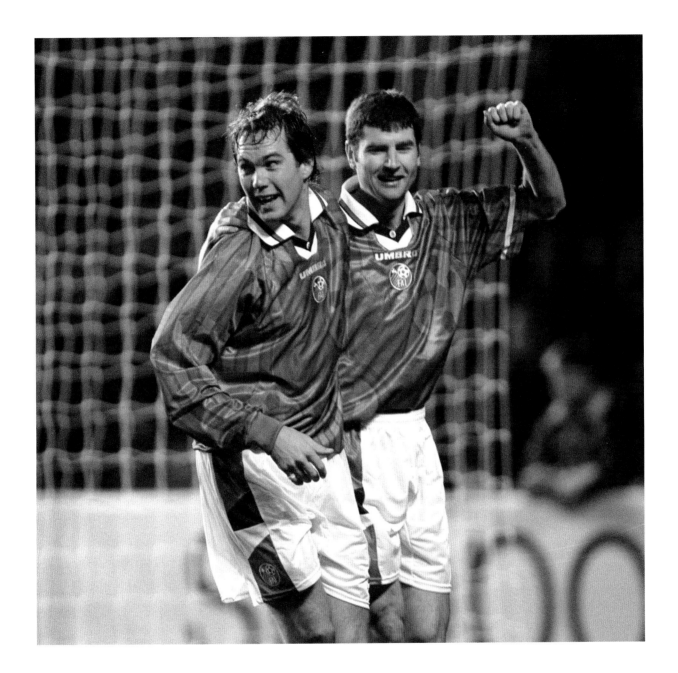

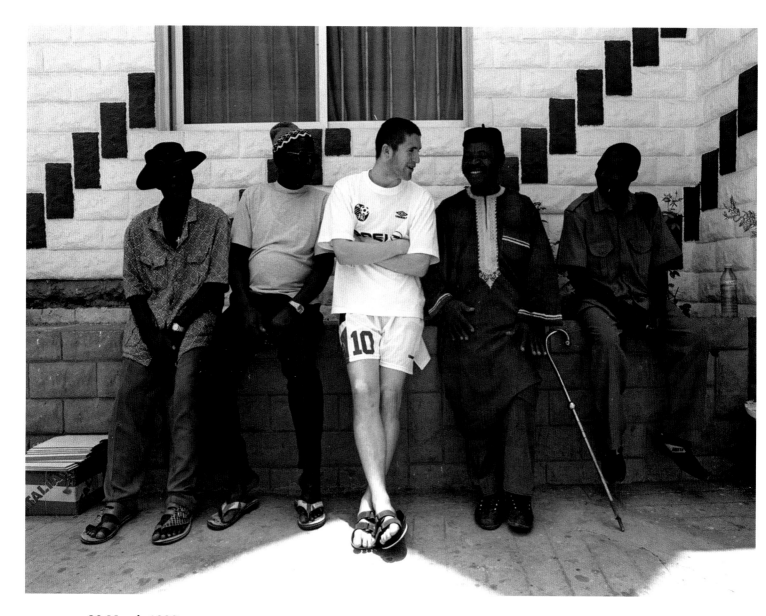

30 March 1999

Eighteen-year-old (centre) Robbie Keane, Republic of Ireland, talks to locals in Ibadan, Nigeria. Many of Brian Kerr's squad from this tournament – Robbie Keane, Damien Duff, Richie Sadlier, Colin Healy and Stephen McPhail – went on to success on the senior team. FIFA World Cup U-20 tournament, Ibadan, Nigeria.

David Maher / SPORTSFILE

09 June 1999

At last! Gary Breen celebrates Niall Quinn's 64th minute header past Macedonian goalkeeper Petar Milosevski. Republic of Ireland 1-0 FYR Macedonia. Lansdowne Road, Dublin.

David Maher / SPORTSFILE

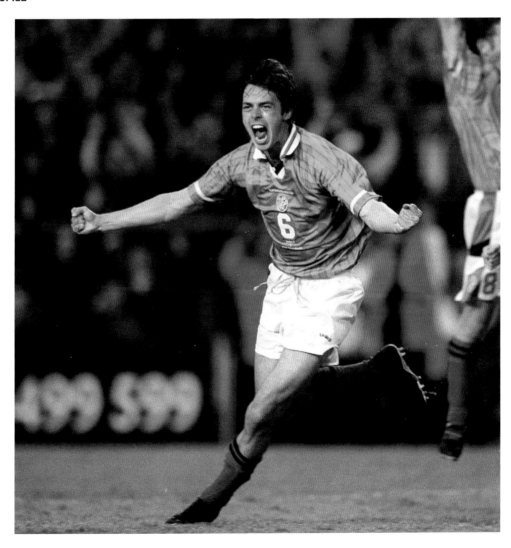

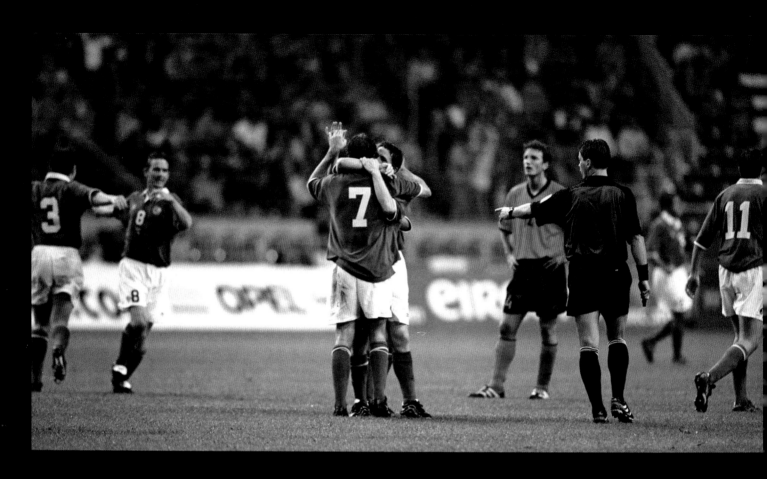

02 September 2000

Robbie Keane congratulates Jason McAteer, (7) after McAteer scored his side's second goal. McAteer was a late addition to the squad, coming in to replace Mark Kennedy who, along with Phil Babb, was dropped from the squad after a drunken night in Dublin. Babb was replaced by Richard Dunne who started against Holland for his competitive Irish debut. World Cup Championship Qualifier, Amsterdam Arena, Holland.

David Maher / SPORTSFILE

2000s

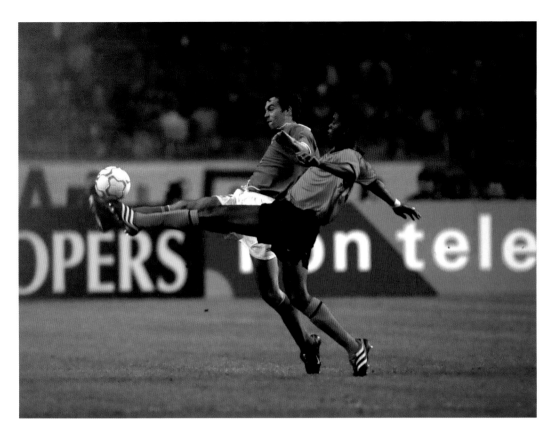

02 September 2000

Gary Breen in action against Holland's Patrick Kluivert. Despite Ireland earning a 2-0 lead in this game, the Dutch fought back to claim a point as the game ended 2-2. World Cup Qualifier, Amsterdam Arena, Holland.

David Maher / SPORTSFILE

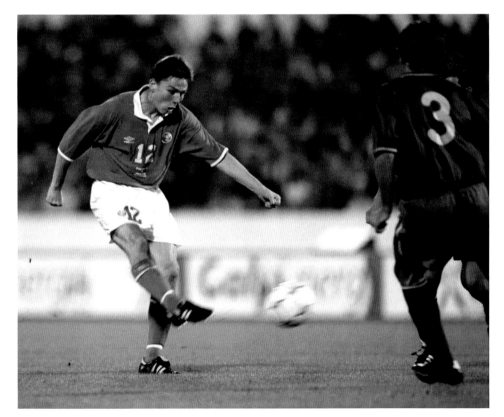

07 October 2000

Matt Holland scores Ireland's equalising goal against Portugal. A stunning strike from twenty-five yards and Holland's first for Ireland. World Cup Soccer Qualifier, Stadium of Light, Lisbon, Portugal.

David Maher / SPORTSFILE

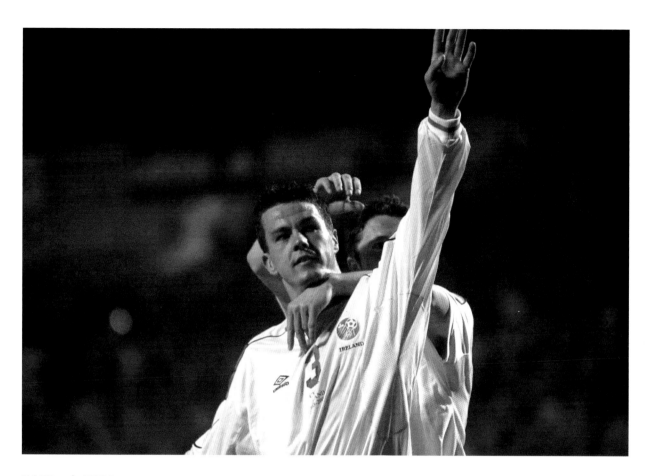

24 March 2001

Ian Harte and Robbie Keane celebrate after scoring against Cyprus. It was in this game that Roy Keane won his fiftieth international cap. Keane spoke of this landmark in typical style, saying it meant 'nothing, absolutely nothing'. World Cup Qualifier, G.S.P. Stadium, Nicosia, Cyprus.

David Maher / SPORTSFILE

25 April 2001

Kevin Kilbane chips past the Andorra keeper, Alfonso Sanchez, to score Ireland's opening goal. This equalizer came just two minutes after Andorra had taken the lead. Further goals from Mark Kinsella and Gary Breen saw Ireland come away with a 3-1 win. World Cup Qualifier, Lansdowne Road, Dublin.

Brendan Moran / SPORTSFILE

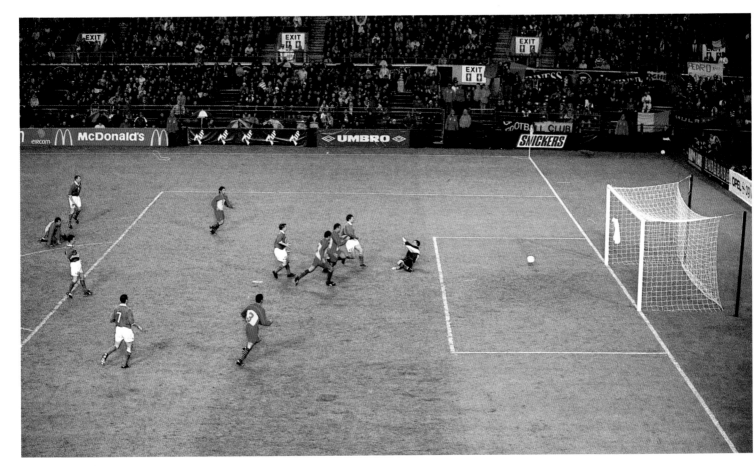

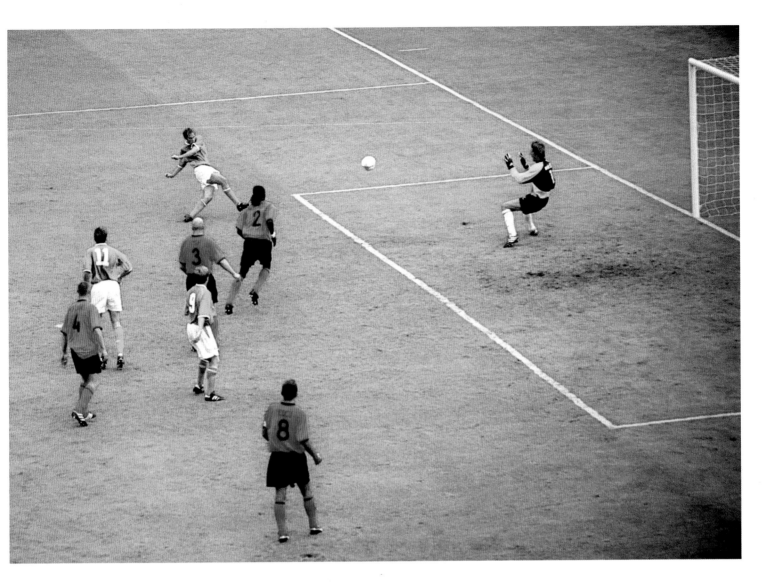

01 September 2001

Republic of Ireland's Jason McAteer scores. Undoubtedly one of the greatest games ever to be played at Lansdowne Road. Despite a penalty appeal and big chances for Patrick Kluivert and Bolo Zenden, the Dutch could not break down the ten men of Ireland. In commentary, George Hamilton described the game as 'one of the most courageous, the most brave, the most committed and ultimately most effective of Irish performances that we've ever seen'. World Cup Qualifier, Lansdowne Road, Dublin.

Aoife Rice / SPORTSFILE

06 October 2001

Ireland teammates Mark Kennedy (7) and Ian Harte celebrate Harte's goal. Known for his proficiency at set pieces, Harte curled in a spellbinding free kick to get Ireland off the mark. The game ended 4-0 and secured Ireland's place in the World Cup Play offs. Republic of Ireland v Cyprus, World Cup Qualifier, Lansdowne Road, Dublin.

Ray Lohan / SPORTSFILE

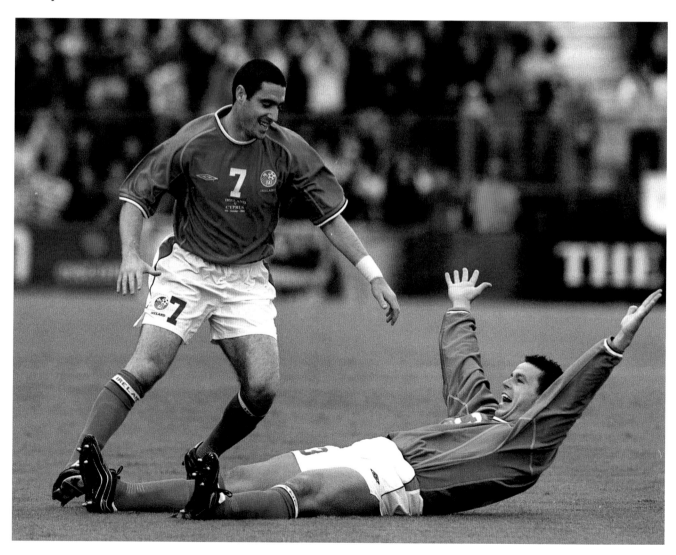

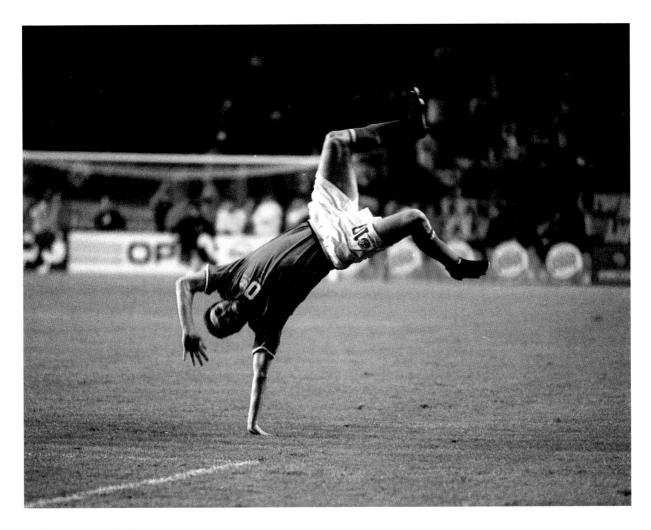

10 November 2001

Robbie Keane, celebrates in his trademark acrobatic style after scoring the Republic of Ireland's second goal. Keane's goal here proved to be the decisive one in the tie as Iran won the return leg 1-0, meaning the final score on aggregate was 2-1 and the Republic of Ireland had qualified for their third ever World Cup. World Cup Qualifing Play-off 1st Leg, Lansdowne Road, Dublin.

Ray Lohan / SPORTSFILE

22 May 2002

Republic of Ireland captain Roy Keane walks past manager Mick McCarthy during squad training. For Irish soccer fans, the island of Saipan will always be synonymous with the infamous public disagreement between Roy Keane and Mick McCarthy. Keane's fierce criticism was directed not just at McCarthy, but at the unprofessionalism of the FAI as a whole. Tensions soon boiled over and the Irish captain was dismissed from the camp and did not feature at the World Cup. The eventual 'Genesis Report' into the incident evidently agreed with many of Keane's complaints about the FAI's structure and decision-making. The Saipan Incident is certainly one of the most divisive and defining moments in recent Irish sporting memory. Adagym, Saipan.

David Maher / SPORTSFILE

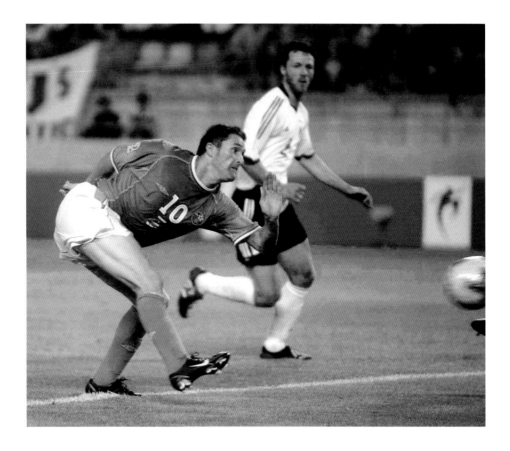

05 June 2002

Robbie Keane, Republic of Ireland, scores against Germany in the
92nd minute. Keane was quickest to react after Niall Quinn flicked on
a long ball from Steve Finnan. The striker took the ball in his stride
and steered the ball past Oliver Kahn to earn Ireland a deserved point.
Keane's goal was the only one that Germany conceded on their way to
making the tournament final. FIFA World Cup Finals, Group E, Ibaraki
Stadium, Japan.

David Maher / SPORTSFILE

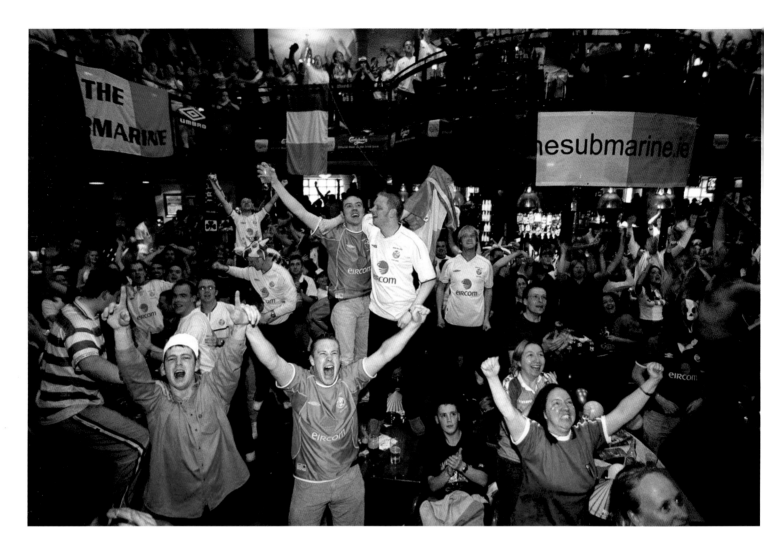

05 June 2002

Republic of Ireland fans celebrate Robbie Keane's stoppage time equaliser against Germany in the FIFA
World Cup Finals. The Submarine Bar, Dublin.

Brendan Moran / SPORTSFILE

11 June 2002

Damien Duff bows to the crowd after scoring Ireland's third goal against Saudi Arabia. A 3-0 win here secured Ireland's progression to the knockout stages. FIFA World Cup Finals, Group E, FIFA World Cup 2002, Yokohama Stadium, Japan.

David Maher / SPORTSFILE

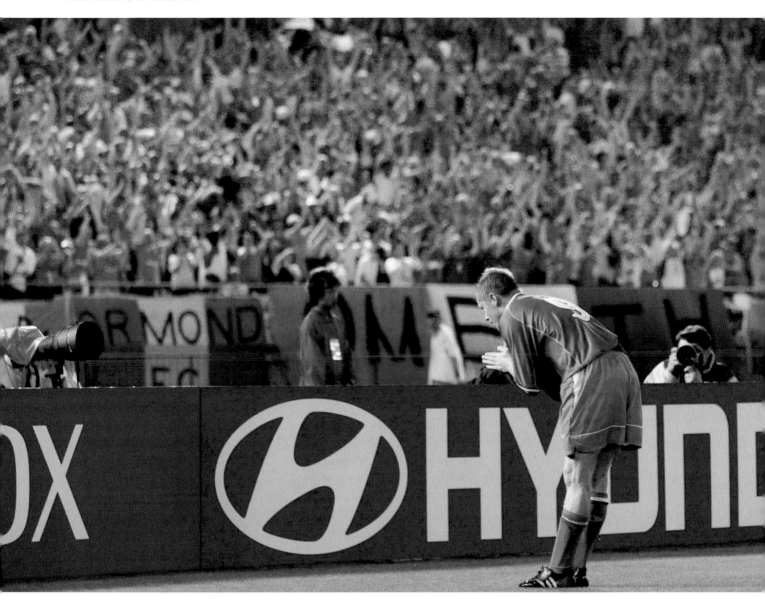

16 June 2002

Republic of Ireland physio Mick Byrne consoles Kevin Kilbane after the game. Kilbane was one of three Irish players to miss from the spot as Ireland crashed out of the World Cup on penalties. FIFA World Cup Finals, 2nd Round, Republic of Ireland v Spain, Suwon World cup stadium, Korea.

David Maher / SPORTSFILE

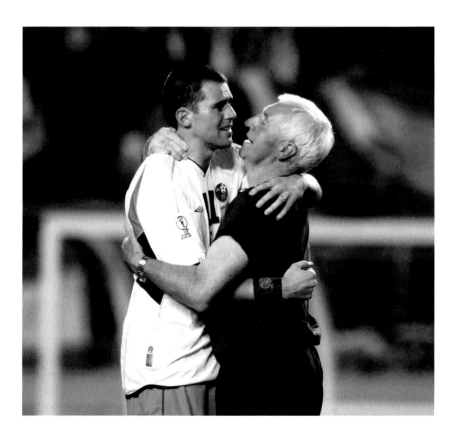

16 June 2002

A dejected Republic of Ireland fan pictured after the game.

David Maher / SPORTSFILE

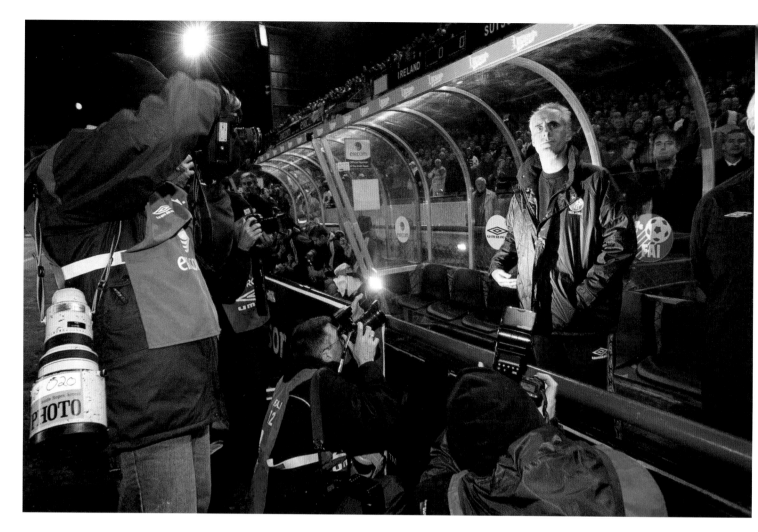

16 October 2002

Republic of Ireland Manager Mick McCarthy is photographed prior to Republic of Ireland v Switzerland. The game ended in a 2-1 loss and proved to be the final game of Mick McCarthy's first stint as Republic of Ireland manager. European Championships 2004 Qualifier, Lansdowne Road, Dublin.

David Maher / SPORTSFILE

29 March 2003

Republic of Ireland manager Brian Kerr celebrates with Lee Carsley after his first game in charge ended in a 2-1 win. 2004 European Championship Qualifier, Georgia v Republic of Ireland, Lokomotiv Stadium, Tbilisi, Georgia.

Damien Eagers / SPORTSFILE

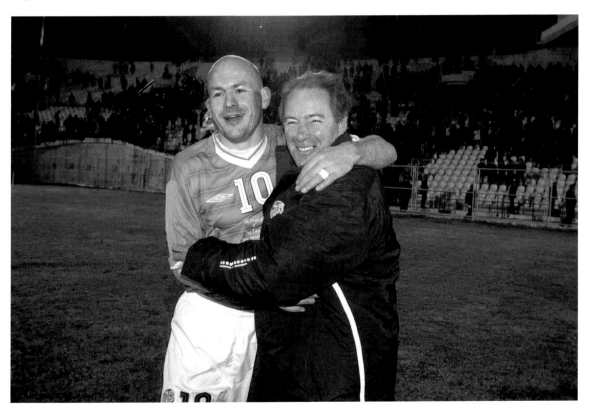

11 October 2003

David Connolly (9) has his shot at goal saved by Switzerland's goalkeeper Jorg Stiel just before the end of the first half. Ireland's qualifying campaign ended in the disappointing fashion they had began in as they failed to reach the Euros. Euro 2004 Qualifying Game, St. Jakob Park, Basel, Switzerland.

Matt Browne / SPORTSFILE

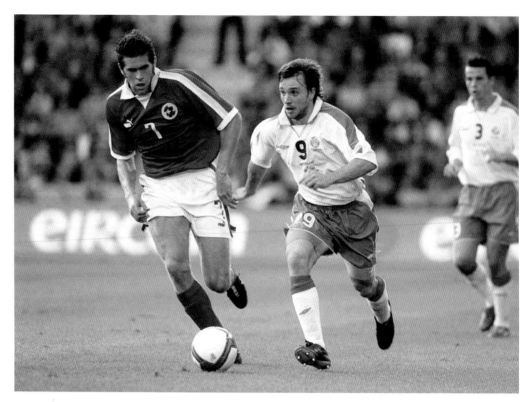

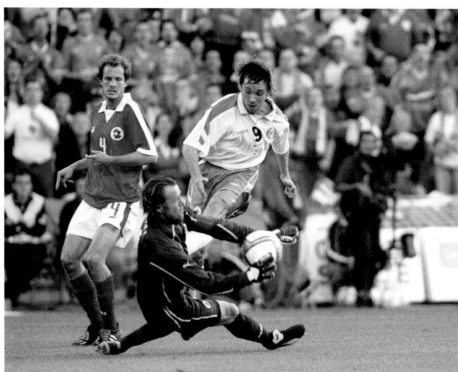

6 May 2006

Katie Taylor in action against Amy McDonald, Scotland. While most would know Katie as a boxer (she won Olympic gold for Ireland in the lightweight division in 2012, and is a multiple world champion in boxing), she has also represented her country in soccer. World Cup Qualifier, Richmond Park, Dublin.

Ray Lohan / SPORTSFILE

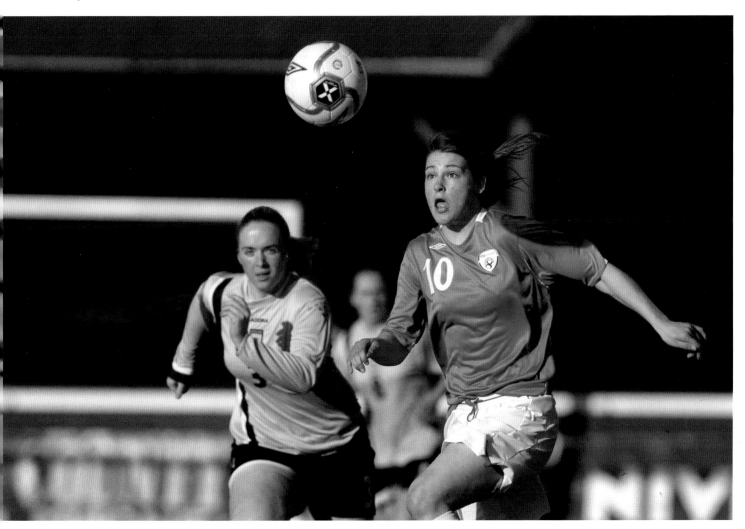

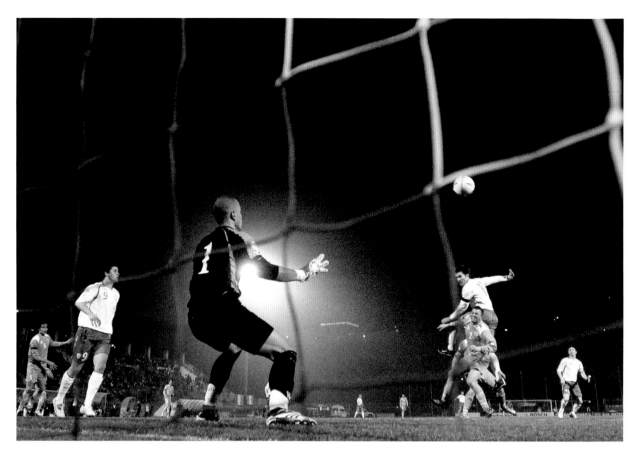

07 February 2007

Kevin Kilbane beats San Marino goalkeeper, Aldo Junior Simoncini, with a header to score his side's first goal. Despite Kilbane's opener, a late Stephen Ireland strike was needed to secure all three points as the game ended in a 2-1 win. While Ireland won the game, it would still have been considered a disappointing result against a side that had been beaten 13-0 by Germany earlier in the qualifying campaign. 2008 European Championship Qualifier, Serravalle Stadium, San Marino.

David Maher / SPORTSFILE

24 March 2007

The crowd and players stand for the National Anthem in Croke Park. Due to the redevelopment of Lansdowne Road, the Republic of Ireland played their home games at Croke Park until Lansdowne Road reopened as The Aviva Stadium in 2010. 2008 European Championship Qualifier, Republic of Ireland v Wales, Croke Park, Dublin.

Brian Lawless / SPORTSFILE

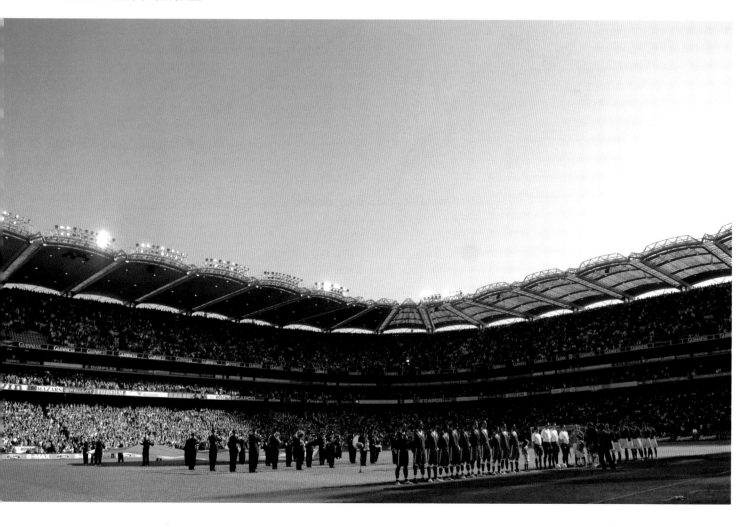

28 March 2007

Kevin Doyle scores a goal for the Republic of Ireland. Ireland finished well off the pace in Group D and had now failed to qualify for back-to-back international tournaments. 2008 European Championship Qualifier, Republic of Ireland v Slovakia, Croke Park, Dublin.

Ray McManus / SPORTSFILE

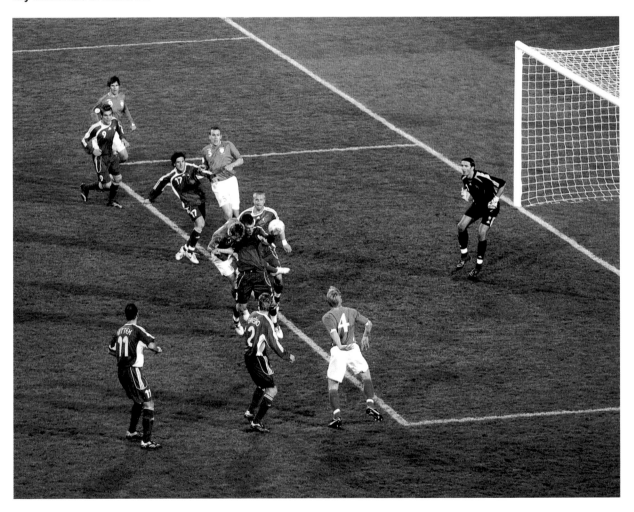

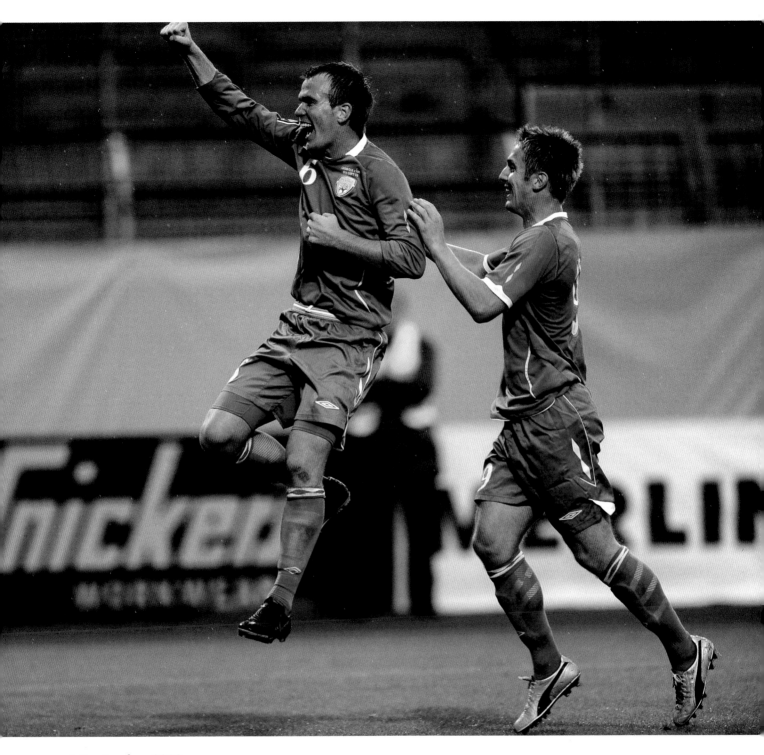

6 September 2008

Glenn Whelan celebrates after scoring his side's second goal with team-mate Kevin Doyle. Ireland saw out a 2-1 win away from home to start off the new campaign. 2010 World Cup Qualifier, Georgia v Republic of Ireland, Bruchweg Stadium, Mainz, Germany.

David Maher / SPORTSFILE

11 February 2009

Robbie Keane celebrates scoring Ireland's first goal against Cyprus. 2010 World Cup Qualifier, Republic of Ireland v Cyprus, Croke Park, Dublin.

David Maher / SPORTSFILE

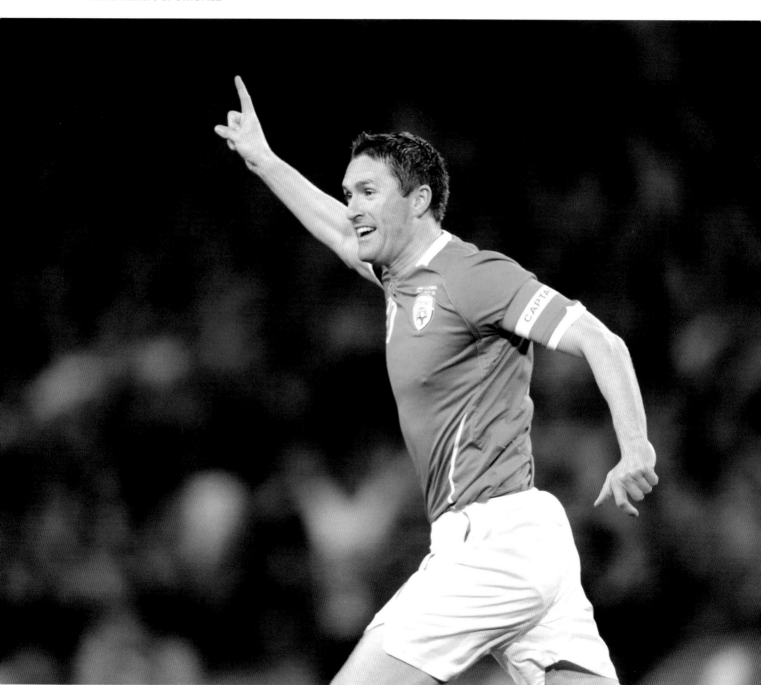

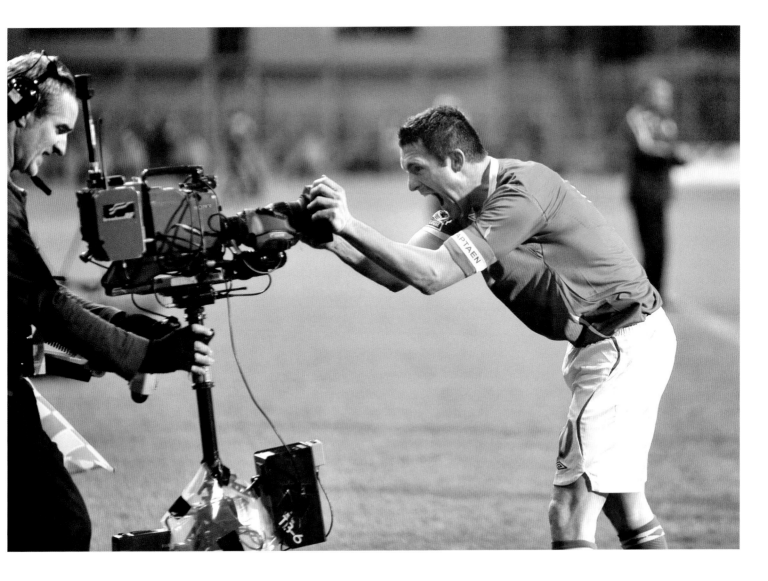

151

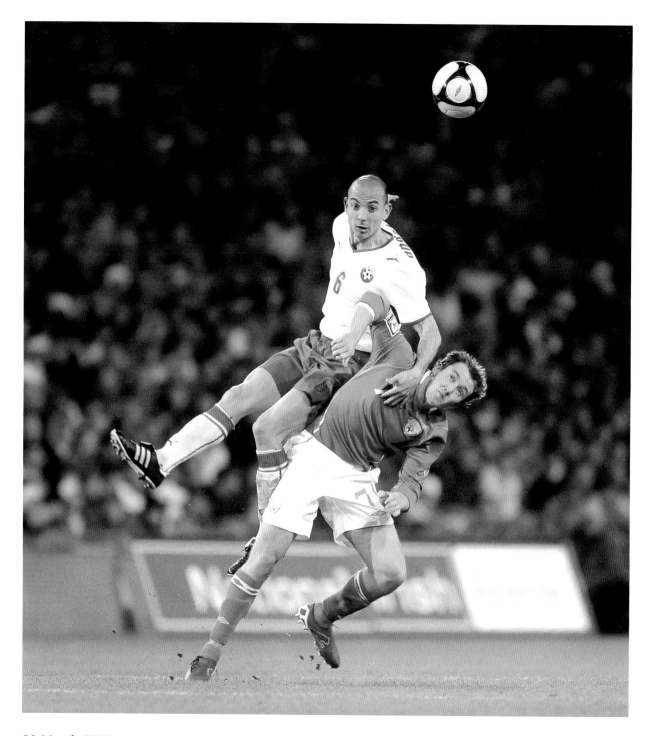

28 March 2009

Aiden McGeady in action against Stanislav Angelov, Bulgaria. Ireland remained unbeaten throughout proceedings in Group 8 and secured a play-off position after finishing second in the group, behind 2006 World Cup winners, Italy. 2010 FIFA World Cup Qualifier, Croke Park, Dublin.

Daire Brennan / SPORTSFILE

01 April 2009

Robbie Keane celebrates after scoring his side's first goal with team-mates Darron Gibson and Noel
Hunt. Keane's late strike helped Ireland nick a point against the world champions. 2010 FIFA World Cup
Qualifier, Italy v Republic of Ireland, San Nicola Stadium, Bari, Italy

David Maher / SPORTSFILE

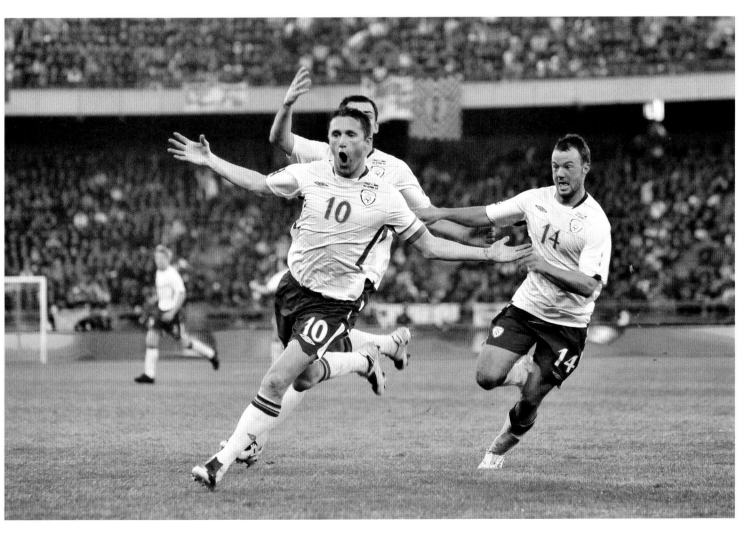

14 November 2009

Damien Duff, Republic of Ireland, stands dejected, as the French players celebrate Nicolas Anelka's goal. This gave the runners up in the 2006 World Cup the advantage going into the second leg of the tie at the Stade de France. FIFA 2010 World Cup Qualifying Play-off 1st Leg, Croke Park, Dublin.

Stephen McCarthy / SPORTSFILE

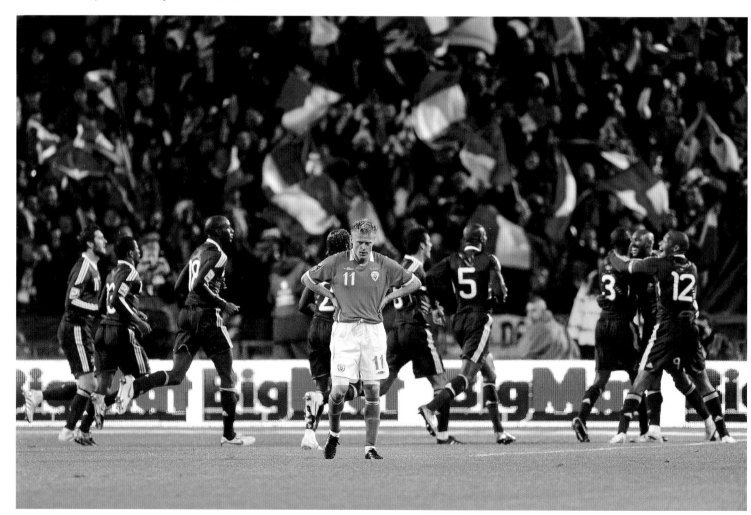

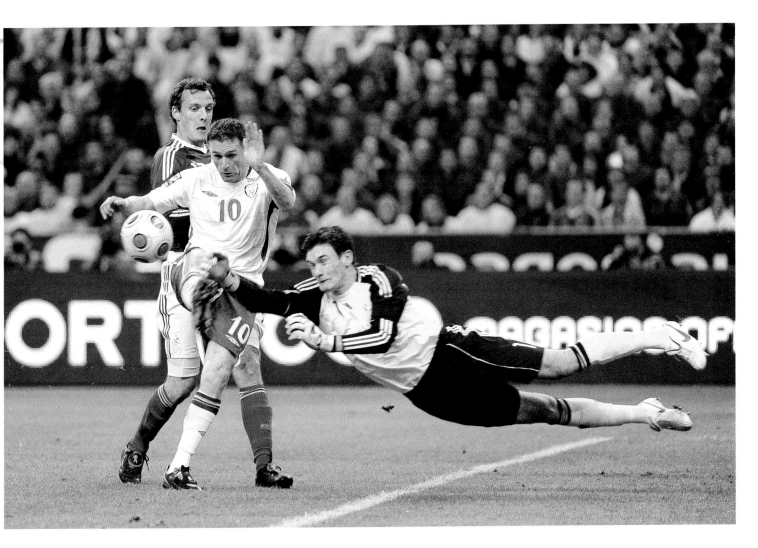

18 November 2009

France goalkeeper Hugo Lloris saves at the feet of Ireland's Robbie Keane. Lloris could not keep Keane quiet all night, however, as the Irishman steered home a Damien Duff cross to score his 41st goal for his country and to force the game to extra time. FIFA 2010 World Cup Qualifying Play-off 2nd Leg, Stade de France, Saint-Denis, Paris, France.

Stephen McCarthy / SPORTSFILE

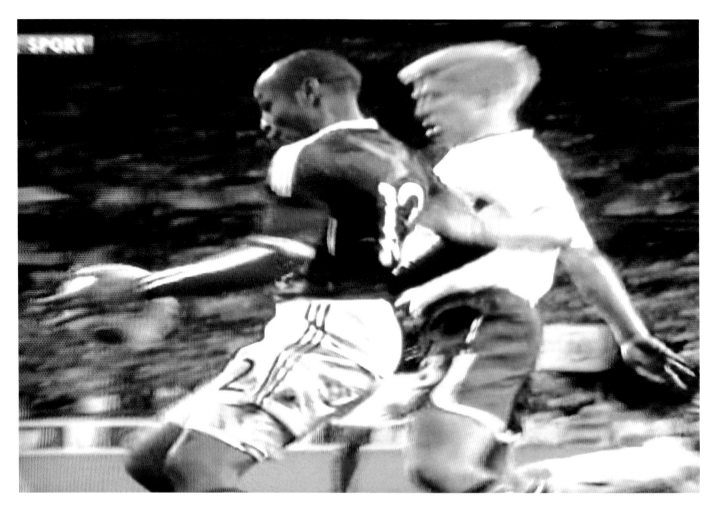

18 November 2009

A videograb of the handball by France's Thierry Henry which directly led to France's equalising goal on the night and put them into a 2-1 lead in extra-time. A moment that incited anger, confusion and heartbreak among the Irish players and supporters as it ended Ireland's hopes of appearing at the World Cup in South Africa. It led to Henry being labelled a villain by the media, a call for Ireland to be instated into the tournament as the 33rd team and the FAI accepting a €5 million payment from Sepp Blatter and FIFA to avoid legal action.

RTE

18 November 2009

William Gallas, France, 5, scores his side's first goal after Thierry Henry had handled the ball as Republic of Ireland players appeal.

David Maher / SPORTSFILE

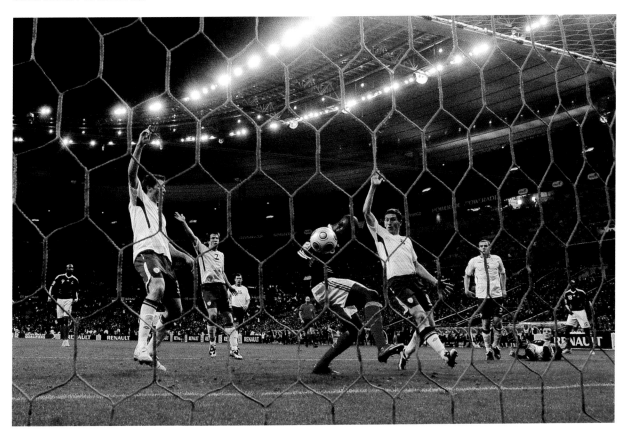

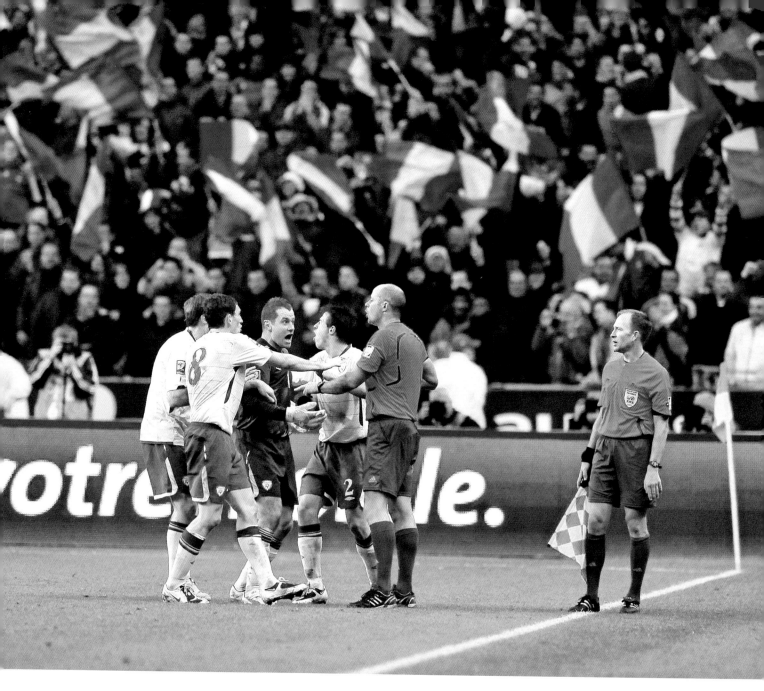

18 November 2009

Republic of Ireland players Keith Andrew, Shay Given and Sean St. Ledger remonstrate with referee Martin Hansson after William Gallas, France, scored his side's goal. Despite their justified protests, the goal stood.

David Maher / SPORTSFILE

18 November 2009

A dejected Damien Duff makes his way to the Republic of Ireland dressing rooms at the end of the game.

David Maher / SPORTSFILE

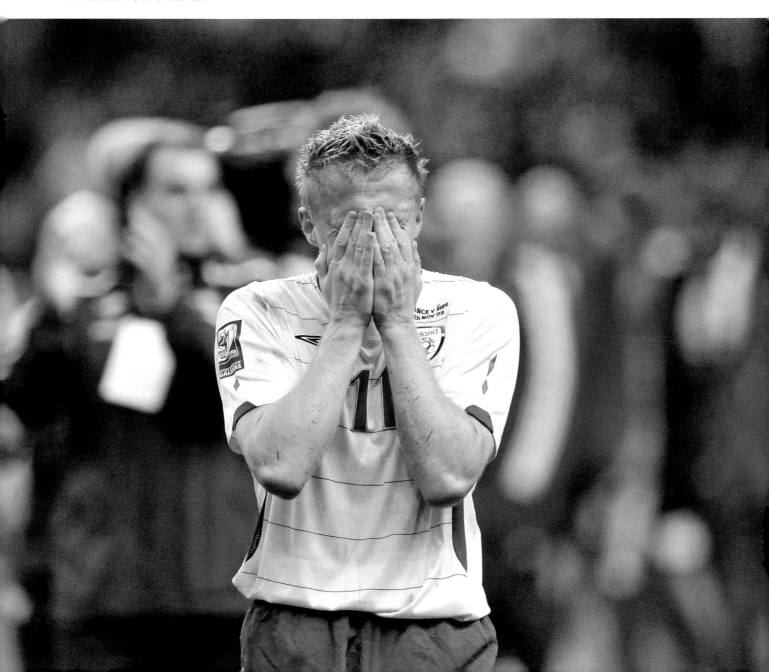

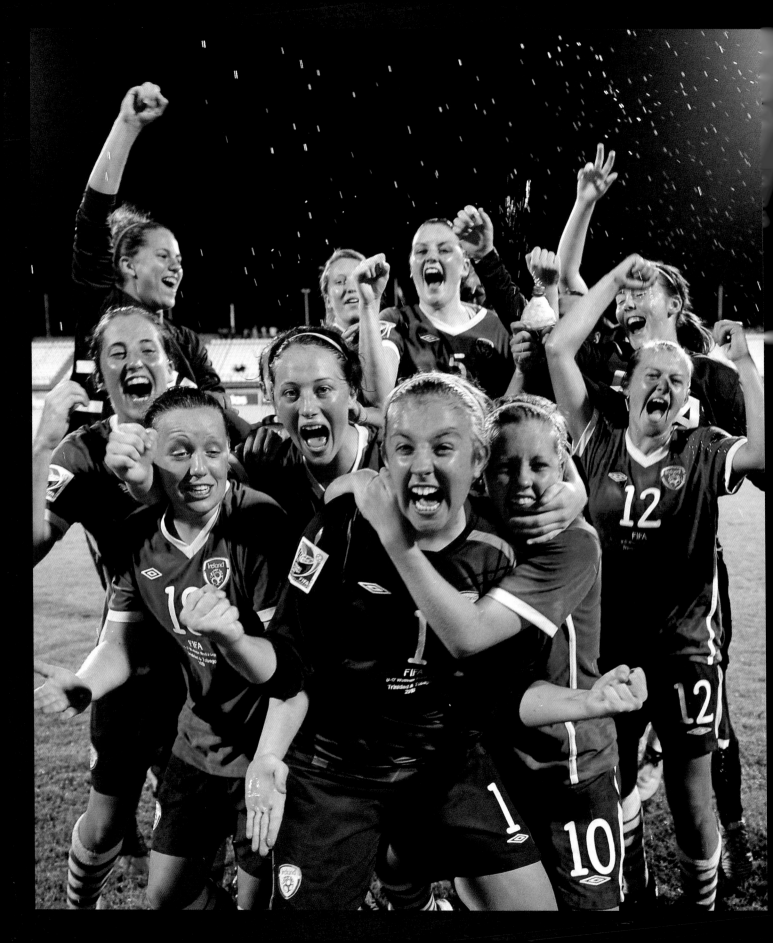

13 September 2010

Republic of Ireland players, from left, Ciara O'Brien, Jillian Maloney, Harriet Scott, Megan Campbell, Emma Hansberry, goalkeeper, Grace Moloney, Jennifer Byrne, Denise O'Sullivan, Amanda Budden and Stacie Donnelly celebrate their side's 3-0 victory over Ghana, and subsequent qualification for the quarter-final. Unfortunately, their campaign ended at the quarter final stage after a 2-1 loss to eventual runners up, Japan. FIFA U-17 Women's World Cup Group Stage, Dwight Yorke Stadium, Scarborough, Tobago, Trinidad & Tobago.

Stephen McCarthy / SPORTSFILE

2010s

06 September 2011

Ireland's Richard Dunne, wearing a replacement jersey with his number written on it during the game against Russia. One of the most admirable individual performances in recent Irish footballing memory. Russia simply could not break down a resilient Irish defence, particularly Dunne, who, many would argue had the game of his career that day. He spectacularly cleared a shot off the line and later whacked his head off the athletics track that encircled the pitch after taking down Yuri Zhirkov as the Russian ran down the line. Dunne needed stitches and a replacement shirt. As the Irish had no spare shirts with numbers on them, the number 5 had to be drawn on Dunne's back and front in marker. Dunne's heroics that day typified his career as an Ireland international. EURO 2012 Championship, Russia v Republic of Ireland, Luzhniki Stadium, Moscow, Russia.

David Maher / SPORTSFILE

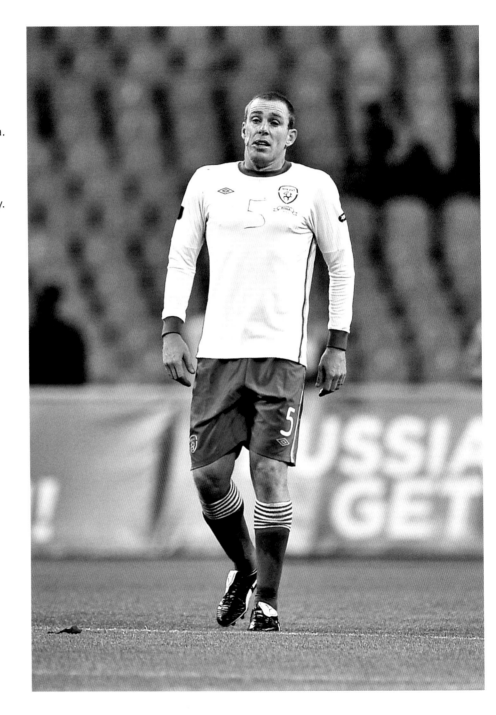

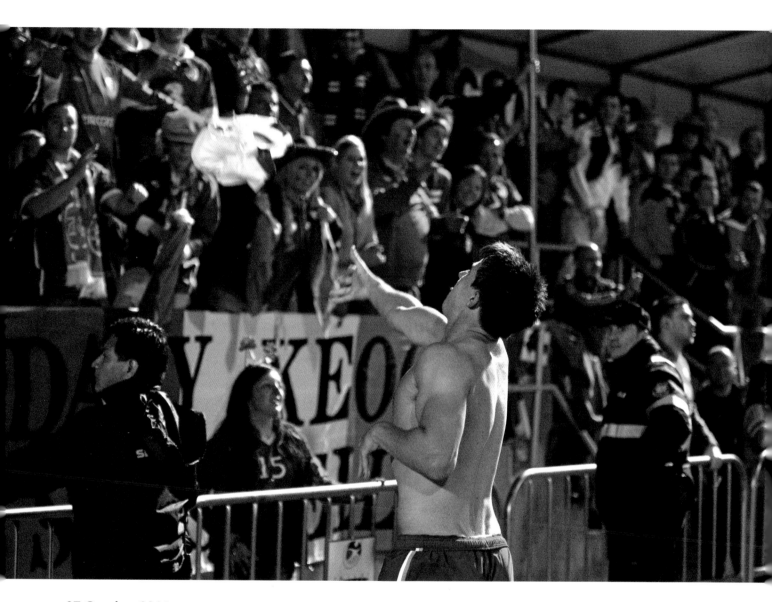

07 October 2011

Sean St Ledger throws his Ireland jersey to the supporters at the end of the game. A 2-0 win here against Andorra meant that a point against Armenia in the final group game would be enough to secure a play-off place. EURO 2012 Championship Qualifier, Estadi Comunal, Andorra La Vella, Andorra.

David Maher / SPORTSFILE

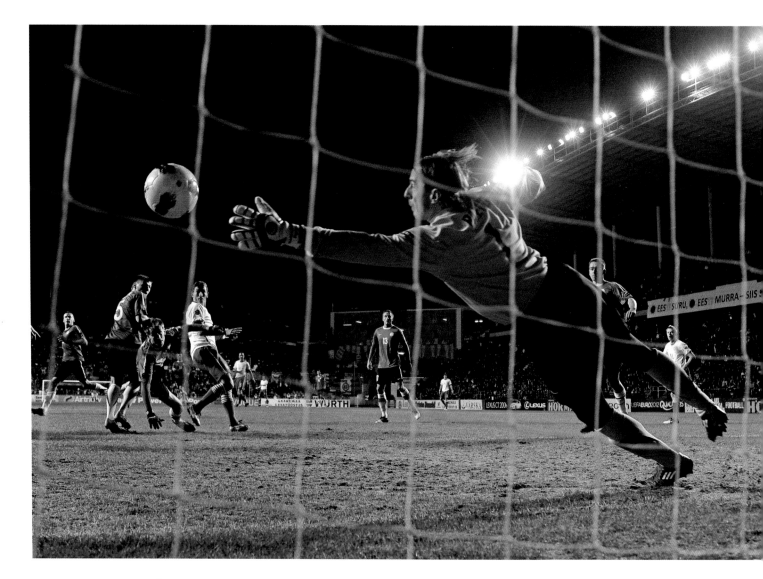

11 November 2011

Keith Andrews heads to score past Estonia goalkeeper Sergei Pareiko after thirteen minutes. A brace from Robbie Keane and a Jon Walters strike saw an efficient Irish side have progression to the European Championships all but wrapped up after an impressive first leg. UEFA EURO2012 Qualifying Play-off, 1st leg, Le Coq Arena, Tallinn, Estonia.

David Maher / SPORTSFILE

Opposite: 15 November 2011

Glenn Whelan lifts Sean St Ledger as they celebrate Ireland's qualification for EURO2012.

Pat Murphy / SPORTSFILE

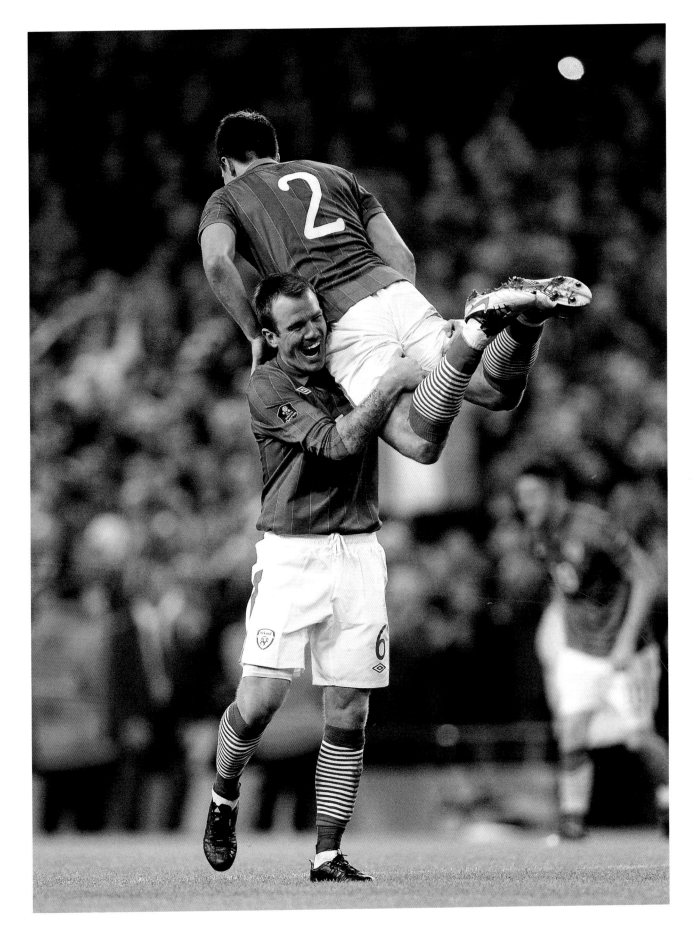

15 November 2011

Ireland captain Robbie Keane, left, and team-mate Damien Duff celebrate in the dressing room after the game. Euro 2012 would be Duff's last tournament with Ireland as the winger announced his retirement from international football not long after Ireland's elimination. His final appearance, and also his 100th in a green shirt, was Ireland's final group game against Italy.

David Maher / SPORTSFILE

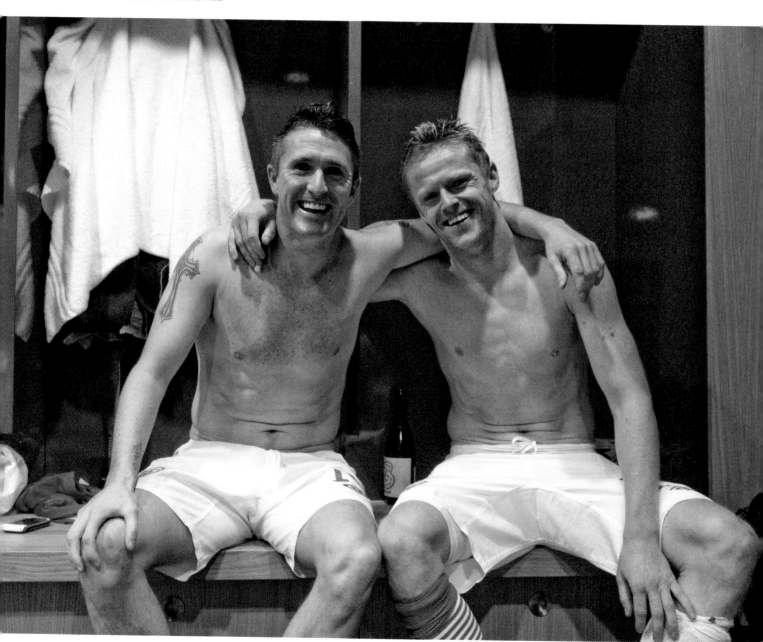

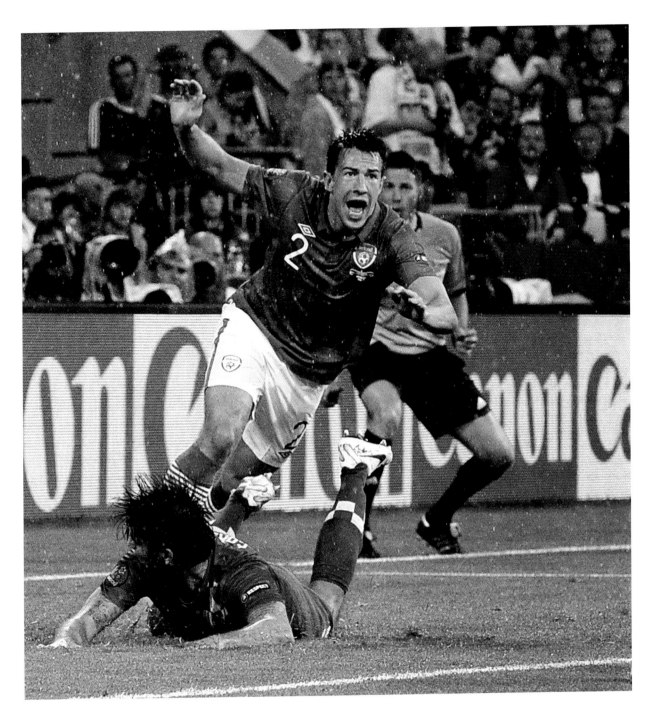

10 June 2012

Sean St. Ledger turns to celebrate after his equalising goal after nineteen minutes. While St. Ledger gave the Irish hope, his goal came either side of strikes from Mario Mandžukić and Nikica Jelavić for Croatia. Mandžukić doubled his tally late on and the game ended as a hugely disappointing 3-1 defeat for Ireland. EURO2012, Group C, Municipal Stadium Poznan, Poland.

David Maher / SPORTSFILE

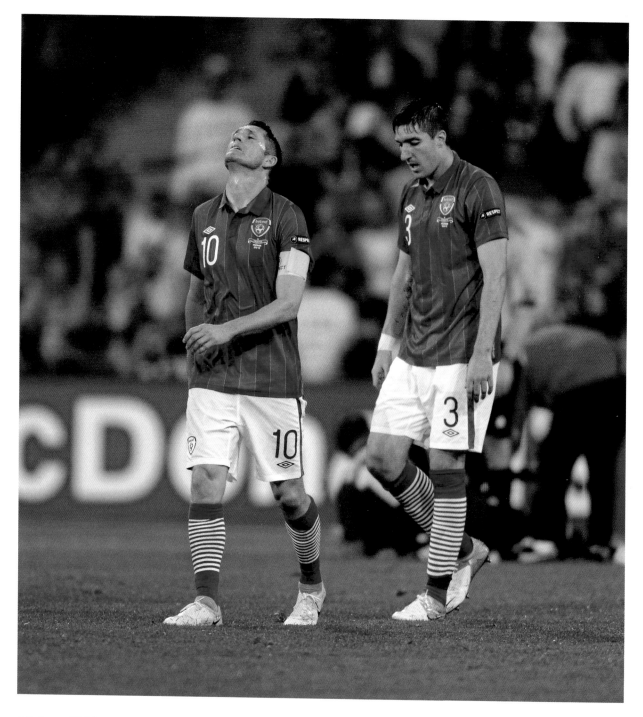

10 June 2012

Robbie Keane, left, and Stephen Ward, Republic of Ireland, after Croatia scored their second goal of the game.

David Maher / SPORTSFILE

10 June 2012

General view of Republic of Ireland supporters at the game. Despite the team exiting at the earliest possible stage, Ireland managed to have a lasting impact on the championships through the vibrant and positive Irish support that lit up stadiums despite the comprehensive beatings the team found themselves on the wrong end of.

David Maher / SPORTSFILE

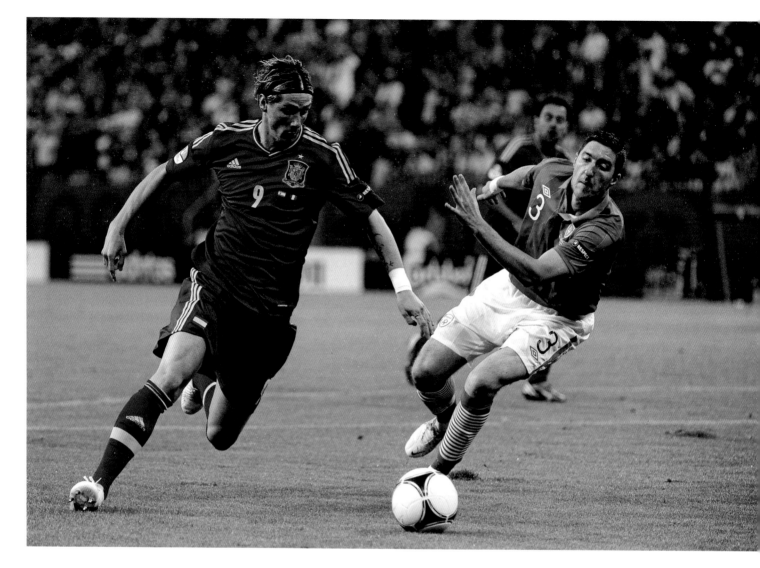

14 June 2012

Fernando Torres, Spain, goes past Stephen Ward, Republic of Ireland, on his way to scoring his side's first goal. The Spaniard was awarded the Golden Boot at the end of the tournament. EURO2012, Group C, Arena Gdansk, Gdansk, Poland.

Pat Murphy / SPORTSFILE

14 June 2012

A dejected Robbie Keane, Republic of Ireland, after Spain's Fernando Torres scored his side's first goal after four minutes.

David Maher / SPORTSFILE

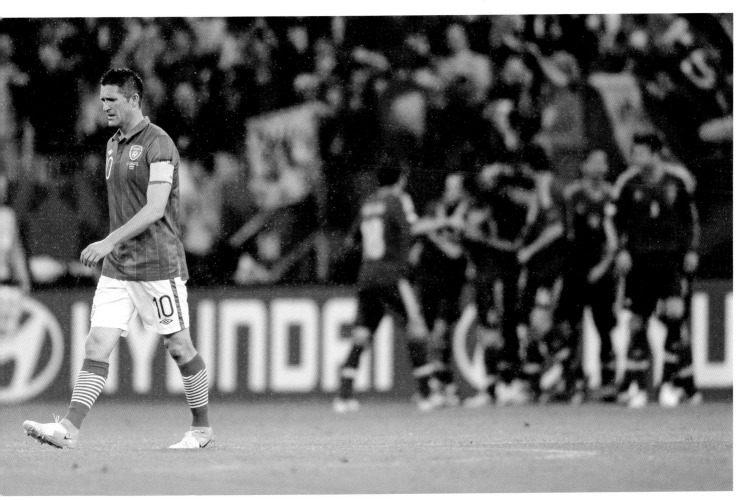

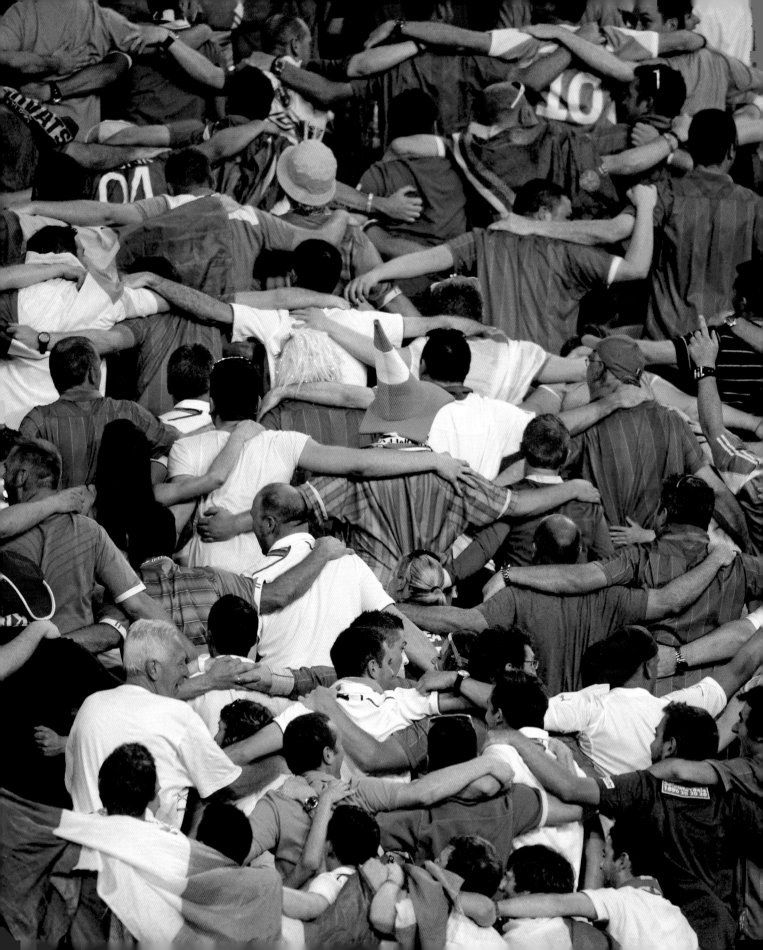

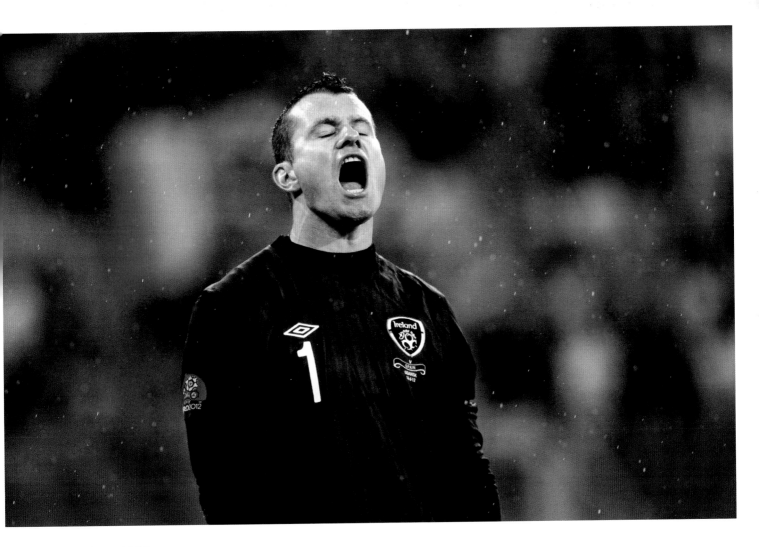

14 June 2012

Ireland goalkeeper Shay Given reacts after Spain's Cesc Fàbregas scored his side's fourth goal after eighty-three minutes; Ireland were taken apart by a Spanish side that never looked like they'd moved out of first gear. Schoolboy errors at the back and general complacency saw the then world champions stroll to a 4-0 win.

David Maher / SPORTSFILE

18 June 2012

Republic of Ireland supporters 'Do the Poznan' during the game. EURO2012, Group C, Republic of Ireland v Italy, Municipal Stadium Poznan, Poznan, Poland.

David Maher / SPORTSFILE

18 June 2012

Antonio Cassano, left, and Giorgio Chiellini, Italy, in action against Ireland's, from left, Kevin Doyle, Shay Given, Keith Andrews and Richard Dunne. Goals from Cassano and Mario Balotelli saw Italy seal a 2-0 win and progression to the knockout stages. The Italians would go on to face Spain in the final, meaning the two finalists both came from Ireland's group. EURO2012, Group C, Municipal Stadium, Poznan, Poland.

Brendan Moran / SPORTSFILE

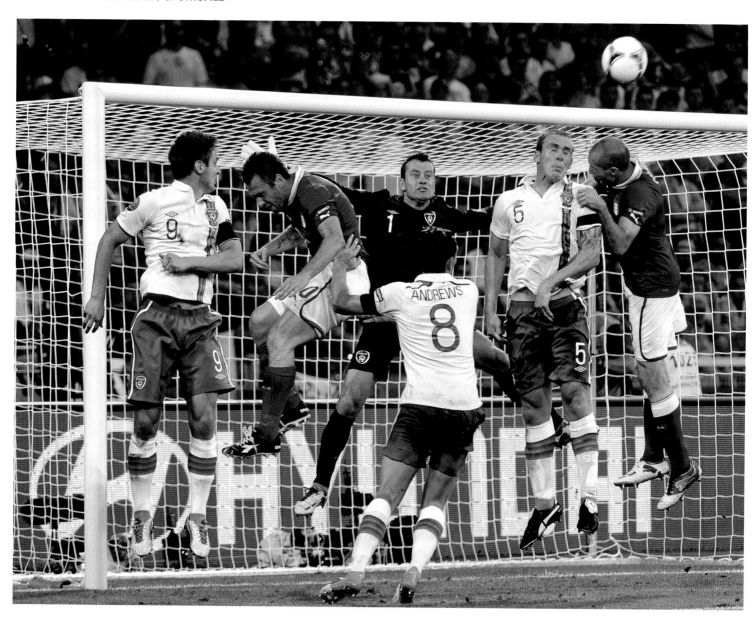

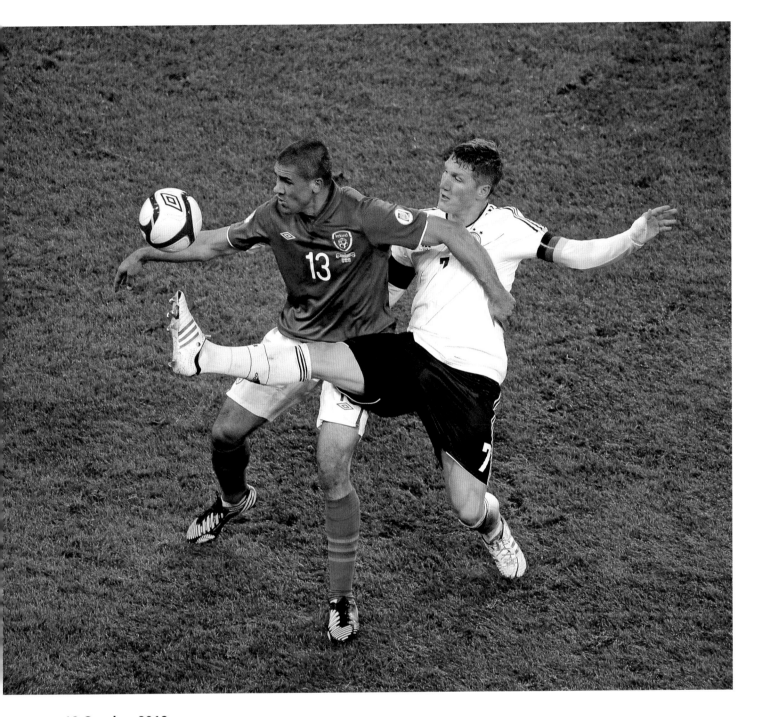

12 October 2012

Jonathan Walters in action against Bastian Schweinsteiger, Germany. An unwanted testament as to how far Ireland were from the world's best as braces from Toni Kroos and Marco Reus, along with strikes from Miroslav Klose and Mesut Özil gave Germany a 6-1 win in the Aviva Stadium, Dublin. Ireland ended the qualifying campaign in 4th place, meaning they had failed to reach three World Cups in a row.

Brendan Moran / SPORTSFILE

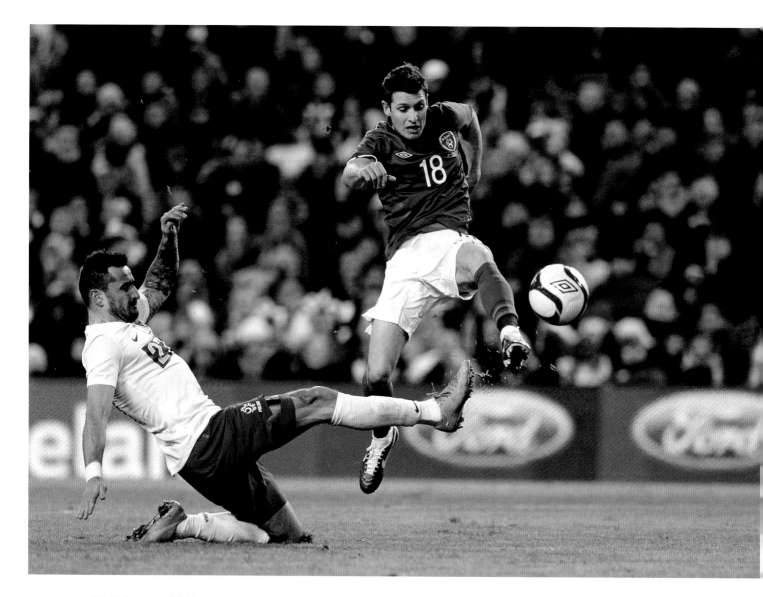

06 February 2013

Wes Hoolahan shoots to score Ireland's second goal, despite the attempts of Poland's Marcin Wasilewski. This was Hoolahan's first goal for Ireland. He would go on to become a key component of the Martin O'Neill era. International Friendly, Aviva Stadium, Lansdowne Road, Dublin.

David Maher / SPORTSFILE

14 October 2014

John O'Shea celebrates with (from left) James McClean, Jeff Hendrick and Stephen Ward after scoring his side's equalizing goal. This stoppage-time goal against the world champions came in O'Shea's 100th international appearance for Ireland. UEFA EURO 2016 Championship Qualifer, Group D, Germany v Republic of Ireland, Veltins Stadium, Gelsenkirchen, Germany.

David Maher / SPORTSFILE

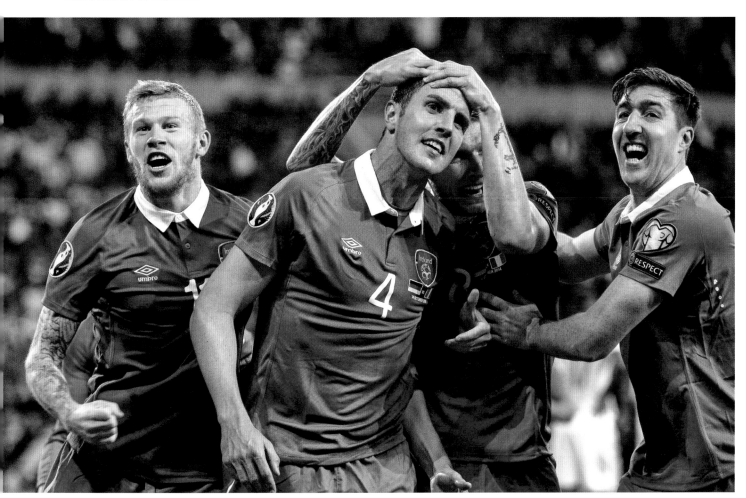

07 June 2015

Former Republic of Ireland manager and England World-Cup-winning player Jack Charlton receives a standing ovation from both sets of supporters before the game. Three International Friendly, Republic of Ireland v England. Aviva Stadium, Lansdowne Road, Dublin.

David Maher / SPORTSFILE

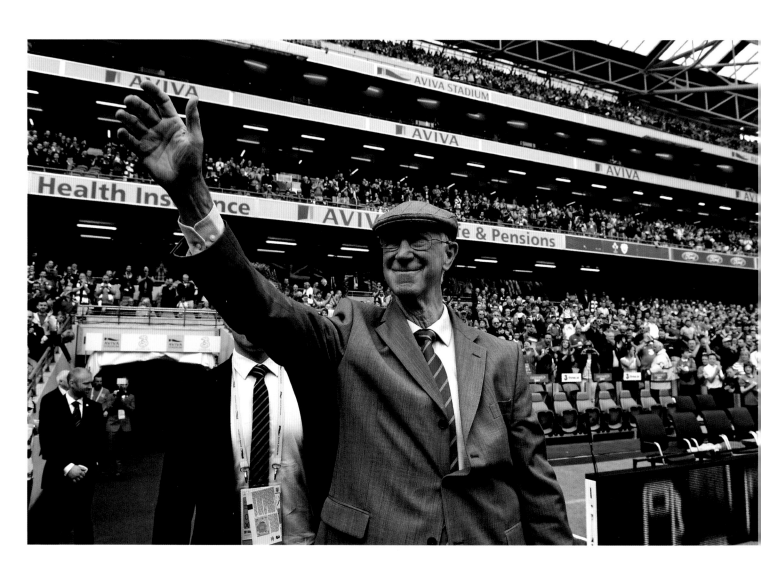

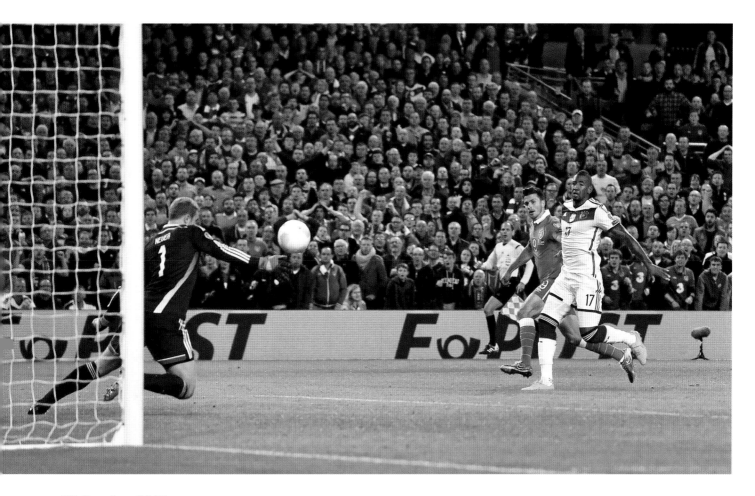

08 October 2015

Shane Long, Republic of Ireland, shoots past Germany goalkeeper Manuel Neuer to score his side's first goal despite the attempts of Jérôme Boateng. A long ball from goalkeeper Darren Randolph released Long behind the German defence. The striker took one touch to get the ball under his control and then drove it home past Neuer. 2016 Championship Qualifier, Group D, Aviva Stadium, Lansdowne Road, Dublin.

Matt Browne / SPORTSFILE

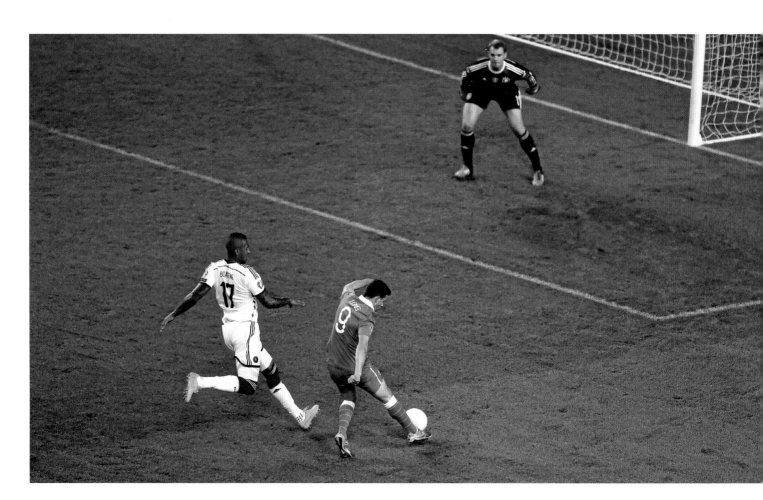

08 October 2015

Shane Long, Republic of Ireland, scores his side's first goal.

Stephen McCarthy / SPORTSFILE

08 October 2015

Shane Long, Republic of Ireland, celebrates after scoring his side's opening goal. Almost three years on from the humiliating 6-1 loss in Dublin, Germany returned to the capital as world champions and were on the receiving end of a huge upset as Ireland claimed all three points.

David Maher / SPORTSFILE

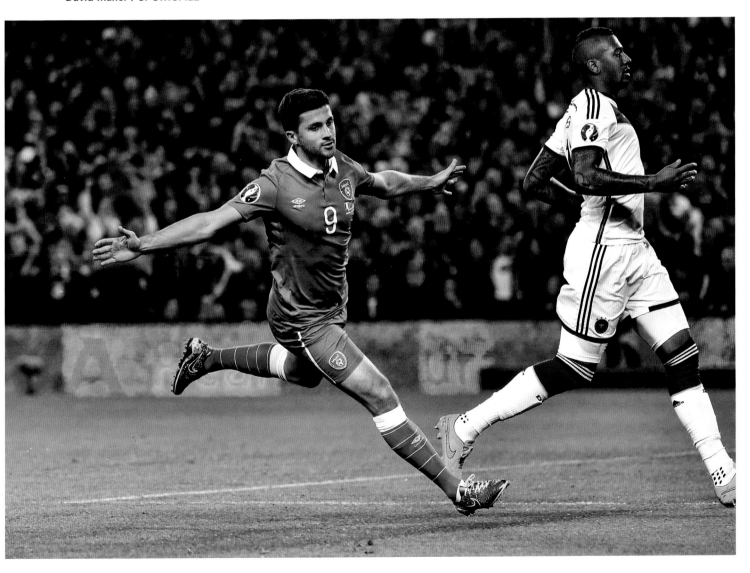

08 October 2015

Republic of Ireland manager Martin O'Neill celebrates after the final whistle. The four points the Republic of Ireland were able to secure against Germany were a huge reason why they were able to edge Scotland to a playoff spot.

Matt Browne / SPORTSFILE

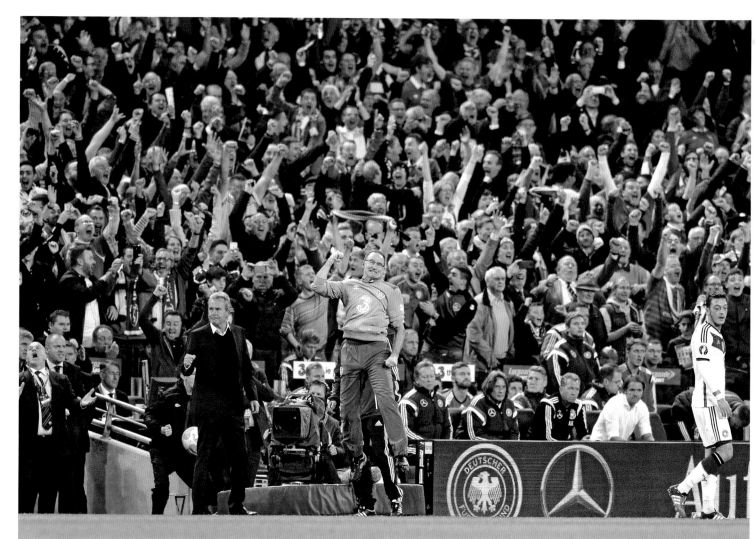

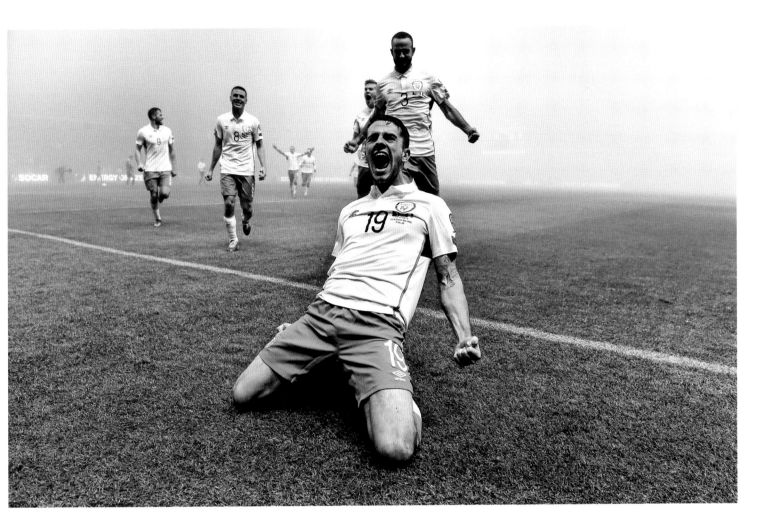

13 November 2015

Robbie Brady celebrates after scoring his side's first goal. A thick fog descended on the Bilino Pole and made the game almost impossible to view from the crowd or from a television screen. The goal, a beautiful individual effort from Brady, was accompanied by a comical three-second delay on commentary between the ball hitting the back of the net and co-commentator, Jim Beglin realising that Ireland had scored. UEFA EURO 2016 Championship Qualifier Play-off, 1st Leg, Bosnia and Herzegovina v Republic of Ireland. Stadion Bilino Pole, Zenica, Bosnia & Herzegovina.

David Maher / SPORTSFILE

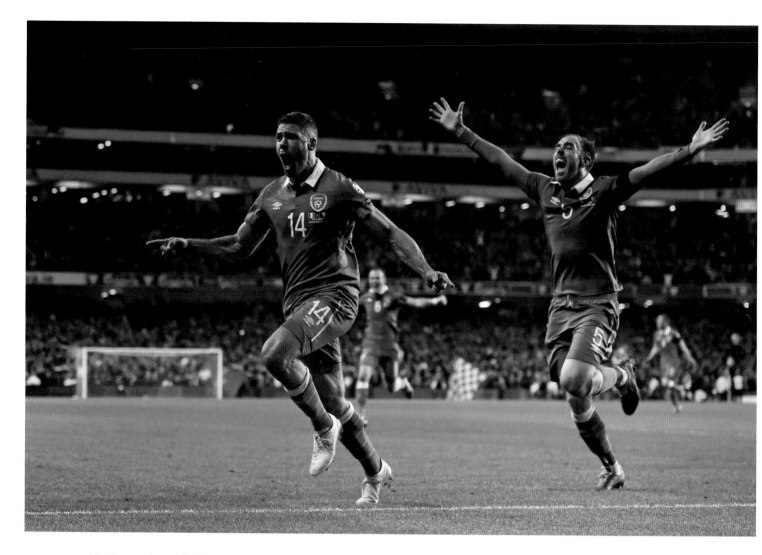

16 November 2015

Jonathan Walters, Republic of Ireland, celebrates scoring his side's second goal of the game with team-mate Richard Keogh. Walters' volley at the back post, along with his earlier penalty, put Ireland 3-1 up on aggregate and sealed their progression to the European Championships. UEFA EURO 2016 Championship Qualifier, Play-off, 2nd Leg, Republic of Ireland v Bosnia and Herzegovina. Aviva Stadium, Lansdowne Road, Dublin.

Ramsey Cardy / SPORTSFILE

16 November 2015

Jonathan Walters, Republic of Ireland, is congratulated by team-mates, including Seamus Coleman, top, after scoring his side's second goal of the game.

Ramsey Cardy / SPORTSFILE

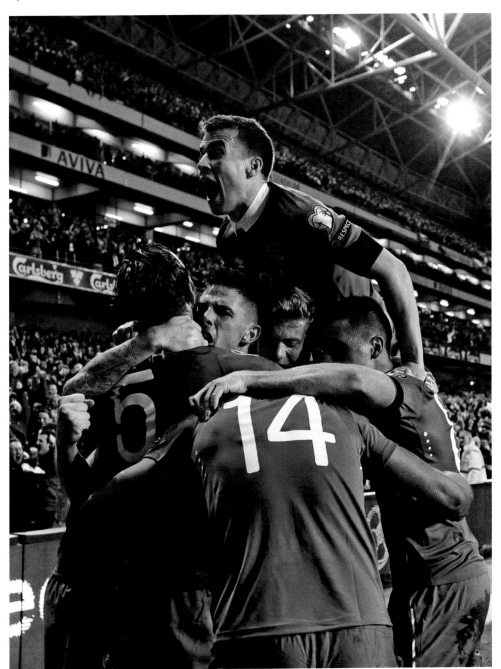

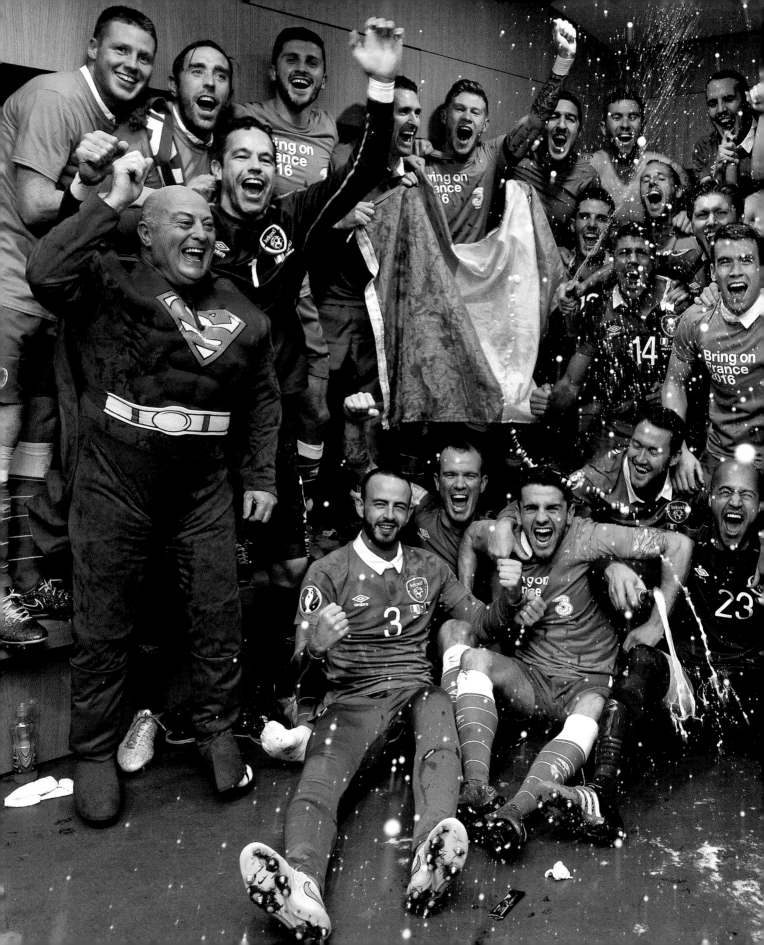

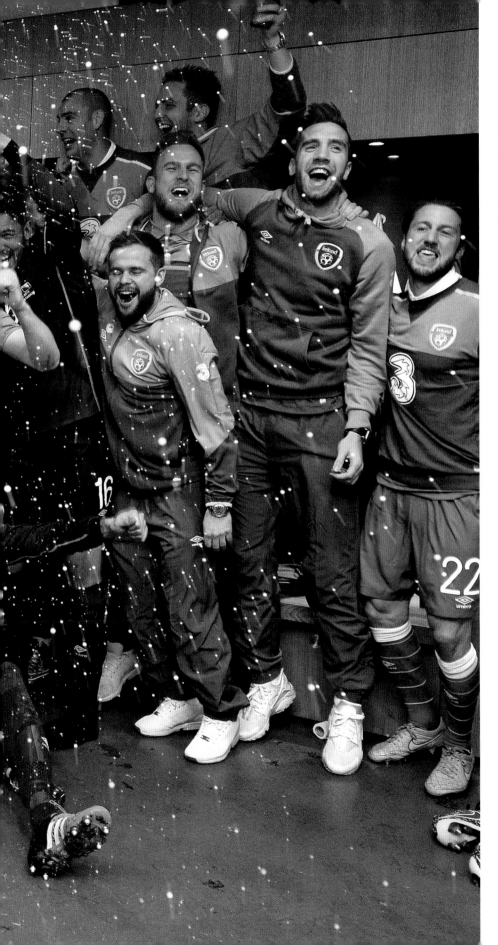

16 November 2015

Republic of Ireland players
and backroom team
celebrate in the dressing-
room after the game.

David Maher / SPORTSFILE

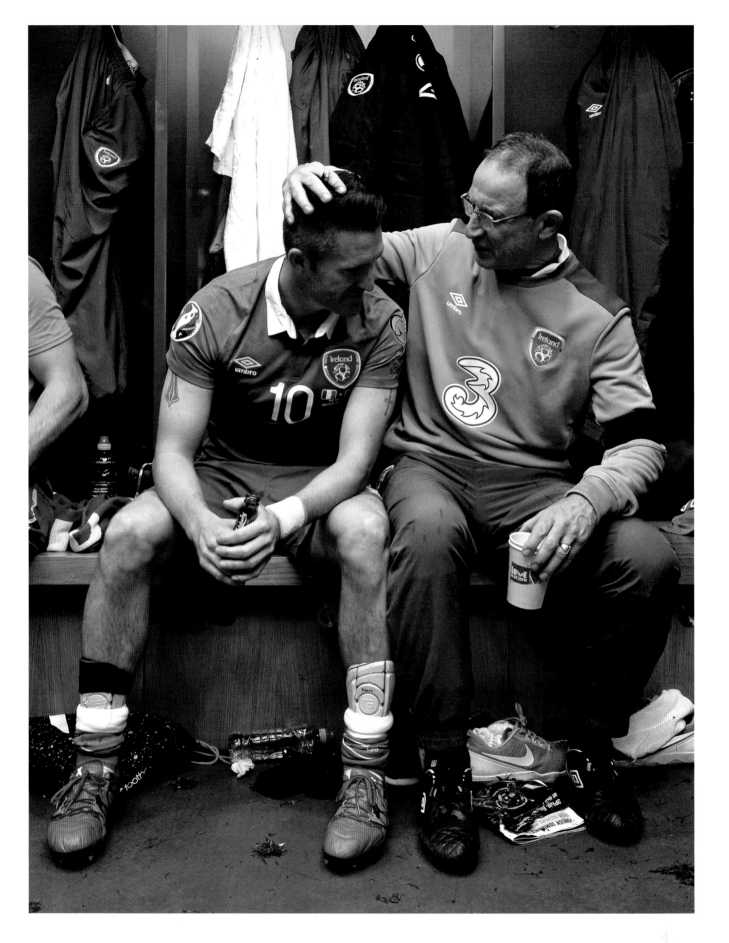

16 November 2015

Republic of Ireland manager Martin O'Neill and Robbie Keane celebrate in the dressing room after the game. Euro 2016 would be Keane's last tournament as an Irish international. UEFA EURO 2016 Championship Qualifier, Play-off, 2nd Leg, Republic of Ireland v Bosnia and Herzegovina. Aviva Stadium, Lansdowne Road, Dublin.

David Maher / SPORTSFILE

13 June 2016

Wes Hoolahan, centre, of Republic of Ireland celebrates after he scored his side's first goal. Hoolahan had established himself as a key figure in the Irish setup since being given more minutes under Martin O'Neill and tended to be the creative heartbeat of the team. A Ciarán Clarke own goal cancelled out Hoolahan's right-footed half volley as the game ended in a 1-1 draw. UEFA Euro 2016 Group E match between Republic of Ireland and Sweden at Stade de France in Saint Denis, Paris, France.

Stephen McCarthy / SPORTSFILE

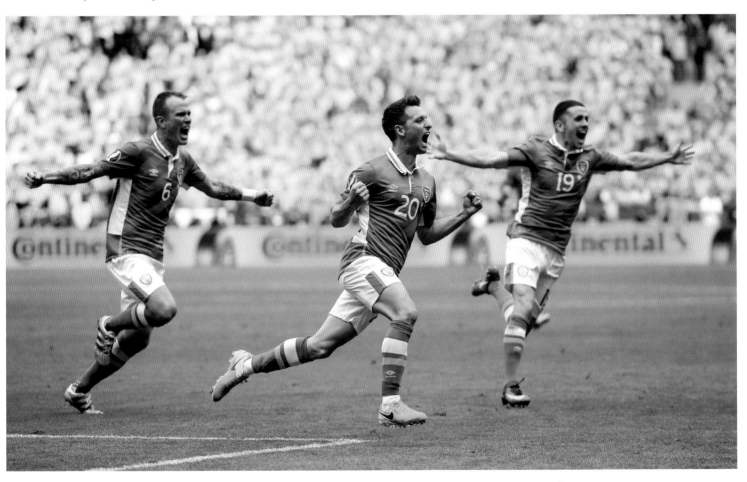

13 June 2016

Republic of Ireland supporters during the match. The Republic of Ireland may have impressed on the pitch, however, their supporters proved to be particularly popular off it. One group was seen helping an elderly lady change a tyre, while others sang a lullaby to a baby on a train. Irish fans were awarded the City of Paris medal for their positive support and were also recognised by UEFA. UEFA Euro 2016 Group E match between Republic of Ireland and Sweden at Stade de France in Saint Denis, Paris, France.

Stephen McCarthy / SPORTSFILE

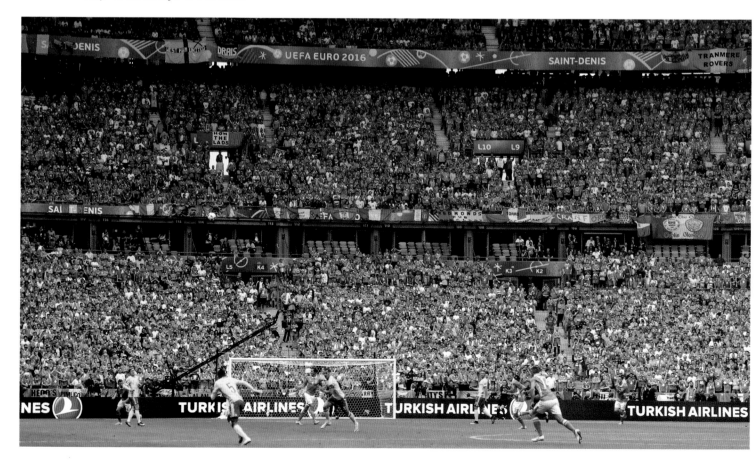

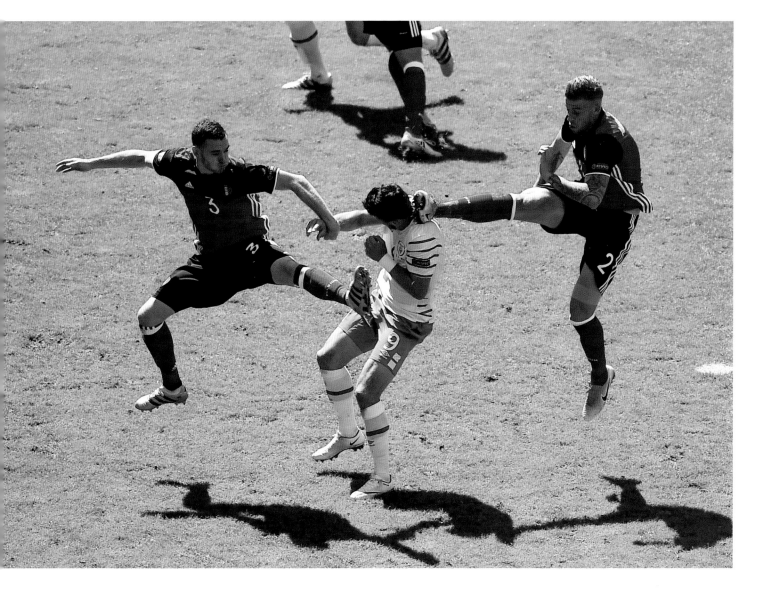

18 June 2016

Shane Long of Republic of Ireland in action against Thomas Vermaelen, left, and Toby Alderweireld of Belgium. The referee, Cuneyt Cakir, felt that this incident didn't warrant a penalty and Belgium went on to score their opener moments later. Belgium went on to win the game 3-0. UEFA Euro 2016 Group E, Nouveau Stade de Bordeaux, France.

Ray McManus / SPORTSFILE

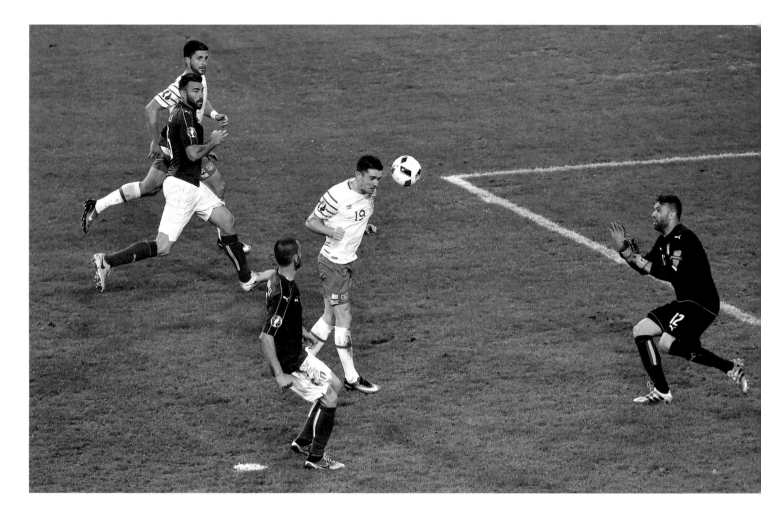

22 June 2016

Robbie Brady **(above and right)** scores Ireland's first goal of the game. With just five minutes left on the clock, Brady's surging run through the heart of the Italian defence was picked out by a sensational Wes Hoolahan cross. Brady beat goalkeeper Salvatore Sirigu to the ball to nod home and give Ireland the lead. Ireland secured their progression to the last 16 of the competition with a 1-0 win in Lille. Martin O'Neill took huge risks with his team selections. Dropping John O'Shea and opting to start Daryl Murphy up front who hadn't scored for Ireland in any of his twenty appearances. These changes paid dividends, however, as the Irish put in a spirited display against an already qualified Italian side to claim a crucial 3 points. Euro 2016 Group E, Stade Pierre-Mauroy, Lille, France.

Paul Mohan / SPORTSFILE

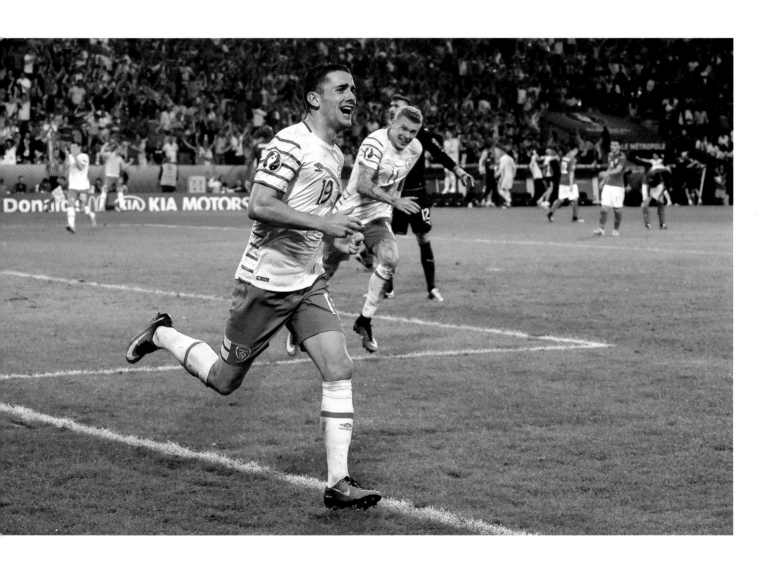

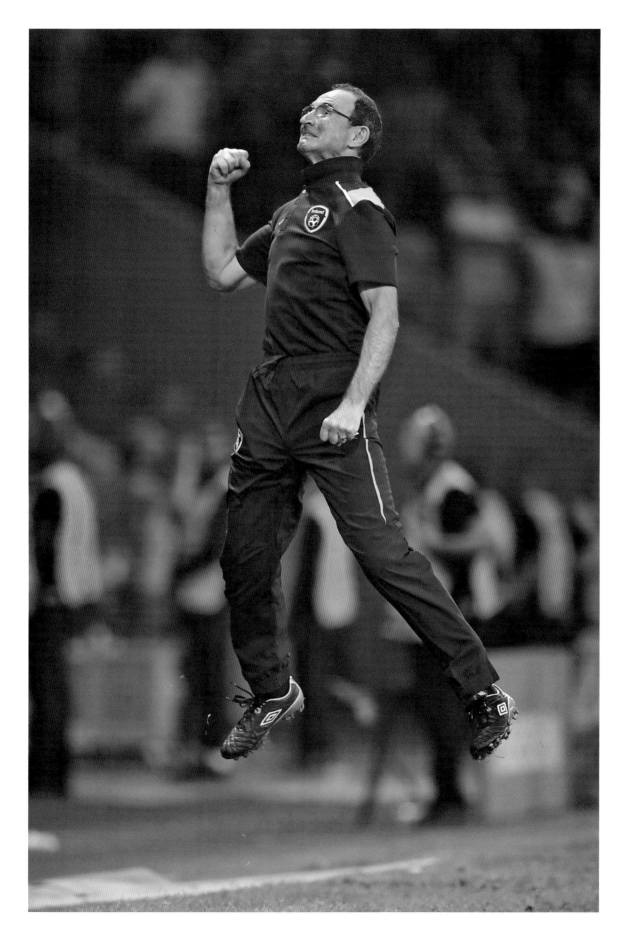

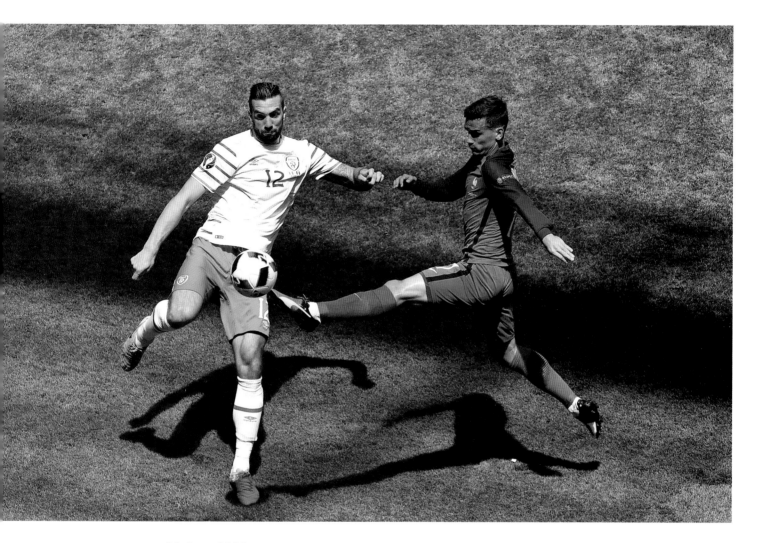

26 June 2016

Shane Duffy of Republic of Ireland in action against Antoine Griezmann of France. Griezmann, the eventual Golden Boot winner at this tournament, grabbed a brace to cancel out an early Robbie Brady penalty and send the hosts on to the next round. Duffy also received a red card late in the game for fouling Griezmann as he raced through on goal. UEFA Euro 2016 Round of 16, Stade des Lumieres in Lyon, France

Paul Mohan / SPORTSFILE

22 June 2016

Republic of Ireland manager Martin O'Neill celebrates at the final whistle of the UEFA Euro 2016 Group E match between Italy and Republic of Ireland at Stade Pierre-Mauroy in Lille, France.

Stephen McCarthy / SPORTSFILE

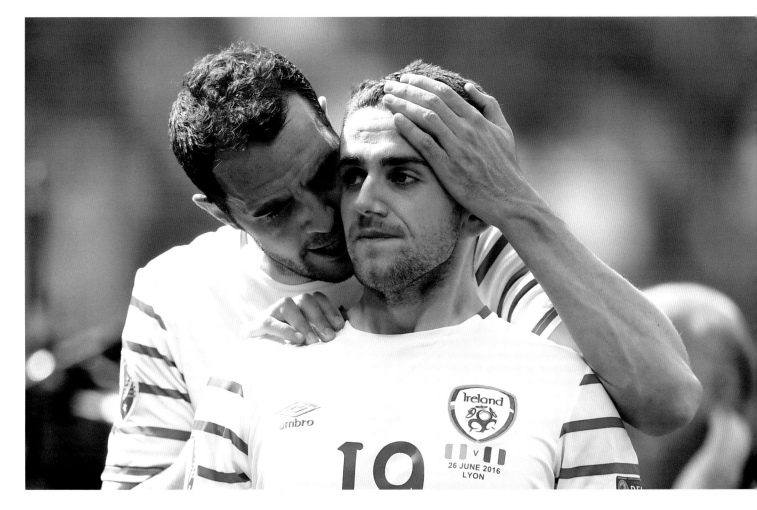

26 June 2016

John O'Shea, left, and Robbie Brady of Republic of Ireland after the game. Brady's converted penalty was Ireland's only shot on target during the game. Ireland finished the tournament with 3 goals in 4 games. UEFA Euro 2016 Round of 16 match between France and Republic of Ireland at Stade des Lumieres in Lyon, France.

Stephen McCarthy / SPORTSFILE

7 June 2016

Stephanie Roche celebrates after scoring her third, and her team's eighth goal of the match. Roche's hat-trick helped her side to a 9-0 win in Tallaght. Unfortunately, Ireland failed to secure qualification to the Euros. Women's 2017 European Championship Qualifier between Republic of Ireland and Montenegro in Tallaght Stadium, Tallaght, Co. Dublin.

Seb Daly / SPORTSFILE

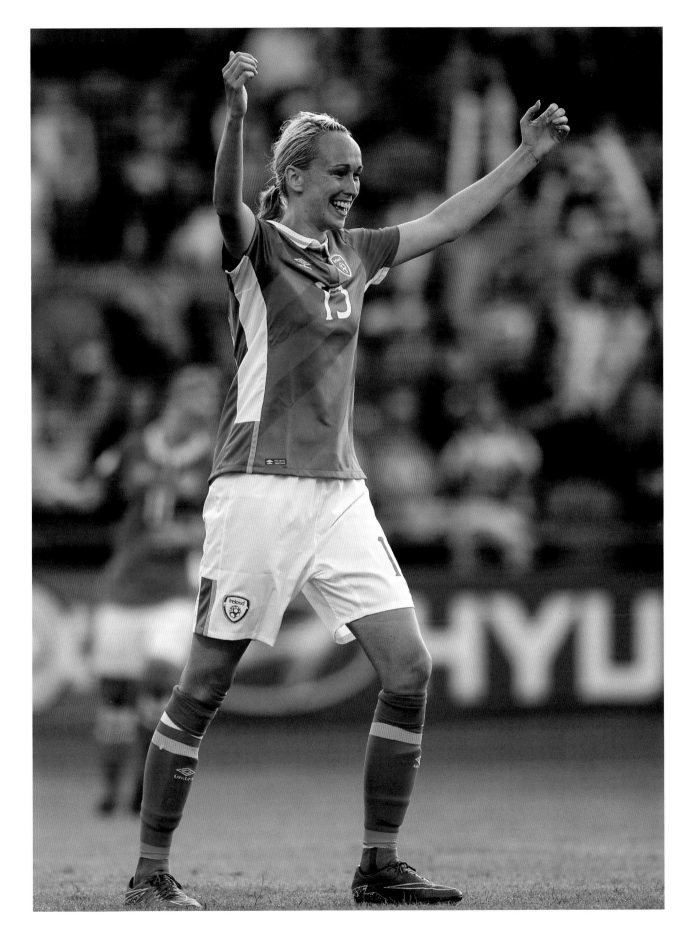

31 August 2016

The President of Ireland Michael D. Higgins presents Robbie Keane with his 146th International Cap during the Three International Friendly game between the Republic of Ireland and Oman at the Aviva Stadium, Dublin.

David Maher / SPORTSFILE

31 August 2016

Robbie Keane, with his sons, Robert, left, and Hudson, salutes the crowd. This was Keane's final appearance for Ireland. His goal on that day meant he ended his time in a green shirt as Ireland's all-time top goalscorer with 68 goals. Keane is Ireland's record appearance holder, surpassing the 125 caps earned by goalkeeper, Shay Given. His international career spanned eighteen years, beginning in 1998.

Dáire Brennan / SPORTSFILE

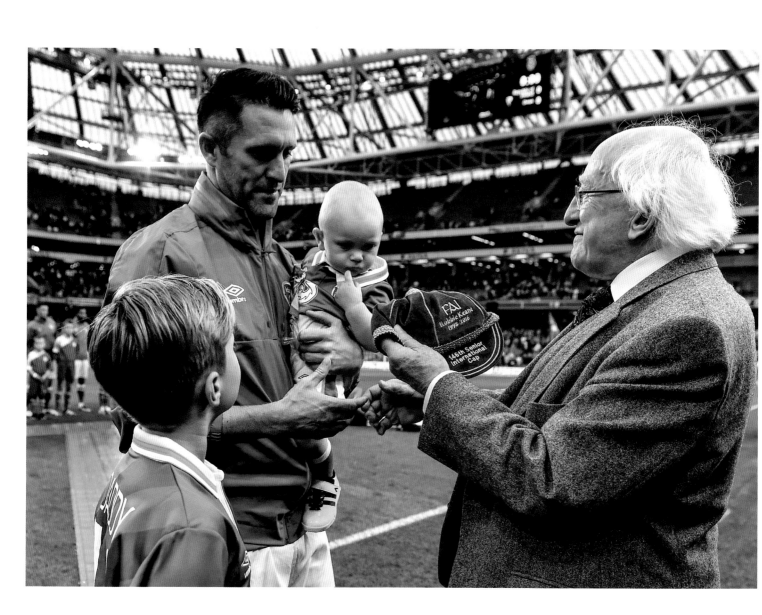

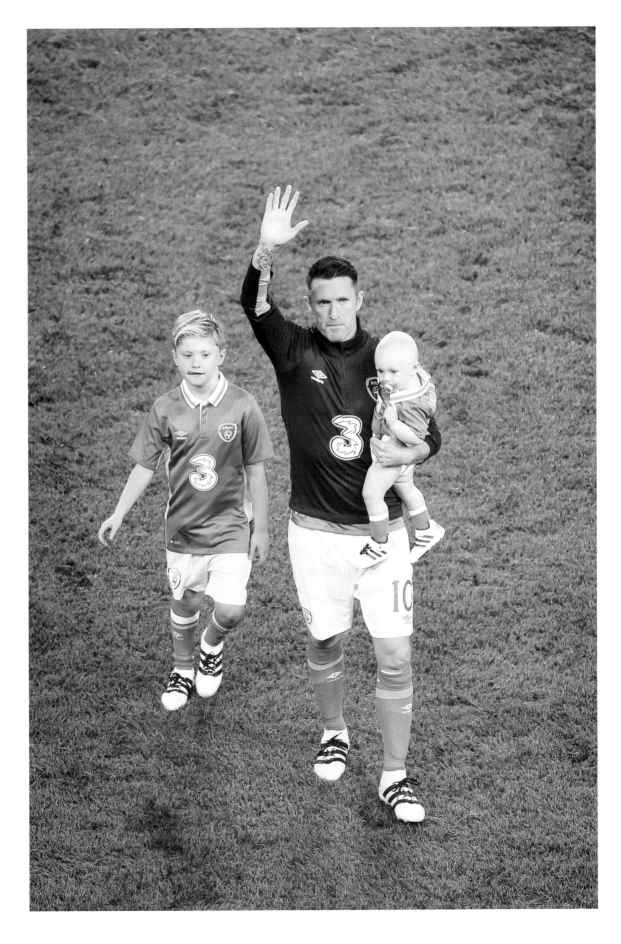

10 March 2017

Hugh Douglas of Bray Wanderers competes with Jamie Doyle of Bohemians for a high ball. A brace from Dinny Corcoran helped Bohemians come from 2-0 down to snatch a 3-2 win. SSE Airtricity League Premier Division, Dalymount Park in Dublin.

David Fitzgerald / SPORTSFILE

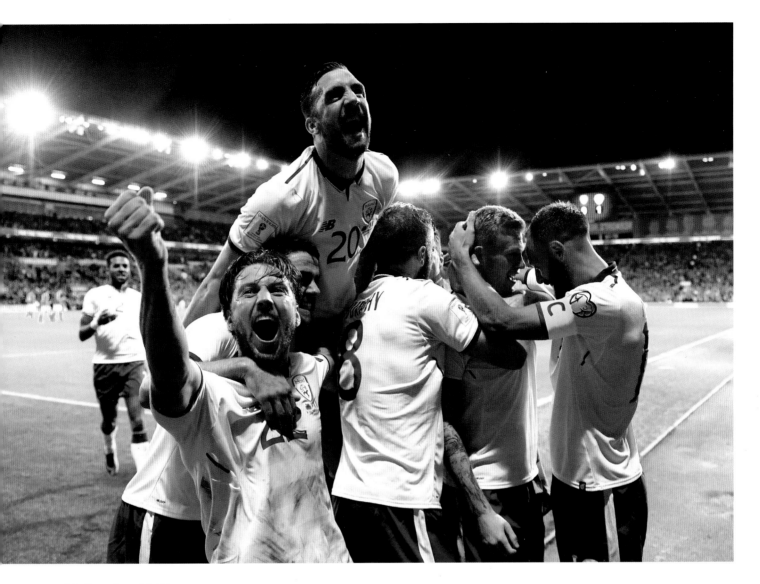

09 October 2017

James McClean, second from right, celebrates with team-mates after scoring his side's first goal. In the last round of fixtures in Group D, whoever won between the Irish and the Welsh would secure a Playoff position while the other would go home empty-handed. Wales, without their talisman, Gareth Bale, couldn't find a way past the excellent Darren Randolph. With just over half an hour left, James McClean steered home a bouncing cross after some great work from Jeff Hendrick out wide to keep the ball in play. The game ended 1-0 to Ireland, meaning they had earned themselves a spot in the World Cup Playoffs. FIFA World Cup Qualifier Group D match between Wales and Republic of Ireland at Cardiff City Stadium in Cardiff, Wales.

Stephen McCarthy / SPORTSFILE

14 November 2017

A dejected Jeff Hendrick, left, and Robbie Brady of Republic of Ireland after the game. After a Shane Duffy opener, Ireland were utterly torn apart by the brilliance of Christian Eriksen. Three stunning goals from the attacking midfielder helped Denmark to an emphatic 5-1 win in Dublin and denied Ireland a place in the World Cup. FIFA 2018 World Cup Qualifier Play-off 2nd leg, Aviva Stadium, Dublin.

Seb Daly / SPORTSFILE

19 September 2017

Stephanie Roche of the Republic of Ireland in action against Ashley Hutton of Northern Ireland. While this particular game ended in a 2-0 win for the Irish, they unfortunately finished a few points behind the Netherlands and Norway and failed to qualify for the World Cup. 2019 FIFA Women's World Cup Qualifier Group 3, Mourneview Park, Lurgan, Co Armagh.

Stephen McCarthy / SPORTSFILE

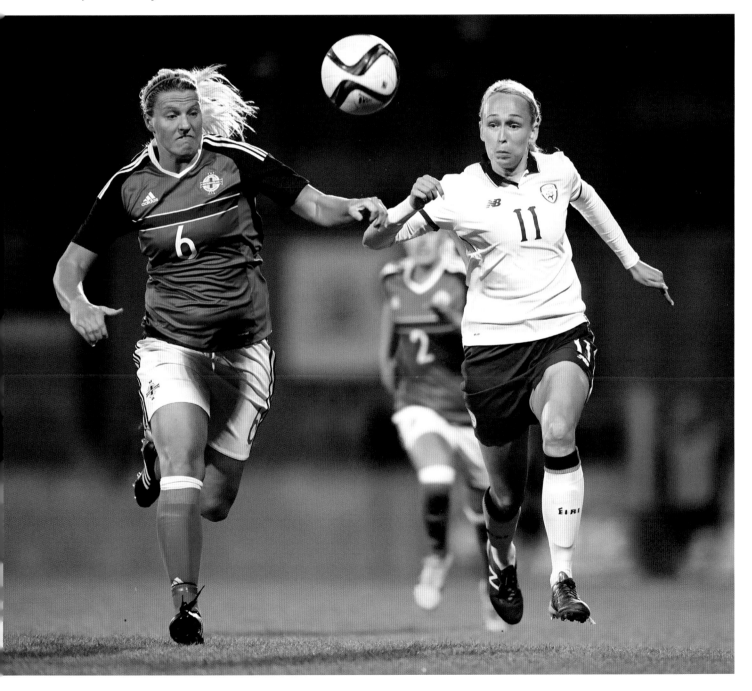

31 August 2018

Leanne Kiernan, 8, celebrates after scoring her side's third goal with her Republic of Ireland team-mates Rianna Jarrett, left, Denise O'Sullivan and Katie McCabe, right, during the 2019 FIFA Women's World Cup Qualifier match between Republic of Ireland and Northern Ireland at Tallaght Stadium in Dublin.

Stephen McCarthy / SPORTSFILE

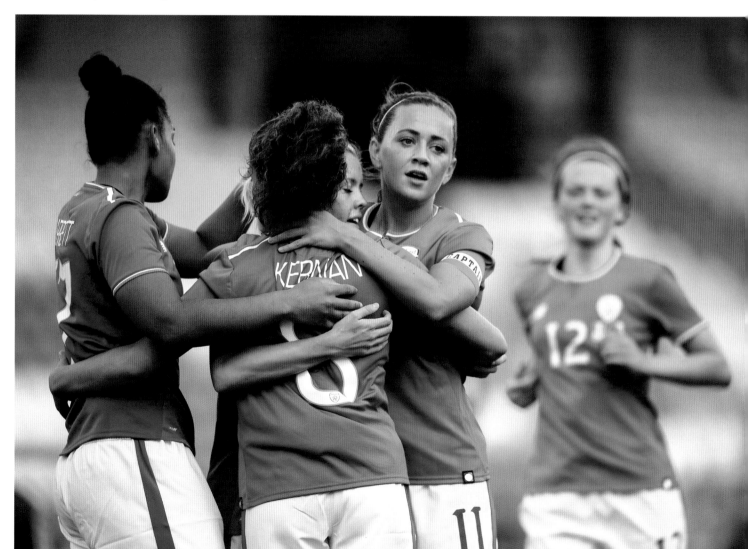

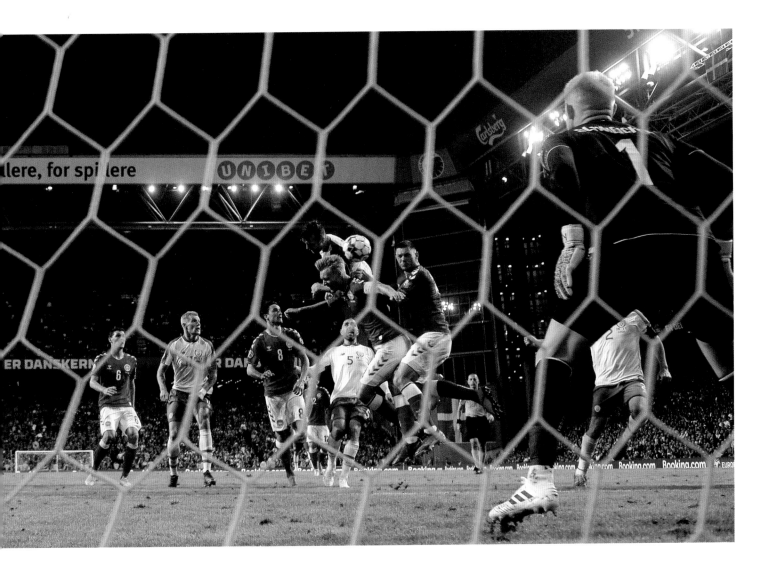

7 June 2019

Shane Duffy of Republic of Ireland heads his side's goal during the UEFA EURO2020 Qualifier Group D match between Denmark and Republic of Ireland at Telia Parken in Copenhagen, Denmark.

Stephen McCarthy / SPORTSFILE

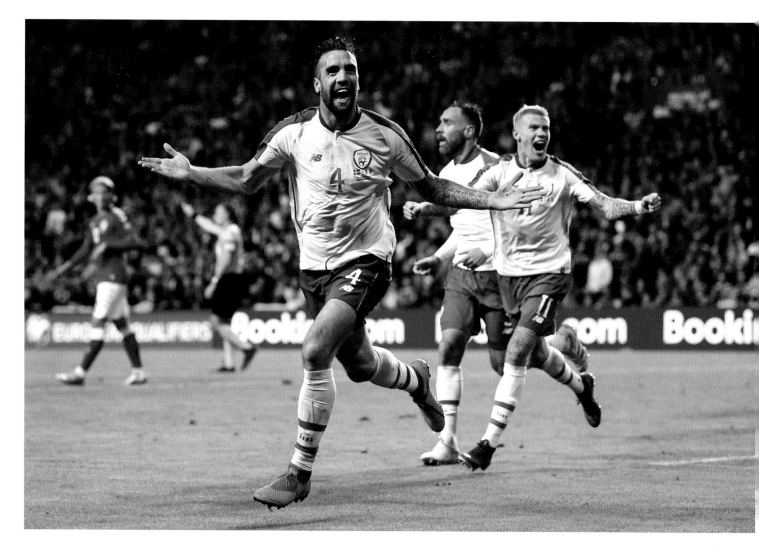

7 June 2019

Shane Duffy of Republic of Ireland celebrates after scoring his side's goal. Pierre-Emile Højbjerg gave Denmark the lead, Duffy rose highest to head home an Alan Judge free-kick with just five minutes left. UEFA EURO2020 Qualifier Group D, Telia Parken, Copenhagen, Denmark.

Stephen McCarthy / SPORTSFILE

10 June 2019

Robbie Brady, Republic of Ireland, celebrates after scoring his side's second goal. Brady's late header secured a 2-0 win and saw Mick McCarthy's side continue their positive start to their qualifying campaign. UEFA EURO2020 Qualifier Group D match between Republic of Ireland and Gibraltar at Aviva Stadium, Lansdowne Road in Dublin

Stephen McCarthy / SPORTSFILE

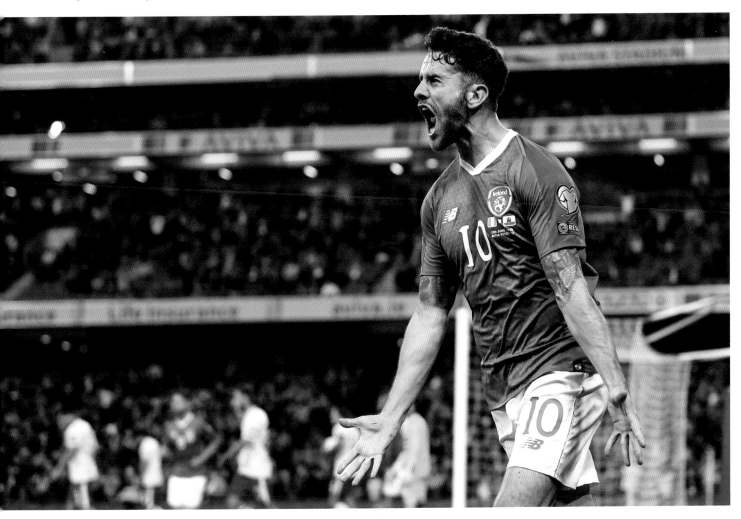